D0501163

VISIONS *of* THE WILD

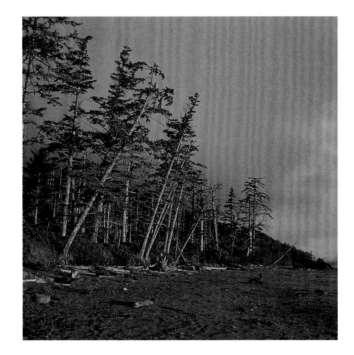

VISIONS
of
THE WILD

A Voyage by Kayak around Vancouver Island

Maria Coffey and Dag Goering

HARBOUR PUBLISHING

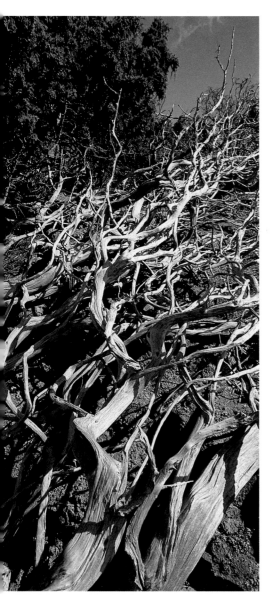

Harbour Publishing
P.O. Box 219,
Madeira Park, BC
V0N 2H0 Canada
www.harbourpublishing.com

THE CANADA COUNCIL | LE CONSEIL DES ARTS
FOR THE ARTS | DU CANADA
SINCE 1957 | DEPUIS 1957

Harbour Publishing acknowledges the financial support of the Government
of Canada through the Book Publishing Industry Development Program
(BPIDP) and the Canada Council for the Arts, and the Province of British
Columbia through the British Columbia Arts Council, for its publishing
activities.

Printed in Canada

Cover and page design by Tara Williams and Candice Hazard.
Edited by Irene Niechoda.
Front cover photo: Brooks Bay, Brooks Penninsula.
All photos in this book are by the authors, unless otherwise noted.
Preliminary pages photo credits:
p. V, Morris Donaldson; p. VI, Mark Kaarremaa.

National Library of Canada Cataloguing in Publication Data

Coffey, Maria, 1952-
 Visions of the wild

 ISBN 1-55017-264-6

 1. Coffey, Maria, 1952- —Journeys—British Columbia—Vancouver
Island. 2. Goering, Dag—Journeys—British Columbia—Vancouver
 Island. 3. Vancouver Island—Description and travel. 4. Sea kayaking—
British Columbia—Vancouver Island. I. Goering, Dag. II. Title.
GV776.15.B7C63 2001 917.11'2 C2001-911180-0

A portion of the proceeds from this book is being donated to the Friends of
Clayoquot Sound : www.ancientrainforest.org

For Justina Epp Goering,
in memory of her adventurous spirit and her love of life.

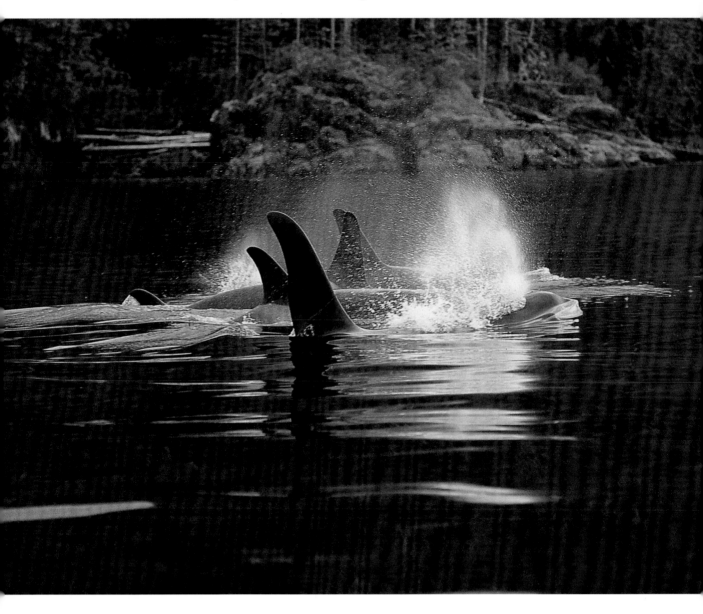

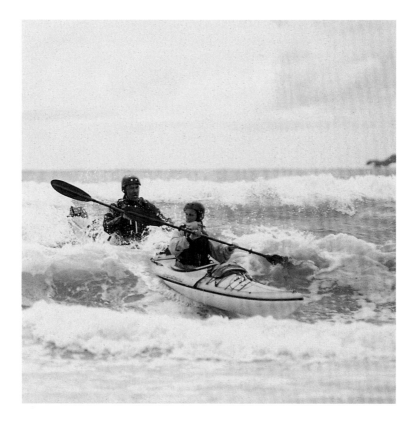

CONTENTS

VISIONS OF THE WILD

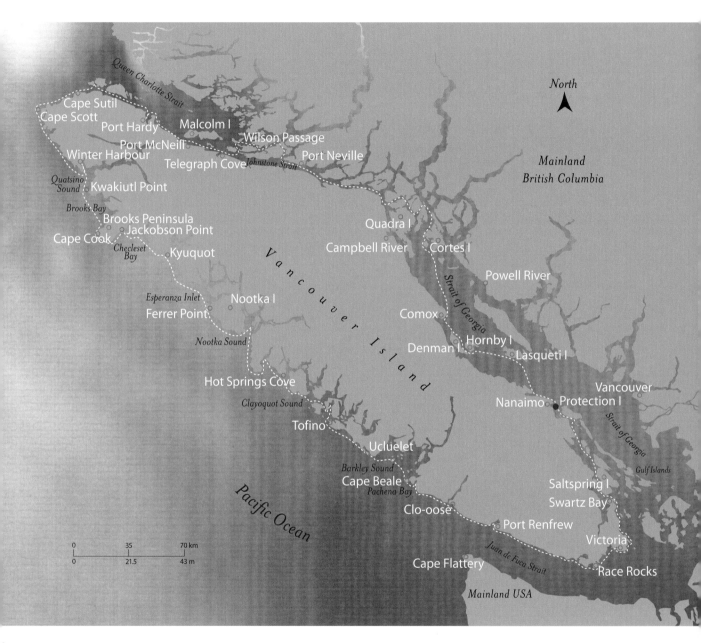

North

Queen Charlotte Strait

Cape Sutil
Cape Scott
Port Hardy
Malcolm I
Wilson Passage
Port McNeill
Port Neville
Winter Harbour
Telegraph Cove
Johnstone Strait
Quatsino Sound
Kwakiutl Point

Mainland
British Columbia

Brooks Bay
Brooks Peninsula
Jackobson Point
Quadra I
Cape Cook
Checleset Bay
Kyuquot
Campbell River
Cortes I

Powell River

V a n c o u v e r I s l a n d

Esperanza Inlet
Nootka I
Ferrer Point
Comox
Strait of Georgia
Nootka Sound
Denman I
Hornby I
Lasqueti I

Hot Springs Cove
Vancouver
Clayoquot Sound
Nanaimo
Protection I

Tofino
Strait of Georgia

Ucluelet

Barkley Sound
Cape Beale
Saltspring I
Pachena Bay
Swartz Bay

Pacific Ocean
Clo-oose
Port Renfrew
Victoria

Cape Flattery
Juan de Fuca Strait
Race Rocks

Mainland USA

Gulf Islands

| 0 | 35 | 70 km |
| 0 | 21.5 | 43 m |

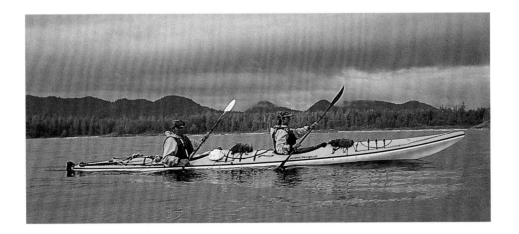

So you think you might like to take off and paddle a wilderness coastline for a month or so? Maria and Dag did just that. This story of their journey around Vancouver Island in the summer of 1999 is told with an engaging style that introduces the reader to a kaleidoscope of wonderful characters and historic places without becoming guide-bookish or losing the point that this is an adventure—an adventure into serious kayaking country by two competent people in one kayak.

The book carries the reader through the authors' various trials by adverse current, overfalls and west coast boomers, stressing the constant watchfulness for weather conditions that might turn a difficult day's paddle into a struggle for survival. At the same time it gives a great sense of the British Columbia west coast, warts, scars and all.

Maria and Dag come across as the ideal people with whom to undertake such a journey. They're lively, warm and spontaneous and the book is candid enough to share a glimpse of their more irascible side when hunger or stress reveals their human-ness. It is something we can all relate to, even if facing down a whiplashing Cape Scott overfall is not likely to be something we might have on our calendars.

John Dowd, **author of** *Sea Kayaking: A Manual of Long Distance Touring*

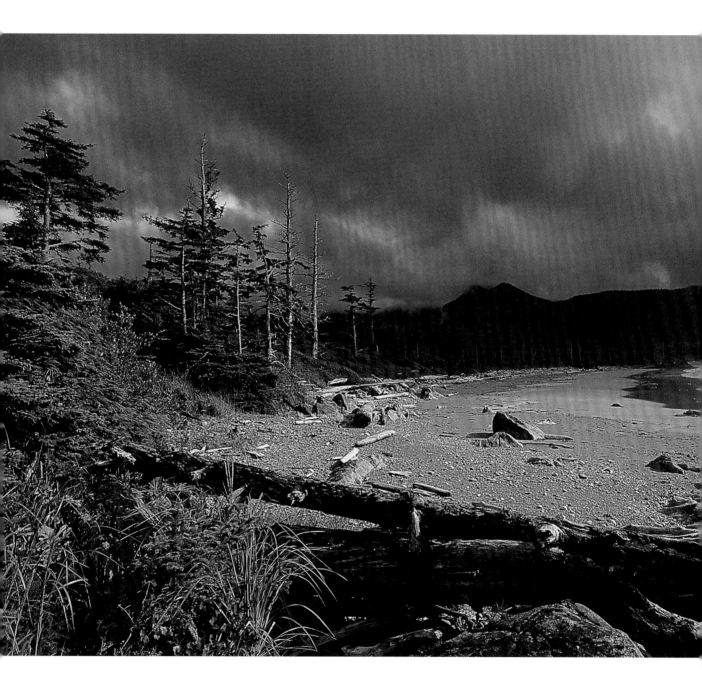

The simplicity of the concept was irresistible: to set off in a kayak outside our house and keep paddling around Vancouver Island until we returned to the place from where we had begun.

With two strong personalities in one small kayak, there were bound to be differences of opinion. Dag saw the trip as a physical and mental challenge. For me it was a search for a new meaning of "home," an understanding of why I am always drawn back to this particular spot on the planet, far from where I was born. At the heart of it all, however, there lay a common focus, a shared longing to embark once more on a long, demanding journey. A journey that, with each paddle stroke, would take us farther from the distractions of everyday existence. A journey that would allow us to fall into the rhythms of the tides and the routines of the days, and to pare down our life to its barest essentials. A journey with a momentum as natural as a heartbeat.

But no matter how strong the pull toward adventure, it's always hard to leave the known for the uncertain, and this trip was no exception…

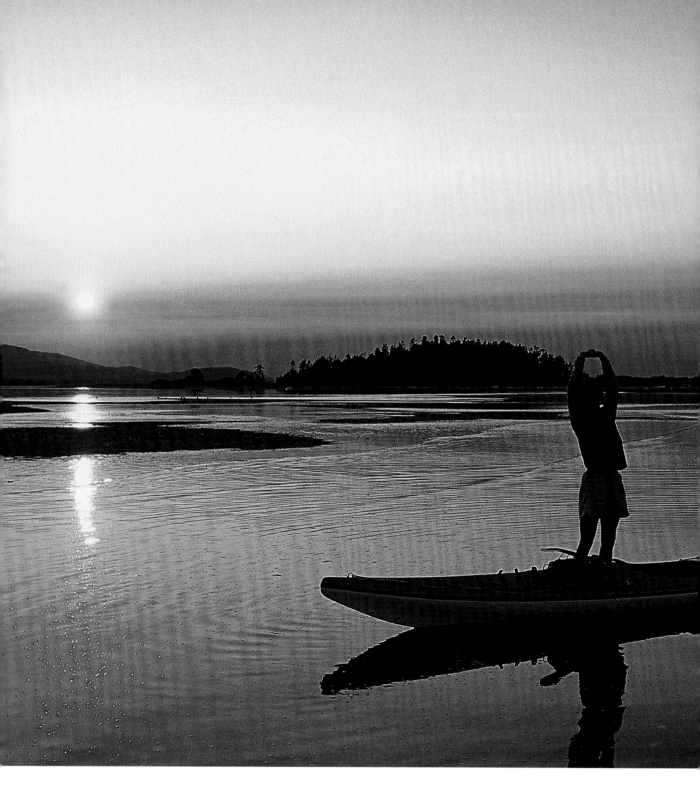

ABOVE : *Maria stretching before a long day's paddle*
OPPOSITE : *Roosting cormorants*

Thursday July 01

PROTECTION ISLAND

MARIA : I gaze out the rain-streaked windows of our living room at a cold, unfriendly scene. The sky is leaden, low clouds obscure the mainland mountains, and gusty south-east winds scour across the Georgia Strait, whipping up steep, cresting waves. Sighing, I shift my gaze to the chaotic sea inside the house. Mounds of gear and equipment, over a hundred and fifty pounds of it, stretch from wall to wall. Dry bags, wetsuits, rubber boots, a tent, sleeping bags and mats, a cooking stove and pots, flares, a radio, paddles, paddle floats, life jackets, cameras, books, throw lines, a fishing rod, jumbles of clothes, heaps of marine charts. One of the charts is spread out on the floor, with a cat sleeping soundly on top of it. I envy her. Tomorrow, she and our other two cats will stay in the warmth and safety of the house while Dag and I squeeze this stuff into our Current Designs Libra XT kayak and set off north along the Georgia Strait. We'll paddle all day, and the next day, and for weeks on end, until we've circled Vancouver Island and ended up back where we started, on the beach outside these windows.

We've been planning this trip for a couple of years, and I've been greatly looking forward to it, but these last few weeks of bad weather have dampened my enthusiasm. Plus, I'm exhausted by all the preparations, fraught with the knowledge of what we still have to do before we leave, and daunted by the thought of what lies ahead. I glance across at Dag. He's in the kitchen, another disaster area, frantically making pesto to take with us. Basil leaves, olive oil and nuts whirr around the blender jug; he pours the green paste into canning jars and screws the lids on tight. Heaped on the counters around him, and all over the dining table, is more food—pasta, rice, muesli, sugar, dried fruit, herbs, tea, milk powder, flour, apples, onions, garlic, bars of chocolate—all waiting to be sorted and decanted into Ziploc bags. Suddenly, Dag turns around, pesto dripping from his fingers.

"Whose idea was this, anyway?" he asks.

"Yours, darling," I say.

DAG : It's always hard to remember how the ideas for our trips originally evolve. Three years ago, when we were kayaking around the Brooks Peninsula, I mentioned that someday I'd like to circumnavigate the entire island. At the time, Maria just laughed; but some months later she picked up the idea. Having explored so much of the world by kayak, she suggested, it was time for us to properly check out our own backyard: Vancouver Island.

It's certainly a big backyard, over 12,400 square miles, the largest island on the west coast of North and South America. Even by the shortest route, to get around it we'll have to paddle close to 650 nautical miles, which is over 1,000 kilometres. We've already explored various parts of its coastline: the Gulf Islands, the Broughton archipelago, Barkley and Clayoquot Sounds, the Brooks Peninsula. Now we want to bring it all to a conclusion and go right the way round in one long journey.

While I've been filling these little mason jars with pesto, I've been calculating what that entails: we'll have to average fifteen miles and five hours of paddling a day, for about ten weeks. In terms of individual paddle strokes, this adds up to a grand total of approximately one million each! And then there are all the difficulties we'll have to face: the boiling tidal rapids of the Johnstone Strait, the huge confused seas of Nahwitti Bar, Cape Scott and Solander Island, and the "Graveyard of the Pacific"—those long windswept stretches in Juan de Fuca Strait, where there's nowhere to land a kayak for miles on end.

Of all the expeditions we've done around the world, none posed the physical challenges of this one. I feel like I'm staring up at an enormous mountain, feeling diminished by its size and queasy at the thought of having to climb it.

Friday July 02

DAY *01* **PROTECTION ISLAND TO MAUDE ISLAND**

Another frontal system is moving through. Rain lashes the windows as we sort the gear on our living room floor and begin stuffing it into waterproof dry bags. A friend phones to tell us that Friday is the unluckiest day of the week for seafarers and gypsies; as we fit into both of these categories, she advises, we should stay put another day.

"Nonsense," says Dag, but I see him glancing worriedly at the sky and the clouds scudding across it.

At 10:00 a.m., a little flotilla of kayaks paddles up to the beach outside our house. Liz, Mark, Sarah and Celeste will accompany us on the first day of our trip, as far as Maude Island. They help Dag carry our boat to the water's edge, and start ferrying down the loads of dry bags. I stay in the house and perform my usual last-minute rituals before leaving on a long journey: sweeping the floor, writing notes for the house-sitters, changing our phone message. Finally I stroke each of the cats, wondering what will have happened in my life by the time I see them again.

Down on the beach, neighbours have gathered to see us off. Rick Scott is among them, resplendent in a bright green suit and an enormous red and white hat, and clutching a battered tuba. His partner, Valley Hennell, is dressed as a jester, in a red

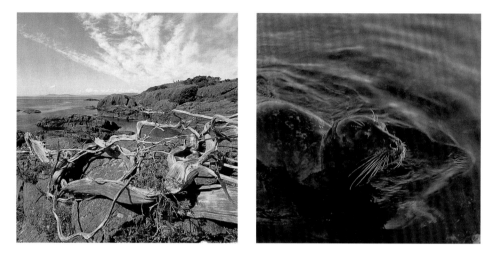

coat covered with gold hearts and with bells on the shoulders. Dag and I are in our own form of fancy dress: waterproof pants, spray skirts like large codpieces, bulky life jackets and sou'westers. We hug everyone; they heap us with good wishes. At last, we push off from the familiar rocks. Rick plays a ponderous Viennese waltz on the tuba, and we keep time with it as we paddle away. Gradually, our friends recede into colourful dots. As we round the northern tip of Newcastle Island and head toward Kanaka Bay, they slip out of sight. All the preparations are behind us now, and our long, uncertain voyage around Vancouver Island has begun.

Saturday July 03

DAY *02* MAUDE ISLAND TO LASQUETI ISLAND

I wake up thinking, Of course, this is what it's like—nights of fitful sleep inside a clammy sleeping bag and a tent that's buffeted by strong winds—how could I have forgotten? Dag is already up, I can hear the swish of his rain pants as he bustles about outside. I stare at the ceiling, thinking about yesterday's trip. With wind and current against us, it took us four hours to cover the nine miles to Maude Island. When finally we got here the tide was so low we had to haul our kayak and all our gear a long way up the beach, and over a mess of rocks. Around 5:00 p.m. the rain set in with a vengeance. And it hasn't stopped since.

Sitting up, I flip back the door and gaze out. We're camped between grassy hummocks, and around the tent wildflowers tremble in the wind. The sea is a relentless series of steep, gun-metal grey waves with foreboding white crests. The sky is low and gloomy. It's ridiculously cold for July. Mark and Liz are cooking breakfast under

ABOVE LEFT : *Juniper on the Finnerties, near Lasqueti Island*
ABOVE RIGHT : *A curious harbour seal*
OPPOSITE : *Our kayak ashore for the night, in the northern Gulf Islands*

a shelter they've erected from a tarpaulin and bits of driftwood. Beyond them, south along the Strait of Georgia, I can see the tip of Gabriola Island. Home seems so close. It would be a slog against the wind, but if we worked hard we could be back there in time for lunch, warm and dry in front of our wood stove, with cats curled up on our laps. I can't bear to think about it; I lie down again and cover my head with the sleeping bag, hoping to escape back into sleep.

"Come on, Maria," calls Dag. "We should leave as soon as possible. You'll need to put your wetsuit on, there are some big waves out there and it's almost twenty miles to False Bay."

Today we're aiming to cross to Lasqueti Island, which lies in the middle of the Strait of Georgia. Right now the wind is blowing at about twenty knots. The marine weather channel predicts that it will diminish over the course of the day, but I don't completely trust these reports. If the wind does keep building I figure we can easily jump across to Ballenas Islands, six nautical miles away, and camp there. If conditions remain stable, then we've got Sangster Island as another stepping stone before heading to our final destination: False Bay on the western end of Lasqueti Island.

While Dag starts quickly and efficiently packing, I bumble about, feeling listless and apathetic. I have three tries at getting all the air out of our sleeping mats, kneeling on them while I roll them up, but still they won't fit inside their bags. Impatiently,

Dag snatches them from me, and within minutes has them tightly stowed away. Then I spend ages searching for my spare glasses, only to remember that I left them in a pocket of the tent that by now is packed into the bag hatch of the kayak. I forget in which order the dry bags go into the front and aft compartments, and soon run out of space. Muttering under his breath, Dag hauls out all the bags and repacks them.

Celeste, whom we met for the first time yesterday, watches us with wry interest.

"After all your expeditions, I thought you guys would be a lot more organized," she comments.

By the time we leave Maude Island, Dag and I aren't speaking to each other. After making a show of cheerily waving to our friends, who have gathered on a bluff to see us off, we paddle in grim silence. He's annoyed by my apathy; I'm irked by his super-efficiency and his criticism. But there's no chance to fight. Four-foot waves are washing over the decks of our heavily laden boat, and the twenty-knot wind is driving rain down our collars. We lean into our paddling, and make good progress. After one and a half hours we've covered six miles and are passing Ballenas Island. The rain eases, the sea calms, and we begin to argue.

Arguing in a kayak is something we've perfected. From the front cockpit I hurl abuse at the wind and waves, while Dag, sitting behind me, vents his feelings at my back.

"You're so bossy!" I shout.

"Maybe that's because you're so passive," he counters. "You leave me to do everything; I feel like I've got all the responsibility of this trip on my shoulders. You don't even try, Maria. Look—we've been kayaking for thirteen years and you *still* can't tie a proper bowline!"

This silences me for a while. Eventually I stop paddling, and swivel around in my seat.

"You know what's really bothering me?" I admit. "I'm not looking forward to what lies ahead. It scares me. I'm regretting that we ever started this trip."

If I were honest, I'd have to admit that I feel pretty much the same way. But I'm reluctant to say so for fear of plunging Maria into even deeper pessimism. Instead I mouth some optimistic words and try to maintain a confident front. As we paddle toward Sangster Island, my thoughts drift back to other expeditions. I remember the first days on the River Ganges, in India. We were cold all the time, afraid of being attacked by bandits, totally unsure of ourselves in a strange new culture. Back then I responded to Maria's despondency by burying my own doubts and concerns and promising her that things

would get better, even though at the time I didn't believe a word of what I was saying. And now I find myself doing exactly the same thing.

Halfway to Jenkins Island, Dag takes out our kite. The wind catches it, pulling us along at a good clip. I'm inordinately cheered by this; I stow my paddle, sit back in my seat and begin to feel far less resistant to the whole idea of the trip. By the time we've reached the tip of Jenkins Island, the kite keeps collapsing in the dying wind, so we have to starting working again. But now it's only four more miles, just over an hour's work, to the day's destination.

By late afternoon we reach Wolf Island, a seven-acre island in False Bay. Our friend Judy Batstone lives here, and she's invited us to stay in her guest cabin. There's a note pinned to the door: Judy has gone over to Lasqueti for the annual Arts Festival, and suggests we join her there. It's been a long day and we're in need of a rest, but we don't want to miss a party. Hurriedly, we change our clothes, stash our gear in the cabin and paddle the mile over to Lasqueti's government dock, from where we hitch a ride to the community hall.

Outside the wooden hall, the grass has been churned into mud, and the air smells of damp earth, incense and marijuana. At the gate, we pay our entrance fees to a woman with long, grey braids wound artfully around her head and topped with a wreath of fresh flowers. She wears a Nepalese waistcoat over a crushed silk dress, lots of heavy silver jewellery and black rubber boots.

"They're already taking down the art exhibit," she tells us. "But you're in time for dinner and the dance."

We eat chicken and salad around a firepit, then dance for hours to the local marimba band. The crowd spans all ages: there's a baby being bounced around on its mother's shoulder, a frail man who looks as old as Methuselah, with a long white beard reaching to his waist. There are toddlers and teenagers, svelte twenty-some-things with pierced belly buttons, and paunchy fifty-year-olds with ponytails. There are dreadlocks, tattoos, flower wreaths and toe rings galore. Hardly anyone dances in pairs; we dance alone and with everyone else, and when the band finishes we demand four encores and make the floor bounce as we leap up and down to the final tune. Then we stagger out into the cool night air. Dazy, the local taxi driver, gives us a free ride to the dock in the back of her pickup truck, and we share the space with ten other people and a dog wearing a red bandana.

The sea is black as coal, but our kayak pushes up a bow wave filled with bio-luminescent sparkles. Each time we dip our paddles into the water, there's an

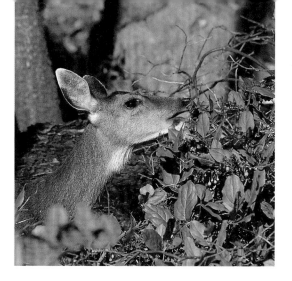

explosion of light, and we see fish streaking away in clouds of silver starbursts.

We've paddled for six hours today and danced for three. When my head touches the pillow in the cabin, I'm instantly asleep.

Sunday July 04

DAY *O3* LASQUETI ISLAND

The kayak noses around a rocky promontory and there, lying at anchor in a protected bay, is the *China Cloud*. As always, I catch my breath at the sight: the angled masts, the sweeping shear, the dragon woman engraved on the bow, the smoke curling from the stovepipe, all caught in shimmering reflection on the still water. We let the kayak drift, and sit in silence as memory wraps around us. Four years ago, we spent a summer sailing our dory alongside this boat and its owners, the legendary Allen and Sharie Farrell. Travelling slowly, powered only by wind and sculling oars, we returned with them to all their old haunts along the Strait of Georgia, places where over fifty years they had homesteaded, fished and built boats. At the end of the trip, Allen decided they were too old for sailing, so they gave up *China Cloud* and moved ashore. Fourteen months later, Sharie died. Allen was utterly lost without her, and unable to settle anywhere on land, or another boat. Last year, he moved back aboard *China Cloud*, and since then has been slowly regaining some peace of mind.

The hatch to the companionway slides back, a head of long white hair pops out and Allen appears, clutching a bucket. Barefooted, he moves nimbly along the deck to the stern, flings the contents of the bucket over the side, then peers across the water in our direction, shading his eyes with one hand.

"Hi Allen," I shout.

"Dag! Maria! It's you! Come aboard."

He seems smaller since we last met, nine months ago. But, as we throw our arms around him, we're thrilled to see some of the old twinkle back in his eyes.

"It's so hot today," he says. "I used to like the heat, but now I can't stand it. I guess I must be getting old. I was just thinking about going in for a swim. Want to come?"

He strips off all his clothes, balances on the gunnel and executes a perfect dive into the ocean. His physique is remarkable, and as I dive in after him I can't help wondering what sort of shape I'll be in if and when, like Allen, I reach eighty-eight.

After the swim, we follow him down the companionway into his comfortable little cabin, and share the food we've brought for lunch. Sharie's spirit is everywhere. I keep

OPPOSITE TOP : *A deer snacking on salal, Wolf Island*
OPPOSITE MIDDLE : *Provisioning on Lasqueti Island*
OPPOSITE BOTTOM : *Sushi on the beach*

seeing her out of the corner of my eye; she's standing at the stove, turning to smile at something Allen has said, her eyes shining and her smile warm.

"It's been awful since Sharie died, " says Allen, reading my thoughts. "We were always together. If we ever got out of each other's sight, we'd panic. I'll never find anyone else like her."

In the evening, Judy throws a party. Allen rows over from *China Cloud*, and other guests arrive in canoes, kayaks and skiffs. Everyone brings food: a fourteen-pound homegrown turkey, stuffed and roasted, a vegetarian chili, home-baked bread and fruit pies, potatoes, beans and salad greens straight from their gardens. As the house fills with people, I watch the easy interaction of the crowd and think about Lasqueti Island. In the 1960s it became a mecca for hippies and American draft dodgers, and their imprint is still firmly here. It's easy to laugh about the place: its new generation of 1960s-style flower children, its obsessions with whole-earthness and the New Age, and the veneer of peace and love that covers its squabbles and intrigue. But for all the eccentricities and contradictions, it has a remarkable sense of community. Lying twelve miles off the coast of Vancouver Island, Lasqueti has only a bare-bones ferry service, and no piped water or electricity. Its inhabitants have chosen to keep the island this way; they say they like the fact that the lack of amenities forces them to depend upon each other. There's a tribal feeling on Lasqueti, and the women here are among the most spirited I've ever met.

Shrieks of laughter draw me over to the kitchen, where I find Judy, whose husband recently left her after thirty years of marriage, young Rainie who has a brain tumour, and Dazy, who was recently diagnosed with breast cancer. They're all wiping away tears of mirth.

"We're talking about healing," gasps Judy, as another bout of laughter bubbles up.

"Everyone around here is always on about wanting to hold healing circles for us," explains Rainie. "I can't stand it anymore! So we're planning a 'Healing Through Siege Weaponry Party' on Wolf Island. We'll build catapults and things on the beach, and we'll only allow organic munitions like bread or spuds or melons. We'll use the tourist boats anchored in the bay as targets. Now *that* will be healing!"

Monday July 05

DAY *04* WOLF ISLAND TO SANDY ISLAND

In bright, early morning sunshine, we wander about Wolf Island. Narrow pathways wind through stands of arbutus trees, their branches reaching out in organic curves

and angles, the red bark peeling away to reveal smooth green skin beneath. At the north end of the island is an intertidal knoll that's awash with a carpet of stonecrop, its egg-yolk yellow flowers nestled among sage-green, succulent leaves. While Dag wades over to take photos, I lean against a tree and start to write in my notebook. A rustling sound makes me look up. Less than three metres away, a young deer is grazing on some salal. From time to time she lifts her head and gazes at me with liquid black eyes. She has a white underchin, a large wet nose and a short tail that flicks constantly. I watch her intently, hardly daring to breathe, but she seems unperturbed by my presence and only gradually moves away, nibbling on salal bushes as she goes.

It's hard to leave the tranquil comfort of Wolf Island, but by 1:00 p.m. we're on our way. Judy stands on her deck waving us goodbye, then turns and disappears among the arbutus trees around the house.

As always, the first hour of paddling is hard. My back stiffens, I can't get comfortable in my seat and the minutes inch by. Suddenly there's a shift; my body remembers the movement and readjusts to it, and paddling becomes less of an effort and more of a pleasure. The sea is like glass, only occasionally furrowed by gentle puffs of wind. On either side of us the topography is changing, with the smaller mountains farther south giving way to higher snow-capped peaks. After an hour, I turn around and see Lasqueti shrinking away, wrapped in a heat haze. Ahead, Hornby is steadily easing up from the horizon. Suddenly I think, what could be better than this? Kayaking up the Strait of Georgia with Dag, both of us strong and healthy on this glorious afternoon, and seeing discovered landscapes disappearing behind us, while the map of our journey unrolls ahead, filled with endless possibilities and surprises.

At four o'clock we reach Tribune Bay, at the south end of Hornby Island. It's a two-mile detour to the sandy beach at its head, but nostalgia leads us here.

"Do you remember losing your pants, the day we got married?" I ask Dag, as we step out of the boat.

Twelve years ago, almost to the day, we had a secret wedding on this island. The Justice of the Peace lived in a waterfront house, and we turned up outside it with two kayaks strapped to the roof of our old car. She married us on her deck, with her next-door neighbours as our witnesses. The tide was low, seagulls were swooping down to pick up oysters from the beach, and as I made my vows I could hear the *crack!* of the dropped shells landing on rock. We drank a bottle of champagne, then we drove to Tribune Bay to explore the sandstone formations along its cliffs. Before we carried our boats to the beach, Dag took off his white wedding pants and left them

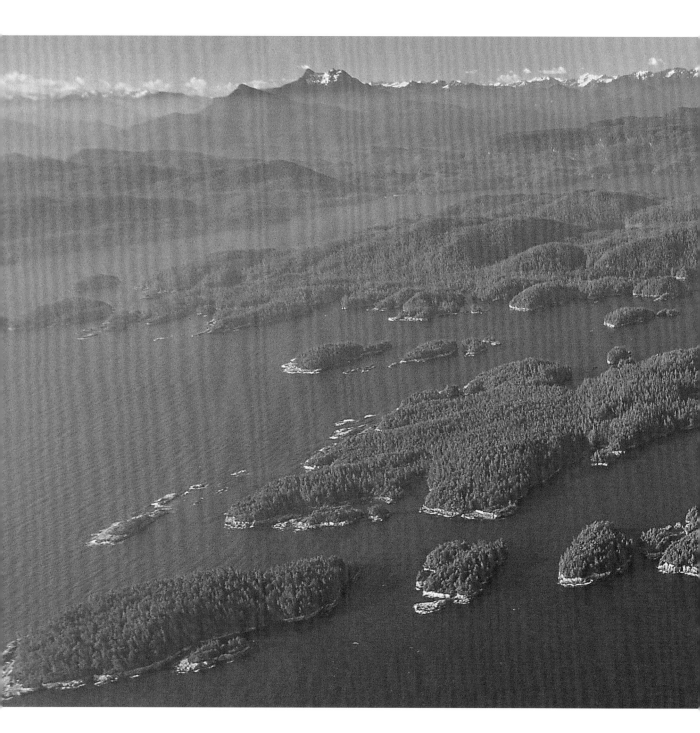

ABOVE : "...the map of our journey unrolls ahead, filled with endless possibilities and surprises." The Broughton Archipelago. Russ Heinl photo

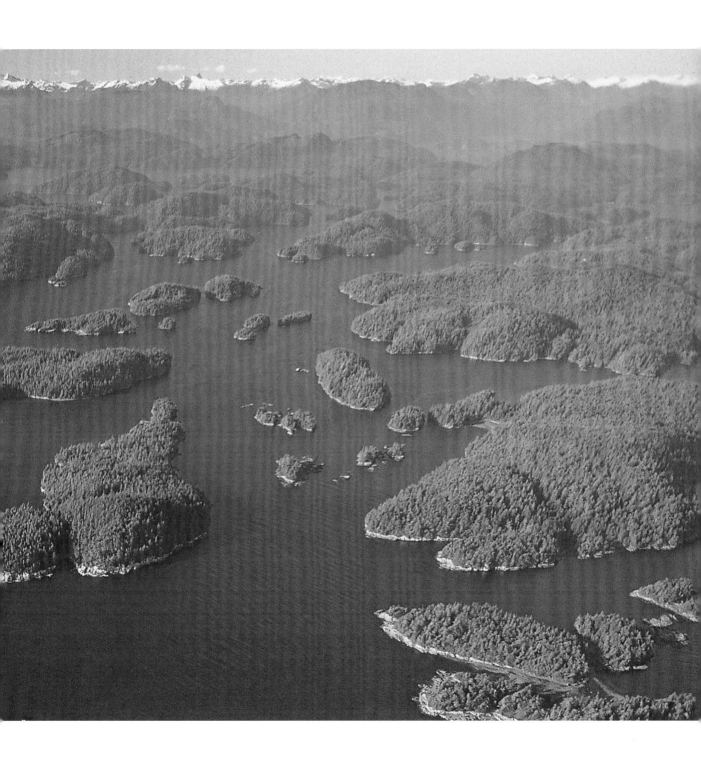

wrapped around the car roof rack. When we came back, they were gone.

"Maybe someone here's wearing them," he laughs, scanning the beach.

It's a typical seaside scene: sun umbrellas, deck chairs, children splashing in the shallows and digging in the sand, harassed mothers, bored fathers and lots of teenagers, the girls self-consciously lounging about in bikinis and pretending to ignore the boys listening to their boom boxes.

After a quick snack on cheese, bread and peanut butter, we start up the passage between Hornby and Denman Islands.

"Let's keep going to the north end of Denman," Dag suggests. "We can camp on Sandy Island."

"How much farther is that?" I ask. I'm beginning to feel saddle-sore, and am eager to stop.

"An hour and a half at the most," he replies.

I don't have a chart for this area, but from driving on the highway I'm accustomed to passing the south end of Denman, and shortly thereafter seeing the distinctive spit and the sparse trees of Sandy Island. At first I'm sure it's no more than several miles away, but in fact the distance turns out to be as far as the crossing we've already made from Lasqueti. As the sun sinks lower in the sky, we make what seems like very slow progress up Lambert Channel. Up ahead a line of dark blue forms on the water, and minutes later we have a steady breeze on our nose that begins to sap the last of our strength. To get out of the annoying wind, I decide to hug the eastern shore of Denman. Because of its gradual curve, we can't see our destination, and I keep fooling myself—and Maria—that it's just around the next little headland. Finally, close to sunset and four hours after leaving Tribune Bay, we clear Denman and paddle along the spit connecting it to Sandy Island. But we can't get across it until the tide rises another foot. While we wait, we climb unsteadily out of our cockpits and stretch our stiff backs. We've covered twenty-five miles today.

The sun is an enormous orange ball in a violet sky, and the water is a wash of pink and amber. Little sandpipers wade on the spit and seagulls perch contentedly on rocks sticking above the surface. I struggle to appreciate the loveliness of the scene, but what dominates my thoughts are the two large blisters that have developed on my backside. When it's time to leave, sitting down in the kayak again is torture.

Within ten minutes, we're on the aptly named Sandy Island, which resembles a large, shallow dune and is covered with beach grasses and sparse trees. During World

War II it was a training base for amphibious vehicles, which could be easily driven up onto its gently sloping beaches. Now it's a provincial park. Dag wants to explore the island before all the light is gone, but I can barely walk because of my blisters, and my gnawing hunger.

"I have to eat!" I snap at him.

"Okay, okay!" he laughs, holding his hands above his head in mock surrender. Over the years he's come to learn that it's best to stop and feed me regularly, rather than deal with the temper that bubbles up when my energy runs low.

Sitting at a picnic table, by the light of tea candles, we eat pasta and Dag's homemade pesto. It's close to midnight before we zip the tent door behind us. We crawl into our sleeping bag, make pillows from our clothes and curl up happily together. We're on land, safe, with another day behind us and many more long days yet to come.

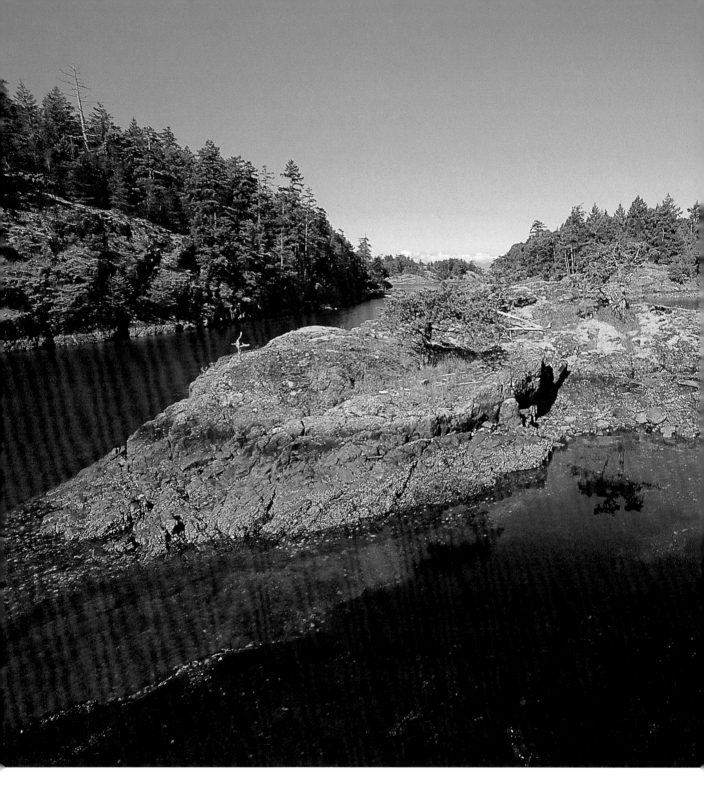

ABOVE : *Flowering stonecrop on Wolf Island*
OPPOSITE : *Packing up on Sandy Island*

Tuesday July 06

DAY *05* SANDY ISLAND TO CORTES ISLAND

We're getting better at packing. It only takes an hour now, and most things have found a permanent place below decks, so that not much has to be strapped to the top of the kayak. By the time we launch, and start paddling toward the Comox Peninsula, an unfavourable northwesterly breeze has already sprung up. This seems unfair, considering that during the last few weeks before our departure the winds were predominantly southeasterlies. But I remind myself that heading north in this part of the world usually means paddling into the wind in sunshine, or with the wind in miserable wet weather.

I'm still tired and sore from yesterday's long paddle and I can tell from Maria's tentative strokes that she isn't faring much better. By 1:00 p.m. we have covered the eight miles to Kye Bay, and we pull our kayak onto one of the sloughs that cuts through the large expanses of sand flats. Mobs of plovers scurry frenetically back and forth along the water's edge. Small tourist bungalows line the beach, and several groups of people are taking leisurely walks across the flats, throwing sticks for their dogs. Overhead,

planes scream by every few minutes as they land and take off from the adjacent air force base.

Sitting on the kayak, we devour some bread and cheese and listen to the marine weather station. The forecast calls for a shift of wind direction to the southwest this afternoon, with an outlook of strong northwesterlies for the following twenty-four hours. Our original plan was to head farther up the coast and overnight at the provincial campsite on Miracle Beach. But since we got here, I've noticed that the airplanes are now landing and taking off in different directions, and the flags along the shoreline have gone limp.

"It looks like the wind has dropped," Dag says. "That means it will soon be flat calm out there. We'll easily get to Miracle Beach, but if it blows a strong northwesterly tomorrow we might not be able to make the crossing to Cortes Island. So we might get stuck in a place that—well, I imagine it's a bit like here. What do you want to do?"

Much of this stretch of coastline has been cleared, graded and covered with drab houses. I long to escape and get into wilder places.

"How far is it to Cortes Island?" I ask.

He stretches his fingers across the chart.

"About twenty-five miles."

So it's between paddling another twenty-five miles or ending up in a busy campsite close to a highway. The decision is quickly made: I try to forget about my sore backside, we take some Tylenol for the twinges in our wrists and shoulders, and we set off into the middle of the Strait of Georgia.

Our first stop will be Mitlenatch Island, which is almost twenty miles away, and hidden behind the curve of the Earth.

"We'll have a break every hour," Dag promises. "Every hour on the minute, mind you. No cheating."

The sun beats down, the air is still, and the smooth sea holds perfect reflections of big thunder clouds building over Vancouver Island. My paddle slices through these clouds; it's as if the world has turned topsy-turvy and we're kayaking across the sky. I'm hot and sweating beneath my life jacket, my blistered backside hurts and my right wrist aches. After what feels like an hour of paddling, I glance at my watch. Fifteen minutes! We've covered, at most, only a mile. I'm about to tell Dag I need to stop paddling and drink—a weak excuse for a break—when I notice two lines of small, standing waves ahead. They stretch as far as we can see to the east and west, and between them is a band of water that looks as if it has been ironed flat.

"Current?" I ask Dag over my shoulder, as we approach the first set of waves.

"Could be two currents meeting, or an upwelling from somewhere down deep," he says.

Despite the heat, a shiver goes through me. Suddenly I'm aware of our fragility, afloat in this tiny craft on a vast body of water. How many fathoms of dark water lie beneath our hull? I imagine floating down there, lifeless, lost forever. I think of the stories I've heard of the places that await us on this journey: Johnstone Strait, with its whirlpools and eddy lines that can be a nightmare for people in big boats with powerful engines, never mind self-propelled craft like ours; the stormy northern end of Vancouver Island; the infamous Cape Scott; and then the long, exposed west coast. Such thoughts begin to overwhelm me, until I push them away and concentrate on my paddling.

"An hour's up!" calls Dag.

We stop and share some chocolate. A seal pops up its slick head and catches my eye. A graceful tern alters its flight path to glide over us. A dolphin silently breaks the surface, then dives and is gone again without trace, leaving me to wonder if I imagined him. I lean back and let my gaze drift—at the shining sea stretching for miles around us, at the big snowy mountains of the mainland, at the great blue arc of the sky. For now, all doubts and fears dissolve, and I'm infused with a sense of absolute happiness.

The hours slide by, and so does the coast. Behind us, Lasqueti is slipping beneath the horizon. Ahead, Vancouver Island and its satellites appear to merge with the mainland, so that we are faced with the illusion of a solid wall of mountains. Smoke from the Campbell River mill rises above the dark outline of Quadra Island. We pick out the white sandy bluffs of Savary Island and a sliver of land that we think must be Mitlenatch. The Kwakiutl name for Mitlenatch is Mah-keww-lay-la, which according to one translation roughly means "It looks close but seems to move away as you approach it." This is certainly so in our case, and the last hour drags by interminably slowly.

By 6:00 p.m., when we drift up to the beach on the southeastern side of Mitlenatch, the tide is almost at its lowest. Standing knee-deep in water, I flex my shoulders and gaze at the sky. A change in the weather is quite evident now: Vancouver Island has completely disappeared in a blue haze below a bank of tall cumulus clouds. I feel pleased that we decided to escape that developed stretch of coastline, and satisfied with having made such a long crossing up the middle of the Strait of Georgia. It was good judgement: recognizing a window of opportunity when the wind shifted and altering

our plans accordingly. These are the kinds of judgement calls that, particularly during the more challenging portions of this trip, will make the difference between our success or failure.

The shoreline around us is littered with sharp black rocks and oysters. We can't haul the laden kayak across this without damaging it, and the only alternative is to unpack its contents. But camping isn't allowed on Mitlenatch, so we still have to carry on another five miles to Cortes Island before nightfall. I anchor the kayak with a line tied to a rock, and an additional line secured to the shore gives us the peace of mind to leave our boat unattended for a while.

Above the beach is a weathered cabin, home to the voluntary wardens who are posted here for week-long stints throughout the summer months. A smiling blond woman emerges and tells us about the birds nesting on the island. Glaucous-winged gulls are the predominant species, and at least 3,000 pairs are now engaged in raising this year's chicks. Pelagic cormorants, pigeon guillemots and oystercatchers also nest along the rocky shoreline, and the interior of this eighty-eight-acre island is home to northwestern crows, which have been studied here for years.

"The nearest land is a four-mile swim away, too far for raccoons, so it's a haven for nesting birds," the warden says.

We follow one of the two designated trails across the island, toward a wildlife blind. Dag hurries ahead of me, fiddling with the lenses of his camera. The evening sun illuminates everything with a soft, warm light, perfect for photography. I follow

ABOVE : *Heading north up the Strait of Georgia*

more slowly, through meadows filled with golden grasses and spring wildflowers that are blooming late this year, a result of the cool, wet weather. The air is filled with urgent bird cries, and from the blind we gaze down at bluffs flecked with thousands of white gulls and their fluffy grey chicks.

"Too bad we've got to leave so soon," says Dag. "Maybe we should come back here one year and be wardens."

By the time we reach Cortes Island, dusk has fallen, and the waterfront buildings of Hollyhock Farm appear to be fading into the surrounding forest. Hollyhock is a retreat centre, where people take courses that plumb their emotional and spiritual depths in an atmosphere of safety and trust. Turning up unannounced and without a booking is not encouraged; we're only expected here tomorrow, so I know that we might be turned away. But after eight hours and thirty miles of paddling, the thought of having to carry on makes my knees sag.

While Dag starts unpacking the boat, I walk up to the main lodge, a large wooden building of post-and-beam construction, with a generous wraparound deck. French doors open into a dining room, which leads in turn into a sitting room, a lobby and kitchens. Seascape watercolours hang on the walls, and in every corner there are exuberant arrangements of cut flowers. The place appears to be empty, but the back door of the lodge is open, and from the forest I can hear the sound of drumming. When I call up a central staircase, a pair of pink leggings appears on the landing. They quickly descend, and I'm faced with a woman wearing a purple dress over the leggings, and a Nepalese hat pulled low over her frizz of hair.

"Can I help you?" she asks, her piercing look making me suddenly aware of my dishevelled, salty state.

After I've blurted out my story, she tells me to wait and bustles back up the stairs. A different woman appears. Red-haired Susan introduces herself as a "host" and tells us she's heard about our journey. Waving away my apologies, she assures me a campsite is available. It's up in the forest behind the lodge, and she offers to drive a truck down to the beach to help us move all our belongings.

In near darkness, we pitch our tent between lofty cedars and tall ferns. Close by is the washroom complex, a luxurious affair with private shower rooms and supplies of newly laundered bath mats. After a quick supper, we fall into bed. Around midnight we're startled from sleep by an explosion above our heads: a huge, restless storm is rolling all over the sky, with great crashing booms of thunder and fierce flashes of lightning. It doesn't keep me awake for long. I curl up to Dag, feeling the utter relaxation that only a cessation of hard physical work can bring, and soon slip back into my dreams.

Wednesday July 07

DAY *06* CORTES ISLAND

The deep, sonorous note of a struck gong resonates through the trees, summoning us to breakfast. We walk down sun-dappled paths, across a riotously colourful garden and into the lodge. In a light-filled room off the kitchen, a statue of Buddha overlooks a table loaded with big bowls of fruit, yogourt, granola and porridge, plates of homemade bread and muffins, and pots of organic honey, jam and peanut butter.

Most people are discussing last night's storm. There are strange weather patterns here. An average of sixty centimetres of rain falls each year on south Cortes Island, while north Cortes gets one hundred centimetres and Mitlenatch only twenty-four centimetres. We had no rain during the storm, but a few miles away a torrential hailstorm decimated people's gardens, and the roads around Whaletown were flooded.

After breakfast, everyone else disperses to join one of the two courses being held this week. We spend the morning on the sandy beach, reading, making notes and swimming in the warm waters of the bay. Before we know it, the lunch gong has sounded. Once again, Buddha watches us file around the table, which now offers a tureen of sorrel soup, stuffed tomatoes, a dish of nuts and wild rice, a salad of freshly picked greens topped with nasturtium, lily and pansy blossoms, and jars of chilled water infused with lemon balm, mint leaves and rose petals.

After lunch, we learn that we're invited to stay here until Friday. We should be getting on with our journey, but tonight's dinner menu is spinach pie, hummus, garden salad and whole wheat pita bread. And after that we could try the outdoor hot tub, with its view over the ocean. Early tomorrow morning there's a yoga and meditation class we can join. While we make our decision, we stretch out on comfortable garden chairs and snooze. Already we're lulled by the womb-like serenity of Hollyhock, and right now life seems far too good to be hurrying along.

Friday July 09

DAY *08* CORTES ISLAND TO MARINA ISLAND

Perched atop a bluff on Marina Island is an old cabin that reminds me of a little gingerbread house, all odd angles, weathered shakes and windows in unexpected places. Big stands of flowering Scotch broom grow around it, and close by there's an orchard of elderly, gnarled apple trees and a fenced-in, overgrown garden. Our friend David lives here. He's an oyster grower and the caretaker of Marina Island. This evening we paddled over from Hollyhock, an easy jump of eight miles, and

now we're gathered around a table with David and his girlfriend Jennifer, talking about the history of the island.

It was formed from glacial deposits at the end of the last ice age. The original inhabitants named it Chamodaska, and traces of their settlement can be found on the midden beach close to where we are camped. In 1792, the Spanish explorers Dionisio Alcala-Galiano and Cayetano Valdez y de Flores named the island after a woman who Hernan Cortes, the Spanish conqueror of Mexico, had captured and made his mistress. By the early 1900s, there was a homestead and a fox farm here. The orchard close by is at least sixty years old, and David's cabin was built twenty-five years ago by a couple who squatted on the island. They established the garden, and they also ran a little business making yellow plastic suns on sticks that they sold at music festivals.

"They called the island 'Hawaii'," says David. "They had an idyllic time until the loggers arrived. Then a road was put in, and big trucks drove by the cabin all day, with old-growth trees on the back. The original trees here were so big that the operator had to buy a new skidder, and to justify the extra expense he ordered the entire island to be clear-cut."

The changes eventually drove the couple away. But the cabin they left behind is still sound, and the soil in the garden is fertile enough for David to grow basil, dill, onions, scarlet runner beans, squashes, cabbage, broccoli, potatoes and sunflowers. They also left a bathtub. It stands close to the outhouse, and when David wants a bath, he fills the tub with water from a hose, then lights a fire underneath it.

As well as running his oyster lease, David has plans for another operation: reforesting Marina Island.

"The secondary growth mostly consists of red alder. But this place has a phenomenal growth rate, because of the high water table and the sandy soil. So I'm proposing to the province that the island be reforested with fir and cedar. You could deter the deer by using wire mesh, or by thinning the alder and planting the new trees among it. According to my reckoning, in eighty years there would be a stand of trees here, each with a diameter of about twenty-five inches."

"That would be long after you're around to see it," I say.

David smiles. "I know. That's what I like about the idea."

Saturday July 10

DAY *09* **MARINA ISLAND**

A light southwest breeze is blowing; it would help to push us north, but we want to linger here for a day and spend time with our friends. After breakfast we walk along

the beach to where David has picked fifteen dozen oysters, and is bagging them. He wears knee pads, boots, gloves and an apron, all made of rubber. When the bags are tied he kneels on the sand and starts digging through it with a rake-like implement, searching for clams.

"It looks like back-breaking work," I say.

"It's not so bad on a day like this," he tells me. "But in the winter the tides are low at night, so I'm often out here at three and four in the morning, in howling winds and rain."

His business is fraught with potential disaster. Predators abound: crabs, starfish and moon snails, humans who occasionally steal the harvested clams he leaves in bags overnight, and the locals and tourists who help themselves to oysters from the beach. On top of all that there's red tide, a type of toxic algal bloom that can close down oyster harvesting for weeks on end.

For the rest of the day we hang about naked on the beach, and swim in the balmy waters of Desolation Sound. I'm making a conscious effort to soak in this warmth and ease. Very soon we'll be farther north, in a different climatic zone. There will be lower temperatures, more fog and stronger westerly winds. The waters will be colder and more challenging, and I'll be wearing a wetsuit every day. The "holiday" part of the trip is almost over, and we're about to start moving into something far more serious.

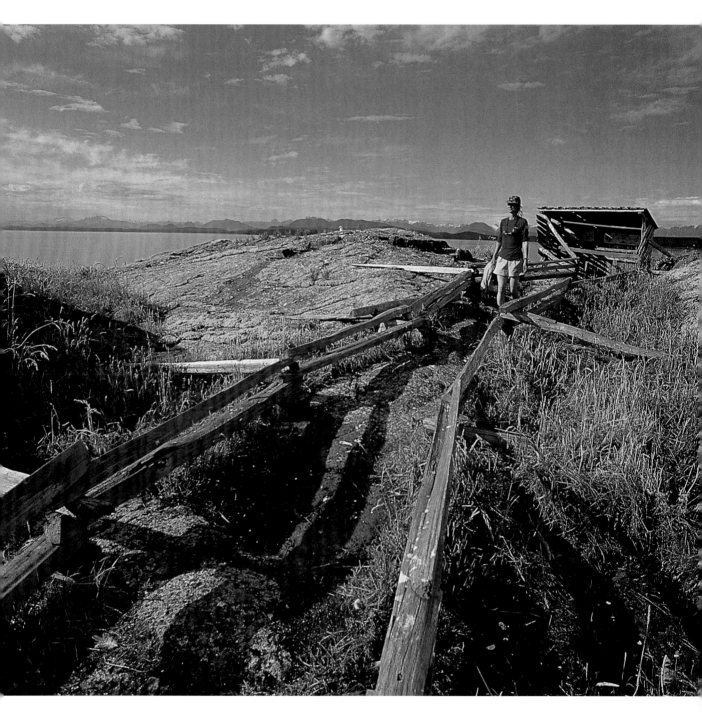

ABOVE : *Leaving the birdwatching blind on Mitlenatch Island*
OPPOSITE LEFT : *David's oyster lease on Marina Island*
OPPOSITE RIGHT : *Fireweed and tiger lily, Mitlenatch Island*

Sunday July 11

DAY *10* MARINA ISLAND TO READ ISLAND

After lunch we leave Marina Island, glorying in the warm, windless day, the serene ocean and the wraparound vistas of islands and mountains. Before we go north, I want to explore Von Donop Inlet, of which I've heard glowing reports. On the chart, Von Donop appears as a gash that almost severs the northern portion of Cortes Island. Halfway down its length, a large saltwater lagoon branches off to the west. This is the place I'm curious about. The marine life here is bound to be unique, because the lagoon's water is relatively secluded from the surrounding marine environment.

The mouth of Von Donop Inlet looks promising, flanked by bluffs covered with flowering ocean spray and arbutus trees that lean over the water at twisted angles. We let the current carry us into the shadows of the inlet, until it narrows to a mere 150 feet across. Cool, damp air wafts down through the trees towering above us. Less than a mile ahead, water gushes through a narrow channel that marks the entrance of the lagoon. We have to wait half an hour for the tide in the inlet to rise to the level of the water in the lagoon. When eventually we manoeuvre our boat through the narrow gap, we're astounded by the colours and textures in the water underneath us. Long, iridescent kelp fronds undulate in the current. Pink algae and colonies of blue-black mussels cover the boulders, and bright yellow sunstars cling to nooks in the rock alongside startlingly green anemones. Once inside the lagoon, however, we are in a different world. There is not a sound and the air is perfectly still. The water is a milky green, and suspended in it are thousands of translucent white jellyfish, pulsing and rotating in slow motion. I tell Maria we have to make a quick decision. Either we stay here overnight, or we leave straight away. The tide is still rising and in a few minutes the current in the gap will be too strong for us to paddle against. It's hard to judge when we'll be able to get out of here again; there are probably only a few minutes each day when the current in the gap is slack.

Close by is an invitingly smooth grassy bank where we could pitch our tent and then relax in the sun. But I'm spooked by all these jellyfish, and already I long for open vistas and sea breezes. I don't want to be trapped here; we turn, and make our escape.

As we cruise north at a steady four knots, the landscapes around us get bigger and more imposing. High, steep-sided islands are cloaked in dark forests; the mainland mountains rise sheer from the sea to a remote, forbidding world of snowfields and glaciers. I feel so tiny, a human speck in a place where the elements still reign. There are no other boats, no buildings along the shores, no voices or lights.

In Sutil Channel, paddling across water streaked gold and red like the evening sky, we're totally alone save for the pigeon guillemots bobbing about close by, and the scores of bald eagles that soar above us or perch on snag logs, fixing us with steady gazes as we pass.

Campsites are hard to come by on these stone-bound shorelines. Around 7:30 p.m. we stop at Read Island to check out a bluff, where we find a flat area, just big enough for our tent. It's covered with deep, crunchy, coastal reindeer moss, but underneath the moss is rock, so there's nowhere to sink the stakes of our tent. While I carry our gear up from the boat, Dag spends ages fiddling with the guy lines of the tent, using driftwood and rocks to help secure them. Eventually he pronounces the tent ready to inhabit.

"We'd have been better off with something more modern," I comment.

"You'll be glad of this tent when we're trapped inside it for days on end," he retorts.

I'm really happy with the tent we decided to bring along for this trip. It's made of cotton, and designed in the old-fashioned prospector style. Weighing in at close to eighteen pounds, it's not light, but you don't feel those extra pounds in a kayak. It takes some patience to set up, but I don't mind spending time adjusting my shelter to get it just right. Isn't that the whole point of camping: to build your own primal home? This tent is high enough for me to stand up and get dressed; it has a seven-square-foot floor area and an equal-sized mud room, where we can leave our wet gear and firewood. The thin cotton emits a beautiful natural light that will keep our spirits up when we are tent-bound in stormy weather. And because cotton isn't flammable, in bad weather we can have a fire close by.

Tonight we build a fire down on the beach and try out one of the instant meals given to us by a friend just before we left. It sounds good—Fettucini Alfredo—but when I pour the contents of the packet into a pot of boiling water, it quickly turns into something resembling wallpaper paste. And it tastes even worse. I'm so hungry I choke down my portion, but Dag chucks his away into the ocean, deciding he'd rather go to bed with an empty stomach. As I wash our dishes, crouched down among the rocks, I hear a wind come up. It starts as a far-off roaring sound, and soon the trees above us are swishing about under its force.

By the time we get around to carrying the kayak out of the tide's reach, darkness has fallen, and we stumble over rocks and logs.

"What about the food?" I say. "There must be bears on Read Island."

Dag sighs. "I know. I was keeping my eye out for a tree sturdy enough to haul the food into. There's nothing close by, and I can't be bothered to go crashing around the bush now. We'll put everything in the back hatch of the kayak. I've got a good fibreglass repair kit in case a bear thinks the boat is a lunch box."

Monday July 12

DAY *11* READ ISLAND TO MAURELLE ISLAND

I've been sleeping fitfully, thinking about tidal rapids and listening to the wind. When the northwest wind blows at night like this, it isn't a good sign for the next day. At 6:00 a.m. I reach for the weather radio. The forecast says that the wind will rise to gale force by afternoon and remain that way for the next few days.

"Let's get out of here," I tell Maria, who is lying awake beside me. "We'll catch the current and get to Surge Narrows before the wind really starts to howl. We can get through the narrows on the slack tide, at about 10:30."

The tide is receding fast. While I stuff bags into the hatches, Dag straddles the kayak, edging it back to keep it afloat and stop it from scraping against the barnacle-covered rocks. By eight o'clock we're on the water, paddling into a strong headwind,

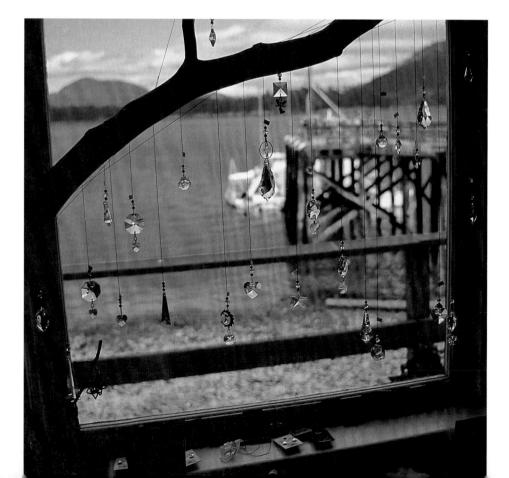

with only a gentle current to help us. Soon, we turn into Whiterock Passage, between Read and Maurelle Islands. Along the northwestern shores of Read are the remains of old settlements, places that hardly ever see direct sunlight. I shiver to think of all the pioneering women who lived here, enduring the long dark winters in deep shadow.

At the far end of the passage we skirt by some pretty islets, the Settlers Group, where turkey vultures circle the trees. From beyond them, we can hear the rushing sounds of tide rips.

The water in Surge Narrows is roughened with whitecaps and small standing waves. It's still well before slack tide, and I'm unsure if it's safe enough for us to go around the corner into the rapids. Suddenly a fishing boat appears from behind Maurelle Island, crazily swinging this way and that as if there's a drunken driver at the wheel. The current is obviously still very strong, so we hang onto some bull kelp to collect our thoughts. Twenty minutes later, we go for it. As the current zips us past Antonio Point, the full force of the northwest wind hits us in the face. It must be blowing twenty-five to thirty knots by now. Spray is flying everywhere and the noise of wind and breaking waves is deafening. Adrenalin courses through my veins and I whoop with excitement, but Maria remains grimly subdued. We battle the last half mile to a protected bay on Maurelle Island, arriving there completely soaked.

I hate this sort of cold, relentless wind. Allen Farrell always maintains that northwesterlies have bad ions, and I think he's right. They sap my strength, make me tense and jangly. I'm glad when we pull up to a dock below a wooden sign welcoming us to Port Maurelle.

Our friends Rob and Laurie Wood have been homesteading on Maurelle Island for twenty-five years, and their house is on the cliff high above this dock. A steep trail runs up to it, between stands of spindly alders and an honour guard of tall foxgloves. We emerge into a bright clearing, where a wooden house with many windows and a multifaceted roof looks out over the narrows.

In 1985, when I first came to Canada from England, several people in the mountaineering community gave me Rob and Laurie's address and advised me to look them up. They were climbers, they said, good folk who lived in a wild place. Every so often I'd glance at their address—c/o General Delivery, Surge Narrows—and be impressed by its strangeness and romance, but I never got around to directing a letter there. Eventually Rob and Laurie found me, calling one day out of the blue to

OPPOSITE : *Creative window dressing in Surge Narrows store*

say that they were passing through Nanaimo, and since we had so many friends in common, we should meet. Hours later we were sharing a meal, and a friendship had begun.

We walk into a large sunny room that encompasses dining, living and kitchen areas and opens onto a plant-filled solarium. Rob and Laurie are sitting at a table, drinking tea and deep in conversation. Their German shepherd, Skookum, notices us first, and bangs his tail in greeting on the wooden floor.

"Hey up, look who's here!" cries Rob in his unmistakable Yorkshire accent, then he and Laurie are on their feet and hugging us. In many ways, they're opposites of each other: Rob has chiselled features and an intense, blue-eyed gaze, and he's gregarious and cheerfully opinionated. Laurie's long, fine hair frames a delicate face and she is gentle and shy, like a deer. But both are physically strong. Their mountain guiding, tree planting and the hard labour of homesteading have kept them in peak physical condition.

"You'll have breakfast, won't you?" says Laurie, going straight over to the kitchen. She quickly whips up scrambled eggs, toast and coffee. We've only been paddling for two hours, but I'm happy to have stopped for the day. Outside, the wind is still building, the crowns of big Douglas firs are swaying about, and pine cones and small branches occasionally cascade down and patter against the deck of the house. Through an open window I can hear the rushing of the narrows, where the current is now flooding full bore.

Tuesday July 13

DAY *12* MAURELLE ISLAND

We wake up in a comfortable bed, with sun streaming through the window and a wind blowing outside that is forecast to rise to gale force by the afternoon. Laurie and Rob insist that we stay another night, and invite us to sail over with them to the little settlement of Surge Narrows, where Laurie supplies the store with organic eggs and vegetables.

In the mid-1980s, Rob and Laurie built their thirty-three-foot catamaran, *Quintano*, on the beach below their house. Over the years they have put the boat to many tests: sailing it around Vancouver Island, using it to ferry huge loads of building supplies in desperate winter storms, even transporting their daughter's horse, Riskie, in the cockpit. So I'm not worried when we set off under sail across the tide rips, bucking into the current.

I'm keen to see the place that has sat in my address book, and my imagination,

for so long. It's even tinier that I expected: a post office inside a corrugated iron shed on the government dock, a one-room schoolhouse and a general store that dates back to 1930. Outside the old white clapboard store are tables and chairs where shoppers can sit and enjoy coffee and home-baked scones. But today it's too windy for that. We duck through the door and, while Laurie delivers her eggs and vegetables to Theresa, the owner of the store, Dag and I wander about.

Crystal mobiles hanging in the original casement windows catch the sunbeams and send rays of refracted light over the planked floor, which is scuffed and pocked from years of footsteps. Crammed onto the wooden shelves and tables is a surprisingly eclectic array of goods. One table heaves with books: nature guides, novels, serious non-fiction, children's literature. There are smudging sticks and incense on offer, Nepalese hats, pet foods, organic corn chips, a freezer stuffed with meat, fishing gear, hardware, gardening supplies, jars of old-fashioned candies, videos for rent. On the notice board, among the ads for outboard engines and puppies for sale, someone has tacked a quotation by Wendell Berry:

> *"And the world cannot be discovered by a journey of miles, no matter*
> *how long, but only by a spiritual journey, a journey of an inch, very*
> *arduous and humbling and joyful, by which we arrive at the ground*
> *at our feet and learn to be at home."*

I think about this all the way back across Surge Narrows. It turns out to be a very wet, hour-long journey, as the tide has turned against us and we're bucking into it again, as well as fighting the wind.

In the afternoon, Laurie shows me around her garden, which covers a third of an acre. Surrounded by a high deer fence, it's been carefully landscaped and planted so that ferns, tall flowers and bushes provide shade for the vegetable beds. She's growing Brussels sprouts, carrots, cabbage, squashes, onions, garlic, potatoes, beans, corn, kale, lettuces and herbs of all description, and rhubarb and gooseberries. Tomatoes flourish in a greenhouse, and in the nearby henhouse we find an abundance of newly laid eggs.

We dine on the fruits of Laurie's land and labour: homegrown chicken cooked in herbs and peas, with potatoes and a huge salad. Rob pours out gin-and-tonics, red wine, Baileys and coffee. Meanwhile gales howl around the house, and as I make my way unsteadily to bed I decide that for the expeditionary life, this really isn't so bad!

ABOVE : *A sanctuary from the gales, Maurelle Island*
OPPOSITE : *Rockfish for supper, just caught by Dag*

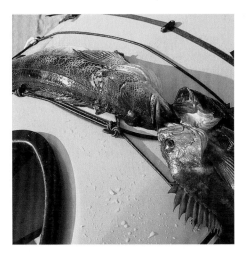

Wednesday July 14

DAY *13* MAURELLE ISLAND TO TURN ISLAND

Even before I'm properly awake, I register that the morning is silent save for the clear melody of a songbird. There's no wind whistling through the trees, and the rapids are quiet. This may be our chance to carry on. I go through the familiar motions of switching the VHF radio to the weather channel. Once again northwest winds are called for in the afternoon.

It's obvious that we are going to have to come up with a plan to forge on, despite the winds. After breakfast, Rob pulls out his marine charts and we discuss our options. One possibility is that we could make our way between Maurelle and Sonora Islands and then go north into Calm Channel, so avoiding the strong northwesterly winds and their treacherous combination with current in Discovery Passage and Johnstone Strait. The problem with this plan is that it means we will face the rapids in Hole in the Wall, and then a notorious stretch of water that includes the infamous Dent and Yuculta Rapids. A close examination of the charts doesn't inspire a lot of confidence. These waterways are covered with wavy symbols for tide rips and overfalls, and loads of

arrows depicting strong currents point in all directions. The phrases "extremely dangerous turbulences" and "violent eddies and whirlpools" jump out at me from several annotations, and there are features named Devil's Hole and Whirlpool Point. Particularly disquieting is the fact that we're just one day past the new moon, which means we have a spring tide and that the currents are even stronger than usual, reaching ten knots.

"Look," I say to Rob, pointing to a section in the *British Columbia Coast Pilot*," it says here that the tide change in these rapids can be 'quite abrupt with no period of dead slack.' We could never paddle through the four-mile stretch with Dent and Yuculta Rapids during one slack tide."

"Okay, then, do the rapids in several portions," suggests Rob. "When the current starts picking up, go ashore and wait, or camp."

I wonder if the precipitous coastline will offer places to land and camp when we need. I'm really not looking forward to exchanging the security of this beautiful home for such uncertainty, but we can't stay here all summer. Deciding to catch slack tide at Hole in the Wall at about noon, we start to pack.

Rob and Laurie help us move our gear down to the dock where our kayak is tied up.

"Be careful on your way around the island," advises Rob. "Watch yourself on Nahwitti Bar, and off Cape Scott and the Brooks Peninsula. There will only be small windows when conditions are right to get past those places. You'll need to be poised, ready to go when the opportunity arises. And don't forget to trust your intuition."

It's valuable advice. Rob is a seasoned adventurer and has had his share of close calls on the water. While sailing around Vancouver Island in *Quintano*, he and Laurie nearly came to grief off the Brooks Peninsula.

"We were overconfident," he told us last night. "We'd come around Cape Scott with a favourable wind, and we decided to just keep going through the night. When we got to the Brooks, all hell broke loose. Huge seas washed over the boat and we couldn't reef the sail. It was pandemonium out there. You wouldn't have survived that in a kayak."

The wind is still light as we paddle northward along the coast of Maurelle Island. I sift through our plan to go through Hole in the Wall, Dent and Yuculta Rapids. It just doesn't feel right. Silently I wonder if this is intuition, or simply fear. Why are we considering going through those rapids? To avoid the strong northwest winds, right? And yet the wind doesn't seem to be building as it has over the past few days. Maybe it has blown itself out. If so, it would be incredible luck. We just need a few days of clement weather to make it through the worst of Johnstone Strait.

WITCH'S CAULDRON | 37

"Hey Maria," Dag calls out. "Why don't we go ashore and rethink what we're going to do?"

I'm more than happy to agree. I can sense that Dag is troubled by what lies ahead, and this hasn't been helping to boost my confidence. Sitting on a gravel bank at the mouth of a small stream, we completely rearrange our plans. We'll follow Okisollo Channel through two smaller rapids at the northern end of Quadra Island, then turn north into Discovery Passage. We can't go through the rapids until high slack, which isn't for several more hours, so we decide to look for a protected beach where we can relax while we wait.

The tide is flooding against us, but we cheat it by tucking in close to the shoreline of Maurelle Island, where a back eddy loops around and helpfully pushes us forward.

"See that little beach over there," says Dag, pointing toward a small island a few hundred yards away. "It really catches the sun and it's protected from the wind. Let's get farther upstream of it and then cut across."

When Dag angles our kayak out into the main channel, I feel the current grab the bow with a force that takes me by surprise.

"Come on, paddle hard!" Dag cries.

I put all my weight into my strokes, trying to beat the rushing water. Gradually we close the gap, while the island slides steadily upcurrent to meet us. But just as we are about to escape the tide rip and reach the lee of the island, we hit an eddy line. In an instant, the surface of the water seems to shift its contours, and a high step forms right in front of our bow.

"Lean! Lean!" yells Dag, as we shoot over it. The boat lurches violently and then starts to slowly roll. Desperately, I lean the other way; for a long moment the kayak is suspended on its side, almost perpendicular to the water, before it slips reluctantly back into an upright position. A few more strokes take us through the rip and into the safety of the eddy.

"Jesus," Dag gasps, as we go ashore. "That was close."

All I can think of is our upturned kayak being swept down the middle of Okisollo Channel, our gear floating everywhere and us bobbing around trying to retrieve it.

"I can't believe we almost flipped a twenty-two foot boat in relatively benign conditions," he says, once we're settled on the beach. "But it's so heavy with all our equipment and stuff that it's almost impossible to lean it away from the current. At least this has given us a wake-up call. Every day from now on, we should assume that we could capsize, so we should dress accordingly and stow all our gear properly."

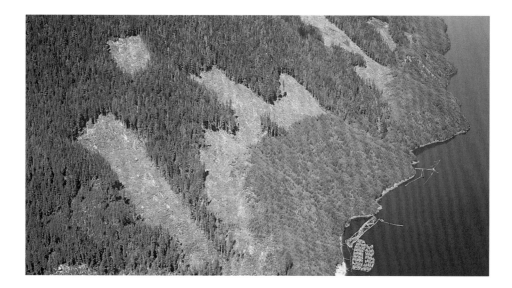

By 6:00 p.m. the current has slowed down enough for us to continue. With some trepidation, we wind our way through the islands in the Upper and Lower Rapids. Upwellings appear all around us—large, eerily smooth bulges of water that gently nudge our kayak and reflect the sun at their rippled edges, creating lazily expanding circles of light.

At the end of Okisollo Channel we turn north into Discovery Passage. This is the main ocean thoroughfare on the eastern side of Vancouver Island, and it drains one third of the tidal exchange to the Strait of Georgia. A favourable current and a southerly breeze sweep us along to the Cinque Islands, where we had planned to camp, but their shore-lines offer no place where we can unload our boat. I'm almost glad about this: even though it's late, I feel we should press on to take advantage of the favourable condi-tions. In the distance, a periodic flash from the lighthouse on Chatham Point seems to coax us onward. According to my chart, just beyond the light Turn Island forms a pro-tected nook on the southern end of East Thurlow Island, and I'm betting on this as a perfect place to overnight.

The sky darkens, and the current keeps building in strength. Approaching Nodales Channel, I begin to worry about rough conditions where the two currents meet. To avoid being swept past our destination, we keep to the eastern side of the passage; after bouncing through a large patch of pyramid-shaped waves, the kayak glides up to the protected side of Turn Island. Maria and I stare up at it in disbelief. Much of the

ABOVE : *Once clear-cut, virgin rain forest is gone forever.*
Roy Tanami/Ursus photo

island has been crudely razed. Slash litters the slopes and broken trees stand at odd angles like the mutilated witnesses to a massacre. What I had expected to be a beautiful place turns out to be an abandoned logging camp. A huge barge lies on the beach, with garbage strewn around it. Above the tide line, mobile cabins, trailers and big machines are rotting into the ground. The earth is badly torn up, and two deep ruts lead to the rusting hulk of a Caterpillar.

I can't bear the thought of staying anywhere close to this place. But the sun has set, and the steep slopes farther up the coast don't look like they will offer any shelter. Reluctantly, we settle for a tiny rock bluff just across from Turn Island. It's a ridiculous place to camp, and we have a dreadful time dragging the gear and the kayak up to the uneven ledge where we pitch our tent. Dinner is late and sparse, just bread and salami with water. We're in bear country, but there are no convenient trees nearby and I am simply too tired to scramble around to look for one, so again I pack the food into the rear hatch of the kayak. It's close to midnight when finally I collapse into our sleeping bag and hug Maria close to me.

My hair is a damp mess on our makeshift pillow—I didn't have the energy to comb out its salty tangles. Dag's breathing is slow and steady, but I can't sleep. Despondently, I think of the day just gone. The best part of it was an hour ago, when I peeled off my wetsuit. Whenever I close my eyes I see waves, whirlpools, eddy lines, bears. I try to focus in. I consider how lucky we are that the night is so calm, and imagine how horribly exposed we'd be on this knoll in a howling wind. We're safe, I tell myself, we're sheltered. I repeat this like a mantra, until I drift into sleep.

My eyes snap open. Something is snuffling around the back of our tent. Through the pounding of my heart, I hear it move away. Then there's a clunking sound, of fibreglass against rock.

"Dag!" I hiss, nudging him hard. "Wake up!"

"Huh? What?" He looks at his watch. "Maria, it's only 4:30."

"I think there's a bear by the kayak."

In seconds, he's grabbed the flashlight and the bear spray and scrambled outside. Hardly daring to breathe, I listen to him walking around.

"Nothing here, Maria," he calls. "Go back to sleep."

DAY *14* TURN ISLAND TO PORT NEVILLE

A strong current helps push us north, away from Turn Island. The sky is heavily overcast and the high, wooded slopes of East Thurlow Island seem to glower down at us. Since we set off at eight o'clock, a light drizzle has been falling. Now, as we emerge into the Johnstone Strait, it turns to torrential rain. Enormous drops bounce off the surface of the water; we're in a dense fog of precipitation that seriously cuts down visibility. Fishing vessels are passing us in both directions, so Dag stops paddling to put up the radar reflector. The mountain ranges of Vancouver Island are wrapped in clouds, which part from time to time, allowing us glimpses of snowfields. The air feels heavy and foreboding.

"I hope it doesn't start to thunder," I say. Seconds later there's a flicker of lightning, quickly followed by a low, rolling rumble.

"Let's go to shore!" I shout to Dag.

He's wearing a sou'wester with the flaps tied around his ears, and he appears not to hear—or maybe he's choosing to ignore me.

Another flash. One, two, three, I count—then, BANG! The thunder unleashes.

Turning in my seat, I yell, "Take down the radar reflector!"

"It's only sheet lightning," Dag insists. "It's not dangerous."

A few minutes later, a distinctive ragged bolt of lightning slashes across the grey sky, followed by an earsplitting crack. While Dag starts to fiddle with the reflector, a high speed Zodiac zips by.

"Well, anyways, they're more likely to get hit than us, with that hulking engine on the back," says Dag nonchalantly.

I'm not reassured; all I can think of are the metal bolts in the body of the kayak, the metal knobs in my paddle, the metal struts my feet are resting on.

Another flash, more loud rumbling.

"Go ashore!!" I screech.

Dag gives in. But before we've reached the narrow, boulder-strewn beach, the storm appears satisfied with its effect on me, and begins to move away.

To make the most of the ebbing tide, we move out into the middle of the channel again. The mist gradually lifts to reveal a corridor of water, flanked by steep mountains. Yesterday, Rob warned us about this section of our journey.

"It's one of the most dangerous pieces of water on this coast," he said, "especially south of Hardwick Island, in Race Passage."

Which is exactly where we are headed now.

With its straight east-west orientation and its bordering mountains, Johnstone Strait acts as a funnel for the winds coming off the open ocean. In addition, the currents here are very strong, so a roaring westerly wind against an ebbing tide regularly whips the strait into a froth of chaotic, breaking waves. I have no intention of experiencing that first-hand; I'm eager to cover as much ground as possible during these calm conditions. If we ride the ebbing tidal stream, I figure we can get past Kelsey Bay today. The only drawback to this plan is that we'll have to go through notorious Race Passage when the current is at its strongest: it will be running at over six knots. I mull this over with Maria and I can tell she's none too happy; she's still spooked by our near-capsize yesterday. But she agrees nonetheless, and we start to paddle hard.

Before Kelsey Bay, we give Ripple Point a wide berth in order to avoid the turbulence caused by the water deflecting off it. Race Passage is ahead. Where Chancellor Channel drains into it, I can see whitewater, so I steer the boat away from the middle of the channel and closer to West Thurlow Island. The shoreline is flying past now. I'm pleased at our progress, and also relieved that apart from some large lenses of water and standing wavelets the conditions aren't as bad as I had expected.

When Helmcken Island is abreast of us, I suddenly realize that up ahead the water is a lot more turbulent; even from half a mile away we can hear a distinct roaring. A quick glance at the chart tells me that we must be crossing over an extensive underwater ledge that stretches right across the channel. The most severe turbulence typically develops downstream from obstacles like these, and I could kick myself for not having taken it into consideration earlier.

"Oh, Christ," says Maria. "Look what's coming up."

"Let's get closer to the Vancouver Island shore," I suggest, "and see if we can avoid it."

We haven't gone more than a hundred yards when the rushing sound increases in volume and a dark line forms dead ahead. In front of our eyes, an upwelling forms—an enormous slab of water that rises from the surface, gushing down at the edges to a perimeter of rapidly forming whirlpools.

"Hard right!" I bark, as the upwelling grows and moves toward us. Suddenly, we're on top of it, moving rapidly sideways away from the centre and then slipping off the edge toward a gurgling vortex. Our kayak skims along the lip of the whirlpool and shoots toward an eddy line.

"Remember to lean!" I shout, but everything seems to be moving in different directions at once, and I'm totally confused myself as to which way to tilt the boat. As we hit the eddy line the bow of the kayak is jerked hard to the left, but miraculously we stay

NEXT PAGE : *Preparing for our passage up Johnstone Strait*

upright. We punch through a series of small standing waves; then, as abruptly as it appeared, the growling mass of water recedes behind us.

No matter which way we turn, there's no escaping the madness. Large upwellings appear randomly around us. We dodge roaring whirlpools with big chunks of drift-wood spinning in their centres, and are jostled and flung about by shearing currents and standing waves. Our bracing and leaning becomes more co-ordinated and we battle on, like two tiny figures afloat in a witch's cauldron, paddling through a mysterious, malevolent brew that is bubbling and erupting all around us.

Half an hour later, the worst is behind us. I've been too gripped to think about how my body feels, but now I realize how wet I am. I'm sitting in a puddle. Water has seeped down my jacket sleeves and my polypropylene underwear is soaked. My feet are cold. My fingers are wrinkly and white. And the rain still lashes down.

In an attempt to cheer me, Dag announces that we've covered twenty-five miles in less than four hours. We're approaching Port Neville, which is on an arm of the mainland. The inlet is deep, with few signs of habitation. A couple of buildings stand above the government dock, but there are no lights and no smoke. I don't relish the thought of getting even colder by walking around in my dripping clothes in search of someone to talk to. So we carry on a little way, as far as a beach with a gently sloping meadow above it.

We're not alone here. There is fresh bear scat on the beach. A young deer wanders by, stopping to gaze at us without any apparent fear. And when we've made a fire and are warming ourselves by its flames, a motor skiff putters up, driven by a blond woman accompanied by a lanky teenaged girl.

"Uh oh. They've come to tell us we're trespassing," says Dag.

We walk to the shore to greet them. The woman cuts the engine and lets the boat drift into shallow water. She introduces herself as Lorna and her daughter as Erica.

"We're the Hansen family," she says meaningfully, and repeats this several times during the conversation until I ask her who the Hansens are.

"Our family came from Norway; we were the first white settlers around here," she tells us proudly. "My grandfather rowed up all the way from Vancouver in 1891. He started a homestead and opened a store."

The Hansens own 161 acres on the inlet. The store is closed now, but Lorna still runs the post office from the living room of her house, and a mail plane comes in here three times a week.

"I saw the smoke and just wanted to check what was going on. You're camped

on Hansen land, but there's no problem with that. I thought you should know about the grizzly bear, though. He's been visiting our garden regularly. The dog sees him off, but he keeps coming back and going for the chicken coop. He's a juvenile, about three years old, I think, and he's really aggressive."

Oh, great, I think. After a day like today, the last thing I need to worry about is a man-eating grizzly.

"Have you seen any deer?" she asks.

I tell her about the fearless young buck.

"He's one of ours. We've got several tame deer that you can hand feed. Our doe has twin fawns—they're up by the house. I think the grizzly is tracking them. If you want to come and camp in our garden, you're very welcome. You might feel safer there."

After she's driven off, I turn to Dag.

"What do you think?"

"I sure don't like the fact that this is a bear who's into doing B and Es. He obviously isn't particularly afraid of humans; it might be better to camp close to the house, where the dog will keep him at bay."

I hate the thought of all the work involved in relocating our camp, but I know I'll sleep better tonight with a guard dog around. We decide to have a snooze, and then move.

One of the coastal First Nations, the Kwakwaka'wakw, originally had a village at the head of this inlet. The generous meadow behind Lorna's house is on a midden—the remains of centuries of discarded shells, fish bones and other household refuse—and the gently sloping beach below looks like an old canoe run. It's almost 7:00 p.m. by the time we arrive there, and we're greeted by a big, fussy, barking dog. Lorna is very welcoming, offering to replenish our water supplies and showing us an outhouse that we can use. Close by, under the leaning branches of an old oak tree, a large buck with a big rack of antlers is lying down, ruminating.

"We call him Rainbow Bright," says Lorna. "My daughter Erica named him that. He's the son of the old doe. His sister has new twin fawns, the ones we think the bear is tracking."

Next to her single-storey house is a big log building. Built in 1924, this was once the family home and also served as the post office and general store. A sign on the door warns visitors about bears. Inside, there are remnants of counters and bits of broken furniture. Lorna's widowed mother now lives in a house on a rise above some gardens and fruit trees. Since Lorna's father died a few years ago, there's been no man about, just the dog to help protect against cougars, brown and black bears and wolves.

ABOVE : *Serious chains for serious waters*
OPPOSITE : *Old barge, Alert Bay*

"Last time we had an incident was six years ago," Lorna recounts. "Me and Erica were coming back from my parents' house, and I was carrying a pan with two pieces of cooked chicken in it. Erica was running in front, when a cougar sprang out at her from behind a bush. It just missed her, probably because it noticed me out of the corner of its eye and was caught off guard. I yelled at Erica to get up on the porch, then I threw the pan at the cat. I kept staring at it and backed away until I reached the garden gate, then I turned and ran for Erica. The cougar came after me, but it hit the fence—later we reckoned it mistook the green stakes for tall grass and thought it could run through them. All our screaming had brought a fisherman running from a boat at the government dock. The cougar had taken off for the henhouse; it was killing a chicken when the man cornered and shot it."

While her mother tells this story, Erica leans against an outside wall of the log house, nonchalantly twirling a strand of hair around one finger. A fourth generation Hansen, she's tall, slim, and very poised for a twelve-and-a-half-year-old. Lorna is home-schooling her, so she spends almost all her time here in Port Neville.

"What's it like, living in such a wild place?" I ask. "Don't you get scared?"

"You get used to it," she says. "If we're going walking and we think the grizzly is around, we take an air horn with us."

We set up our tent right behind the house. I'm glad that we've gone to the trouble of moving, and feel greatly reassured by the fact that the dog will give us good warning of any bear activity. By the time we've finished supper it's almost ten, and light is fading.

"Good night, Dag and Maria," Lorna calls from her porch. "Sleep well!"

Then she calls in the dog. In horrified disbelief, we watch as he bounds into the house and Lorna shuts the door behind him.

"But I thought...," my voice trails off.

"I guess she's scared the bear might eat him," says Dag wryly.

Friday July 16

DAY *15* PORT NEVILLE TO PORT HARVEY

Around mid-morning we leave Port Neville and make for the Broken Islands. The current is again in our favour, and the day is warm and sunny, with barely any wind. But on the horizon, a thin blue line grows steadily as a northwesterly wind kicks in. Luckily, we're soon sheltered from it. In the channel leading to Port Harvey, we thread through islands with overgrown meadows, gnarled fruit trees and cabins colonized by moss—the remnants of long-abandoned homesteads. It's tempting to

linger here, but we're making for Canoe Passage, which separates East and West Cracroft Islands; presuming this to be an ancient route, we're keen to navigate it in our kayak.

In the distance, a large floathouse appears. At first we think that it's associated with a fish farm, but as we draw closer we can make out barrels containing flowers and what look like stands of corn. A man steps onto the deck and waves to us. On the sign behind him we read "Paddle In B & B."

This isn't exactly a floathouse: it's an old barge with a couple of new cabins built onto it and an assortment of logs and floats lashed to the sides.

"Welcome to Port Harvey," says the man. "Come aboard."

Tall and wiry, he's prematurely aged by a slight stoop. Behind him is an attractive woman with her hair pulled back in a ponytail.

"The coffee's on," she says. "Would you like some?"

The deck is covered with strips of rain-sodden shag carpet that squishes under our feet. John and Maggie lead us to their "patio," a sheltered area between the two cabins with plastic tables and chairs, sun umbrellas and tubs of bright flowers. Barn swallows flit about and the couple's pets, Darling the dog and Sebastian the cat, roll around together nearby.

"How did you make out in that blow we had a few days ago?" asks Maggie, as she serves us with coffee and home-baked cookies. "It was crazy out in the strait, blowing more than fifty knots."

"Wow, I'm glad we weren't trying to get through Race Passage then," says Dag.

Maggie's noticed me staring at an old chain saw bar that's hanging on the wall behind John.

"John used to be a faller," she tells us. "We met when I got a job cooking at his camp. A few years ago, a tree fell on him, and he hasn't been able to work since. We were looking around for something else to do, and we saw this place advertised on the Internet. It used to belong to a log salvager. We thought that with all the kayakers coming up here, we might be able to make a go of it as a bed and breakfast."

Silently, I consider the fact that we haven't seen another kayak since we left Cortes Island.

"How's business?" asks Dag.

"Picking up slowly," says Maggie.

"There's nothing for the fallers anymore," John chips in. "The environmentalists have seen to that." His voice has a bitter edge, and he's avoiding our gaze.

"Mining's finished too. And fishing. All there is now is tourism. I'm training as a

kayak guide with the Forestry Renewal Program, but the guide companies won't pay a trainee guide any more than seventy dollars a day. Seventy dollars! How's a man supposed to live off of that? When I was logging, I earned at least four times that much."

Finishing up our coffee, we tell them we're planning to go through Canoe Passage on today's high tide, at 4:00 p.m.

"You won't get that kayak through the passage," says John. "The place is all rocks. They say the Indians used it as a fishing weir."

I'm beginning to feel obliged to offer them some business. And it's not an unattractive option: after yesterday's long haul in the rain, I rather like the idea of spending the afternoon in this sunny, protected spot, and taking the opportunity to dry out our tent and clothes. Maggie is delighted when we ask about a room, and takes us

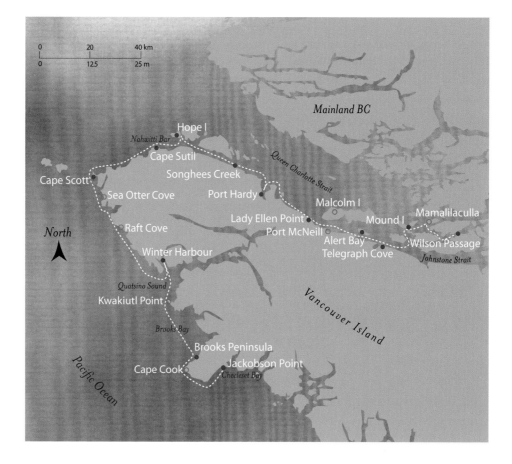

back along the squishy carpet to show us the accommodation. The cabin at the far end of the float has two bedrooms and a bathroom. There's also a shared sitting room with a wood stove and a sagging sofa. Tacked onto the plywood walls are a 1973 Spanish calendar and a black and white photograph of several men sitting inside a huge felled tree stump, with chain saws on their laps. Electric cord is strung between the rafters for hanging up wet kayaking gear, and there's an assortment of knick-knacks around: baskets, glass balls, bits of driftwood, empty macramé plant holders.

"There's as much hot water as you want, and no bugs," Maggie promises. "Would you like to have dinner with us tonight?"

We eat outside, in the early evening sunshine. Pork chops, pasta, salad, freshly baked bread, berries and cream—it's all delicious. By the time we're having coffee, however, the conversation is becoming rather strained.

"What sort of people do you get staying here?" asks Dag.

"All sorts," says Maggie. "City people mostly. I don't like Americans, they're too fussy. The Europeans are good. They really appreciate nature. And they can't believe how many trees are still here. They expect the place to be bald, after all the propaganda that's been shoved down their throats."

"Propaganda?"

"Those people who toured Europe with Stumpy, the log out of an old-growth tree. And that photo—you must have seen it—the one of the big clear-cut on the west coast."

"North of Kyuquot?"

"That's the place. It was in all the magazines, and the Europeans think the whole of British Columbia is like that."

"We paddled past that clear-cut three years ago," I tell her.

"Did ya? It was green, right?"

I gaze at her, stunned. "Green?"

"Yeah. Replanted."

My mind goes back to the long steep slope, clear-cut from sea to sky. Visible from miles away, it stood out like a huge, open wound. Close up, it was a disaster area, riddled with landslides, its streams clogged, and the few remaining trees knocked over and hanging this way and that like fallen skittles.

"I don't remember much green," I say.

"All the kayakers—they turn up from the city and tell us about how terrible clear-cut logging is," says John. "What do they know about it?"

"When we were living in Courtenay," Maggie adds, "our daughter's teacher put up a poster of a section of a mature felled tree, using the rings as a timeline through history. At the bottom, it said something like, 'Not a Renewable Resource.' "

"That's true, isn't it?" I say.

She glares at me. "Do trees grow back, or not?"

"Virgin rain forests don't grow back," I counter.

Dag decides it's time to change the subject. "What do local people think of your business?" he asks John.

"Doug, the old guy who lives close by, he can't stand kayakers," says John with a laugh. "He has notches to show how many he's scored with his boat. I've heard him say, 'Last you see before you hit is the flash of their paddles.' "

I exchange a glance with Dag, then stretch and feign a yawn.

"Thanks so much for the dinner, Maggie, it was wonderful. We've got a long day tomorrow, so I think we'll turn in."

Saturday July 17

DAY *16* PORT HARVEY TO WILSON PASSAGE

Outside our bedroom window, we hear fish splashing on the surface of the water. The morning is sunlit and cool. Around nine, after an excellent breakfast of fruit salad and French toast, we start loading our kayak. Just as we're about to push off, Maggie hands me a plastic bag. Inside, wrapped in wax paper, are two fresh loaves, sandwiches for our lunch and several apples.

"On the house," she says, waving away our thanks.

As we paddle away, I can't help wondering if John was right about Canoe Passage. It sure looks like it's navigable on the chart, but the tide's too low for us to check it out now. So instead we follow the southern shore of Port Harvey, and go into Chatham Channel between East Cracroft and the mainland. At the end of the channel Gilford Island appears. It's a ravaged landscape. Logging roads cut diagonally across the barren hillsides, and from one road near the top of the mountain a landslide has torn away a large part of the slope, almost down to sea level. Anger flashes through me. How can people do this? How can John and Maggie see this every time they go around the corner, and still believe that clear-cut logging is okay?

Lots of big motor cruisers pass by en route to Lagoon Cove, which is tucked away behind some islets. We decide to follow them, and pull in there for lunch. The

marina is jammed with motor cruisers, most of them flying the Stars and Stripes. As we tie up to an old, unused wooden float, the owner of the marina, a genial American, comes out to greet us.

"Are you looking for something, young lady?" he asks. "If you want ice, candy, chips or pop, you'll find them in our store."

He's going from boat to boat, spreading news of this afternoon's happy hour gathering on the dock.

"I'll provide the prawns," I hear him say, then he runs down the dock to offer help to another monster boat that's motoring in.

Maggie's sandwiches are made of home-baked whole wheat bread packed with fresh crab, and seasoned with green onions. I feel a twinge of guilt for riling up her and John about logging. They're products of their environment, I think, just like us, and just like the wealthy owners of these noisy, ostentatious, gas-guzzling yachts.

At 4:00 p.m. we're on our way down Clio Channel, working hard against a fifteen-knot northwest wind. Cruising round Sambo Point and past Bones Bay, we talk about how strong we're beginning to feel, how much our stamina is building up; this is a welcome development, because after we've kept up a steady pace for seven miles, the current turns against us, and the wind blows even more strongly.

By evening we're in Wilson Passage, circling a couple of tiny islets. One has a single wind-beaten fir tree growing from a high meadow.

"Let's check it out," Dag suggests.

The meadow is covered with dried grasses, yarrow and nodding onions, and has an area just big and level enough for our tent. West Cracroft Island, which John told us has a grizzly on it, is only a stone's throw away. But as we start to settle in for the night, I hardly think about the bear. Across the narrow channel, wolves are howling. It's a disturbing sound, and I find myself whispering to Dag. The howling seems to tap into a place of unease, deep inside me, and I sleep fitfully, beset by dreams of wandering lost and afraid through a dark, menacing forest.

ABOVE : *Evening in Alert Bay*
OPPOSITE : *Harvest brodiaea*

Sunday July 18

DAY *17* WILSON PASSAGE TO MOUND ISLAND

In Beware Passage, we come across pictographs on the smooth, sculpted rock of a bluff. One depicts two tall ships and a sun, the other shows a stagecoach, pulled by a four-legged animal. I try to imagine who drew the pictures, and when, and why. At the start of our journey, I barely considered the layers of history contained in this landscape. But over the past few days, as we've gone by ancient village sites, pulled our kayak up old canoe runs and walked across midden beaches, increasingly my thoughts have turned to the culture that once lived and thrived here, and the people who passed their paddles through these waters, centuries before us.

This is the territory of the Kwakwaka'wakw peoples, whose lands stretch around the northeast quadrant of Vancouver Island and as far as the Brooks Peninsula on its western side. They are famed worldwide for their artistry, and remembered as the most active among all Northwest Coast peoples in resisting the laws passed by the colonial government against the ancient ritual of potlatching.

Once around Mink Point, we see Village Island. The tide is very low, so we anchor

the kayak in shallow water, then slog for three hundred yards through eelgrass and mud that sucks at our sandals. Lying on the beach is a recently carved ceremonial canoe, with new paddles floating on the rainwater inside. Behind stands the high, crumbling edge of a large midden. We climb up it, and into the ruins of Mamalilaculla, where we almost stumble across a fallen totem pole. Lying in long grasses, it's partly rotted away, but a wolf head is clearly visible, salal sprouting from its mouth.

It's over thirty years since the last inhabitants of this place left for Alert Bay, and since then the bush has been steadily reclaiming it. The newer houses are in a state of disrepair, with gaping doorways, broken windows and holes in the shake roofs. All that's left of the Big House are its huge, adzed uprights, but these are still firmly in place. I stand between them, gazing out at the smattering of islands–Pearl, Maud, Fern–that make up the Indian Group. In 1921, a potlatch was held right here to commemorate the marriage of Emma Bell and Dan Cranmer. Guests were invited to witness the display of their hosts' wealth, and were honoured with a feast, dances and gifts of songs, stories and material goods. Since pre-contact times, such ceremonies had been a vital part of the culture of the coastal First Nations peoples, but in 1884 they were banned by the colonial authorities on the pretext that they caused the spread of poverty. When word got out about the Cranmer family's potlatch, police descended onto this Big House. Over a hundred people were arrested, and twenty-six of them eventually went to jail. All the potlatch items, including the ceremonial masks and coppers, were confiscated and sent to museums in eastern Canada and New York.

It's hard for me to imagine the raid, or the anger and anguish that ensued here all those years ago. Right now, peace and tranquility reign; the air is drenched with the scent of blackberry and honeysuckle blossoms, and the only sounds are the drone of bees, the rustle of garter snakes in the grass and the whirr of humming-birds' wings.

As we meander between small islands and into Indian Channel, the sun breaks through the slate-coloured sky, revealing large patches of blue. We've planned a rendezvous in this area with Mark and Liz and a couple of old friends from Germany, and as we approach Berry Island Dag tries to raise them on our radio.

"Strike One, Strike One, this is Salamander, over."

There's no response, but minutes later a double kayak appears—the first we've seen for over two weeks—steered by Mark and Liz.

"We've got a camp all set up on Mound Island," says Mark. "Olaf and Sabine are there, waiting for you. You're just in time for lunch."

Monday July 19

DAY *18* MOUND ISLAND

I wake to hear ravens calling in the forest and the scratching of unseen creatures close to the tent. Mark is already up, and when I join him by the fire he hands me a freshly brewed coffee laced with real cream and a bundle of our mail that he and Liz picked up for us on Protection Island. It's strange to be tearing open envelopes and checking accounts and bills; it makes me feel uncomfortable, as if I'm being pulled away from the flow of our journey.

We have a lazy morning paddle, through Whitebeach Passage and into the mouth of Blackfish Sound, where we anchor in kelp and watch for whales. After an hour, Liz sights a blow, close to the light off Parson Island. For fifteen minutes we sit, as several adult whales and a baby slowly come closer, pushed by the current. Liz identifies them as A pod—A5 has an unmistakable dorsal fin, very large with a notch at the top. Time after time they surface; we hear the watery *PHOOSH* of their blows, and see the mist of their breath rising in plumes, then the rhythmic curves of their shiny backs and fins as they arch and sound once more. When they're about three hundred feet from us, a couple of whale-watching boats buzz up and hover close by. The whales sound deeply and are gone for ten minutes. When next we see their blows, they are half a mile away.

Tuesday July 20

DAY *19* MOUND ISLAND TO ALERT BAY

Everything farther than a stone's throw from our tent is obscured in a dense blanket of fog. As we eat breakfast it slowly lifts, and around 10:00 a.m. our party leaves Mound Island. The morning is melancholic: clouds hang heavily over the dark shapes of surrounding islands and our kayaks trail V-shaped ripples through the still, pewter water.

Reaching Blackney Passage at slack, we take advantage of the ebbing tide on our way across Johnstone Strait. I'm shocked when we reach Ella Point, just off Telegraph Cove. Where there used to be steep bluffs and a forest, there is now only a raw moonscape of flat platforms blasted into different levels of the rock.

"Some developer got his hands on this piece of land and managed to sneak the plans through the zoning department," Mark says. "Rumour has it he's going to put the lots on the market for $150,000 to $300,000."

Around the corner, it's a relief to see Telegraph Cove's familiar old boardwalk and its wooden buildings on pilings. But this once picturesque and protected little nook

is now completely dominated by the barren area to the east and, I imagine, newly exposed to winter storms.

While Olaf and Sabine dismantle their folding boat and pile it into the back of their car, we help Liz and Mark hoist their kayak onto the top of their van. Then we invite everyone to lunch in the pub. A couple of hours and several pints of beer later, we wave goodbye to our companions. They'll be back in Nanaimo in five hours. Our journey, to exactly the same place but by a rather longer route, will take six more weeks at least.

Thankfully, today's destination, Alert Bay, is only an hour's easy paddle away. As we skirt the western side of Cormorant Island, the occasional car drives along the perimeter road, past small wooden houses set in the trees. Soon we reach a curving bay, where a series of piers and buildings stands over the water on barnacle-encrusted pilings. Just beyond the Nimpkish Pub, we tie up to a government dock. At the top of the dock is a fish shop run by a large Native man called Freddy. I tell him we're looking for a place to stay—a campsite or a beachside B & B—and ask for his advice.

"There's Janet's Guesthouse," he says. "It's back the way you came about a mile. I'll drive you there to have a look, if you like."

I gaze at my feet, and the puddle that's formed from the water dripping off my wetsuit and jacket.

"Are you sure?"

"No problem—get in the truck."

Janet's Guesthouse is an old heritage home, with wide steps leading up to a generous front porch. We peer through windows hung with elegant drapes into a living room filled with antique furniture and a bedroom with a double brass bed. It looks delightful, but there's no sign of Janet.

"She'll be around somewhere," Freddy assures us. "Leave her a note and come back later."

He drops us off outside the Nimpkish Pub. Some months ago, a neighbour on Protection Island told me a story about this establishment. One night the bar was filled with several seiner crews. They had just had a good opening and were intent on celebrating and spending as much of their money as possible. At last call, one of the skippers commandeered his crew to run heavy steel cables from their boat to the pilings the pub is built on. "You close down," he threatened the bartender, "and this whole place is going to be floating in the chuck." According to our neighbour, who claims he was there at the time, the party lasted until 5:00 a.m.

OPPOSITE TOP : *'Namgis House, formerly St. Michael's Residential School, Alert Bay*
OPPOSITE BOTTOM : *Kwakwaka'wakw canoe, Alert Bay*

When today's bartender comes around to take our order, I ask him about this story.

"It's the gospel truth," he confirms.

He also knows Janet. "She was in here with a friend not long ago. They were heading over to the Orca for a meal."

When we've finished our beers we cross the road to the Orca restaurant. Janet has left already, but the waitress knows her well and writes her phone number on a napkin.

"She'll probably have met someone on the way home to talk to," she advises. "So I'd give her an hour before you call."

When I finally reach Janet, she tells me the guesthouse is full.

"But you can camp in my yard tonight," she offers, "and move in tomorrow."

I enjoy our paddle back toward her house. Cormorants stand on pilings, spreading their wings to dry them, and a river otter runs along the beach, as if keeping pace with us. Across the strait, the mountains of Vancouver Island are a soft green-black in evening light, their peaks shrouded in pale grey clouds. But when we begin the process of moving into Janet's garden, we wonder if this is such a good idea. Everything, including the boat, has to be carried to the top of the beach, over a seawall, up a steep embankment, across the road and behind her house. To ease the task I borrow Janet's wheelbarrow, and I'm pushing it back across the road when a car pulls up and a middle-aged man sticks his head out of the window.

"Is that your wheelbarrow?" he asks, suspiciously eyeing its load of dry bags.

"It's Janet's."

"You know her?"

"No. Well, yes, I'm camping in her backyard."

"Oh. That's okay then."

Wednesday July 21

DAY *20* ALERT BAY

Alert Bay reminds me of a small American town in a 1950s movie: shake-covered houses painted yellow and coral pink or blue and purple, dogs meandering along the middle of the main street, a closed-down pizza place called the Medieval Manor decorated with fake coats of arms and images of knights, and a tiny gas station with two battered old pumps standing on the sidewalk.

Fir Street, which runs the length of the bay, links the two main groups of this 1,300-strong community: the white population who live on the southern reaches of the street, and the First Nations who live in the reserve at its northern end. Right in

the middle is the small ferry terminal, Alert Bay's link to Vancouver Island, and a hamburger joint where we decide to have lunch.

High-backed, turquoise benches flank formica-topped tables. Cracked linoleum tiles cover the floor, and the low, white ceiling is splattered with ketchup. There's a jukebox, an Atari game machine and two pool tables. The menu is short and straight-forward: burgers with fries or sandwiches with fries.

There's no sign outside, so when we place our order I ask the waitress what the establishment is called. She shrugs.

"Cormorant Services, I guess. But everyone still calls it Bill's Pool Hall."

It turns out that the cafe belongs to Bill Cranmer, a descendant of Dan Cranmer whose potlatch on Village Island was raided by the authorities in 1921. It also unof-ficially marks the beginning of the 'Namgis reserve. Originally the 'Namgis people were based across the Broughton Strait, at the mouth of the Nimpkish River on Vancouver Island, and used Cormorant Island as a seasonal gathering place. In 1870, two white settlers, Spencer and Huson, leased the island from the government and built a small saltery for curing salmon. To attract labour, they persuaded Reverend Alfred James Hall to move his mission from Fort Rupert. He arrived in 1880, and shortly thereafter the 'Namgis relocated their village to Alert Bay. A church was built in 1881, then later came a sawmill, and in 1929 the Anglican church opened St. Michael's Residential School, for the education of Native children.

St. Michael's stands at the far end of Fir Street, dwarfing everything around it. The high red brick walls and rows of mean windows remind me of a Victorian work-house; it's a cruel-looking behemoth, a hulking reminder of terrible times. In a mis-guided attempt to assimilate Native children into mainstream culture, students were hauled to St. Michael's from the surrounding areas, forbidden to speak their language and, in some cases, humiliated, beaten and abused. The school was closed in the 1960s; now, in an ironic twist of fate, it is used principally by First Nations people.

" 'Namgis House, Old Residential School" says the sign on the imposing entrance, followed by a list of the offices housed within: the 'Namgis Nation Administration Offices, the Alert Bay Credit Union, the North Island College, the Musgamagw Tsawataineuk Tribal Council, the Kwakiutl Territorial Fisheries Commission Office and Galgalis Project, the Tanakteuk First Nation Administration, the 'Namgis Teen Centre and the Kwakwaka'wakw Carving Room.

The Carving Room is in the basement of the building. It's actually two brick-walled rooms, furnished with old tables and sofas and lit by bare light bulbs. A large painted carving of a sculpin rests in the corner on the linoleum floor.

"That's my nephew's work," says Bruce Alfred, one of the carvers who use this facility. He has a warm smile and sad eyes.

"You might meet my relatives when you get around to Nootka Sound," he says, when we tell him of our journey. "My father's father was Moses Alfred. He often took the Grease Trail over to Nootka."

We sit with Bruce for an hour or more. He talks passionately about the need to pass on traditions to his children, and for them to study the old ways and techniques. He tells us stories about Mungo Martin, the famous Kwakwaka'wakw carver whose grave is in the nearby Nimpkish burial grounds, and he patiently explains about potlatching and its significance.

"I haven't been able to carve for money for a while," he says, "because I only just finished doing forty carvings for the last potlatch, to commemorate the death of one of my relatives. I donated all of them. It takes up a lot of time."

Next door to 'Namgis House is the U'mista Cultural Centre. In 1951, when the Canadian government officially dropped the potlatch laws, the Kwakwaka'wakw asked the Museum of Man in Ottawa to return the items confiscated from Dan Cranmer's 1921 potlatch. The museum agreed, with the proviso that a facility was built to safely house and display the artifacts. Now they reside at the far end of the U'mista Cultural Centre, in the specially constructed Potlatch Room.

A sign instructs me to enter from the right, as a dancer would do at a potlatch ceremony. I step into a miniature version of a Big House; the ceiling is supported by hand-hewn posts, and the air is pungent with the scent of cedar. All around the room, free-standing on narrow black pedestals, are masks.

"The potlatch collection is an open exhibit," another sign says, "as we felt the objects had been locked up enough before being returned to us."

I can get close enough to the masks to see marks left by the carvers' adzes, the areas of paint rubbed away by use, the discolourations on the decorative wolf teeth, and the fine details of the feathers, rope, red cedar bark and shells that also adorn them. They represent Wolf, Raven, Crooked Beak Bird and Cannibal Bird. One is Dzunukwa, a giant who can bring back the dead and who eats children; another is Bakwas, chief of the ghosts and a keeper of drowned souls. Eight decades ago, these masks were worn, danced in and venerated. They are far more than artifacts: they are extraordinary works of art, resonating with story and radiating life, spirit and experience. A strong energy emanates from them; though I'm alone in this room, I feel surrounded by powerful personalities.

In 1995 one of the masks was stolen, and since then they have all been wired up

to alarms. A note under the empty pedestal says: "Gilutlikw is our term that describes the person or persons who stole the artifact from our potlatch collection—it was like 'taking away our soul.'"

Outside the Cultural Centre, smoke is rising from a fire on the beach: a Native fish boat came in today and there's a communal cook-in going on. We walk slowly back along Fir Street, past the Nimpkish burial grounds. Earlier in the day, we'd passed by here without giving the place much attention, but now we stop to look at Mungo Martin's memorial totem. As Dag walks up to it with his camera, a teenaged girl passing by on a bicycle calls out, "Hey! You're not allowed in there!"

We hadn't seen the sign asking us not to enter this sacred ground, and we leave quickly, feeling embarrassed.

Thursday July 22

DAY *21* ALERT BAY

Bruce Alfred has arranged for us to meet his nephew this morning, in the Carving Room. On the way we stop off at the Looking Good, Feeling Better Hairdressers and Beauty Salon, which doubles as a bicycle hire shop, and pick up a couple of bikes.

At the reserve end of town, morning glory winds through the blackberry and salmonberry bushes along the sidewalk, and poppies and harebells are blooming on the grassy bank leading down to the beach. In the Carving Room, Wayne Alfred is using a small electric chain saw to cut through a large block of wood.

"This is one of the few good things about white man's culture," he says, with a provocative smile.

Like his uncle, he is keen to talk about his heritage. Fixing us with an intense stare, he explains how every clan and tribe has its own traditional carving styles and designs. These are personal property, like the songs and dances that are passed down through the families at special occasions. Once you've been given a song or dance, he says, it belongs to you, and no one else can perform it. He's angry about white people expropriating Native art, but what really enrages him is the deliberate dilution of his culture for commercial reasons by those he disparagingly refers to as "urban Indians." Abruptly he switches tack, to the injustices of white people taking First Nations' lands and livelihoods away.

"They steal our fishing rights, they cut down our trees and don't share the profits. Now they say they'll give us some land back, but they've already destroyed most of it. Look at all the clear-cuts. How do we explain those to our children?"

We listen mutely. What can we say? The weight of collective guilt lies on our

shoulders, and Wayne is doing nothing to help ease it.

"It was genocide, what the white man did to the Indians," he continues. "The smallpox they brought killed tens of thousands of people. Everyone talks about ethnic cleansing in Kosovo, but what about what happened here?"

"It's a bit like how the English suppressed the Irish," I offer tentatively. "During the Great Famine, a million Irish died, and a million more left the country."

Suddenly, a door swings open in the conversation.

"You Irish?" inquires Wayne.

"My parents are. And Dag and I have lived there a bit."

His face cracks into a smile. "You should have said that before! We've got the same kind of history."

For a while we discuss the parallels: the suppression of language and culture, the reduction of the population through illness and famine, and the miracle of families surviving against all the odds.

"Yeah, you Irish had a bad time too," Wayne concludes. "The difference is we're not running around throwing bombs at people."

Saturday July 24

DAY 23 ALERT BAY TO LADY ELLEN POINT

The warmth of Alert Bay's people and the comfort of Janet's house are hard to break away from. But at last we're paddling past the Nimpkish Pub once more and heading north. At the government dock we stop to visit a sailboat called *Oohna*, a British-built classic racing sloop from the 1930s. On board are its skipper Paul, a goldsmith from Bamfield, and his girlfriend Ina, a Victoria-based artist. Paul is circumnavigating Vancouver Island, and Ina has been sailing with him for the past month. While Paul shows Dag around the boat, she and I chat. This is her first experience of cruising, and although she's enjoyed it she's ready to go home. Their next stop is Port Hardy, where she'll jump ship.

"The real truth is, I don't want to sail around Cape Scott," she confides.

"I know exactly what you mean," I reply.

Paul and Ina also plan to leave for Port Hardy today, and are waiting for the current to switch. Maria and I are impatient to get going, so we decide to head out straight away. We follow the shoreline of Alert Bay for a while, but once we leave its protection the current is much stronger than I expected. The bulbous heads of a kelp bed bob up and down, and the fronds stream along behind them, in the wrong direction for us. To make

up for the drift of the current, I point the kayak upstream and cross over to the buoy marking Alert Rock. As long as I keep the buoy lined up with a tall tree on Vancouver Island, it means we are travelling a straight line without losing ground to the current. If the buoy seems to be moving to the left, I compensate by letting the kayak fall off to the left; if the buoy seems to move to right I turn the boat more to the right.

I assumed the current would switch when the tide reached its high point, but the high tide has come and gone, and it's still against us. This phenomenon of high and low tide not coinciding with slack currents is common on the coast. But here, adjacent to the open Queen Charlotte Strait, I had expected the two to coincide quite closely, and I can't help feeling annoyed at the extra effort this mistake will cost us.

Once across the channel, we stick close to the shore of Vancouver Island, in hopes of finding some reprieve from the current and the breeze. Out in the strait we see the *Oohna* heeled way over by the steadily increasing wind. It looks like Paul and Ina are having a hard time as well, tacking back and forth without making much headway.

Over two hours later, we pull up on a small peninsula north of Port McNeill. We've only covered six miles and already we're beat. Maria naps in a sunny spot sheltered from the wind, until the sun moves behind some trees. When we put back into the water the current has finally turned in our favour, but a strong wind is now hurling row upon row of steep waves at us. As they wash over the front deck, Maria is constantly doused with spray. I manage to avoid most of it by ducking behind her, and I feel guilty that she's taking the brunt of the cold water. At 6:45 p.m. we finally pull up in the lee of Lady Ellen Point.

While we're walking around the point, looking for a good place to put the tent, we come across a strange little encampment. A driftwood throne stands on the beach, facing out to sea. It has a tall straight back, sturdy armrests and a moss-lined seat. Behind it is an open-fronted shelter made of rough planks and a tarpaulin. Everything inside is neat and orderly: a row of socks pegged to a washing line; woollen underwear, a rain jacket and rain pants hanging from nails banged into the uprights of the shelter; several fishing rods propped up in the corners; a made-up bed covered by a sheet of plastic to protect it from windblown rain. On top of the bedside table, constructed from a plank propped on rocks, there's an arrangement of shells, a pile of books, a candle in a bottle and notes on slips of paper secured by a stone.

"July 22," says the note on top. "Beautiful calm day. No salmon showing. Jellyfish here though, so probably next week. Lots of sole for mom, she should have enough now." A few sheets below, a note in different handwriting is addressed to

"Norman," thanking him for the delights of his temporary home.

Adjacent to the bed is a fireplace and a woodbox.

"Look, it's mostly little pieces of fir bark," says Dag, peering into the box. "That stuff doesn't spark when you burn it. Makes sense when you've got your fire next to your bed. This guy obviously knows what he's doing."

I feel as if we're trespassing, but the wind is blowing hard in Broughton Strait, so it's doubtful that anyone will come here tonight. We set up our tent next to Norman's camp and have dinner by his firepit. I keep wondering about him and his obvious love and care of this place. Before we go to sleep I leave him an admiring note, explaining why we stayed and expressing our thanks.

Tomorrow we want to catch the current and beat the strong northwesterlies that are forecast for the afternoon, so we set our alarm for 5:30 a.m. Dag is more restless than usual: his old shoulder injury has flared up and he can't get comfortable. Every evening he meticulously builds a pillow by stuffing clothes inside his fleece sweater, but at the best of times he's forever fussing over the mat, saying it's on a slope or there's a rock under it. I usually have no such problems and fall asleep quickly, but tonight I lie awake and fret for hours. Our next stop is Port Hardy. Like Ina, I could decide to get on a bus there and be home by nighttime. During the relaxed days in Alert Bay, it was easy to repeat, "Yes, we're paddling around Vancouver Island." Easy to chat on the phone about the trip while lying on a comfortable brass bed, with a cup of coffee on the table next to me. Easy to forget that the really serious stuff is about to begin, that it's just Dag, me and the kayak, and three hundred miles of open coast ahead.

Sunday July 25

DAY 24 LADY ELLEN POINT TO PORT HARDY

Thank God for this steep beach of pea-sized gravel: it allows us to slide the fully loaded boat into the water. We're on the water by 7:30 a.m., trying to make the most of the current before it sets against us again. Although we only covered eight miles yesterday, I must have overextended myself when we were bucking into the current and the wind. My left arm feels weak, and every time I lift it there's a painful grating sensation in my shoulder.

Around nine o'clock we pass a kelp bed, and the direction the fronds are pointing confirms that once again we're dealing with our old nemesis, the contrary current. The shoreline drifts past at an interminably slow rate, and the grey cloud ceiling settles lower and lower over our heads until, when we enter the harbour of Port Hardy, it finally

OPPOSITE : *Nimpkish burial ground, Alert Bay*

releases a heavy drizzle. Cold creeps into our bones as we climb out of the boat and secure it to the government dock.

I'm ravenously hungry. The pub just above the dock is empty save for a rough-looking man sitting at the bar, who tells us that the kitchen is closed on Sundays. We follow his directions to a nearby cafe, where a twirling sign with an enticing photo of pita bread stuffed with juicy meat encourages us to "Try Our Gyros!"

"I think I will try one," I say.

Dag shakes his head. "In a place like this you're safer sticking to the hamburger special."

Foolishly, I ignore his advice. Within minutes I'm staring at something that bears only a passing resemblance to the photograph, and contains some sort of pressed, grey, rubbery substance that's unlike any meat I've ever come across. I consider sending it back, but Port Hardy doesn't seem like the kind of place where you make a fuss about food, so against my better instincts, and before I have time to mull over the possible consequences, I eat the gyro.

We check into the Seagate Hotel, a multistoreyed building close to the dock. The elevator smells strongly of cleaning agents and disinfectant, as if someone had just been trying to wash away something unpleasant. Our room, which we're told is the only one available, has two queen-sized beds, a TV and a kitchenette. With our accommodation for the night sorted out, the only remaining problem is finding a place to leave our kayak. Down on the dock we talk to the coast guard, a cheerful, muscular young man with his hair dyed bright yellow. He points across to a large and rather scruffy heritage house that we'd noticed on the way in.

"See the trailer next to it?" he says. "That's where I live. You can put your kayak under the deck of the house. Tell the people who live there that I sent you."

Most of our gear is in a corner of the Seagate lobby, so while Dag paddles the boat across to the house, I scoot up to the hotel and borrow one of their gilt-handled luggage trollies. I feel extremely self-conscious pushing it down Port Hardy's main street, but no one gives me a second glance. Outside the house I'm met by an overenthusiastic puppy, whose barking soon brings out its owner, the rough-looking man we met earlier in the pub. He seems unperturbed that a strange woman has just wheeled a loaded luggage trolley into his yard and is burbling about storing her belongings and a kayak under the deck of his house.

"Sure you can leave your stuff here," he says. "Need a hand?"

The house is a beauty, but obviously in need of repair and restoration.

"We're just renting it, eh?" he tells me, as we carry the boat up from the beach. "It was built in 1926, across the bay, and towed over here. The owners want to pull it down and built a modern house. Me and my friends are trying to get a preservation order on it."

Just before we leave, a red-haired man with a soft Scottish accent comes out of the house for a chat. In 1976, he tells us, he arrived in Canada to do post-graduate work at Vancouver's Simon Fraser University.

"I decided to visit Port Hardy, and I never left. This was a different place back then. There were artists living here, and musicians. The town had coffee houses and art galleries. We had music festivals over at Winter Harbour, and Joni Mitchell used to come up and sing."

In the 1970s and 1980s Port Hardy was home to the second-largest copper-producing mine in British Columbia, and the place was booming. But in 1995 the mine closed, and around the same time the other mainstays of the community, fishing and logging, also took a downward spiral. This settlement of around 5,000 people is looking at tourism as an option, but is struggling to attract the numbers of visitors it needs.

"Everyone's got a home business now," says the man. "Landscaping, an Internet cafe, guiding, that kind of thing, mostly funded by the Forestry Renewal Program or Human Resources. I'm not sure how many will ever really make it."

Back in the lobby of the Seagate, we meet a disgruntled Polish woman in high heels.

"I saw this hotel advertised in a Polish newspaper in Toronto," she says. "The owners are from my country. That's why we came here. We are staying two weeks. But there is nothing to do in Port Hardy. What can we do?"

"Fishing?" we suggest lamely. "Whale-watching? Kayaking?"

"But it's raining all the time!" she wails. "And it's so cold. They didn't tell me that!"

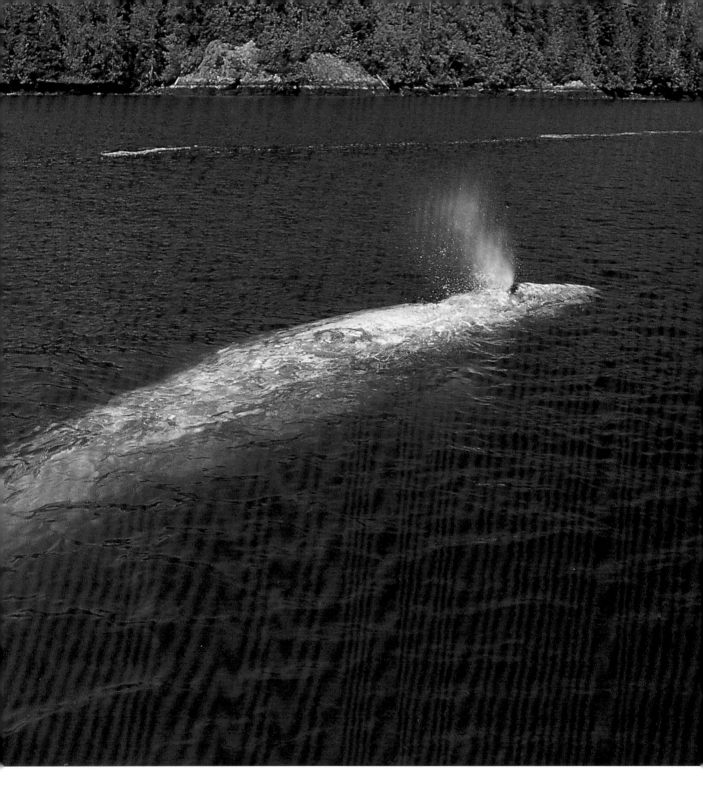

ABOVE : *"...without warning, all thirty-six tonnes and forty feet of gray whale surface right behind the kayak."* Adrian Dorst/Ursus photo
OPPOSITE : *Evening sun on bull kelp float*

Monday July 26

DAY *25* **PORT HARDY TO SONGHEES CREEK**

Dag has dosed himself with ibuprofen and that, plus a good night's rest, has eased the pain in his shoulder. But I wake up feeling queasy and tired.

"I warned you about the gyros," he says smugly.

We spend the morning reprovisioning and wandering around Port Hardy, and it's after lunchtime before we get away. Last night, the *Oonha* pulled into the harbour, so on our way out we go over to chat with Paul and Ina.

"When you're on the west coast, always keep your guard up," Paul advises. "If you ever let it down, that's when you'll get hit."

Ina smiles at me.

"I'm catching the bus to Victoria tomorrow. Want to come along?" she asks playfully, and I feign a lighthearted laugh.

We only did another eight miles today. Maria's paddling was weak and my shoulder isn't getting any better. Luckily we've found an appealing place to camp on a beach carved into terraces by the tides, at the mouth of Songhees Creek. For once, it's a still, warm evening. A mile away on the other side of Goletas Channel, the string of islands that protect us from the swells of the open Pacific lie bathed in the sun's last rays. An eagle squeals and squeaks somewhere high above us, and while we are having supper a school of dolphins cruises by. Then a huge moon rises from behind the forested ridge, individual trees etched against its face. For me, the moment is a turning point in the trip: this is what I've come in search of—wild and beautiful places where there is no reference to the modern lives we have left behind.

Tuesday July 27

DAY 26 SONGHEES CREEK TO BULL HARBOUR

The current is flooding against us and will be for most of the day, so we hug the rocky shore to take advantage of back eddies. The chronic injury in my shoulder is acting up again, and I curse these tidal streams. I can hardly wait to get onto the open coast where finally we'll be free from the tyranny of the currents that have dictated our every move since we left the Strait of Georgia. Yet, in the back of my mind a little voice cautions me not to tempt fate: the real challenges still lie ahead. "Take it easy," I tell myself. "You've got to set a pace that you can maintain all day."

Slowly, my frustration is soothed by the beauty and richness of the sea life around us. All the invertebrates of the intertidal zone seem bigger and more numerous here than elsewhere. Heaps of purple and yellow starfish have been left stranded on the black rock that drops off into deep water below us. Great white plumose anemones on stalks glow from the depths. There are barnacles the size of small teacups, and in cracks and crevices above the tide line the dark rock is covered in startlingly red lichen.

A curious male Steller sea lion, at least half as long as our kayak, tails us for a while. He surfaces and gasps for air only inches behind our stern. I feel he is daring me to return his challenging stare, and I could almost reach out and pat the big, pumpkin-sized head with its yellow fangs and pink, panting mouth.

Twelve miles into the day, our idyll is interrupted by the sound of chain saws whining and buzzing on the slopes above Shushartie Bay. A barge half-filled with newly felled trees is tied up to shore. From the deck of a tugboat nearby, a man watches us closely, and as we draw near he rests his strong, tattooed forearms on the rail and leans over to chat. We ask about the barge, and he tells us that every day for the last month he has towed it to Port Hardy, filled to the brim with logs.

All morning I've been tired and nauseous. What's kept me going is the thought of eventually sitting by a campfire and drinking hot, creamy masala tea. After Shushartie, we press on three more miles to Jepther Point. Behind a long gravel beach is a logged area where a scrubby second growth is just starting to come up. We paddle along the shore, looking for a place to put our tent. I don't care about all the bear prints Dag points to; I'm longing to get out of the boat and stop for the day. But I know he's not keen to camp here; he wants to carry on for another six miles, to Cape Sutil. It's now 1:30 p.m., and we've been paddling for six hours with only one ten-minute shore break. I simply don't feel strong enough to face the exposed stretch to Cape Sutil, or the possible horrors of the infamous Nahwitti Bar en route.

"What if the wind kicks in?" I reason. "Your shoulder's in bad shape, and I'm absolutely beat. We should tackle the difficult stretches when we're fresh."

I just can't stand the thought of camping on the verge of that logged area—I always find there is a terribly depressing ambience in such places. If we just pushed a little farther we could make it to a really inspiring place: Cape Sutil, the most northerly point on Vancouver Island. The conditions are perfect. There's no wind, only a low swell and, according to the current tables, it will be slack when we arrive at Nahwitti Bar. But I'm beginning to realize that it's too much for Maria. Reluctantly, I suggest paddling another three miles into Bull Harbour on Hope Island. Among fishermen it's known as a safe place to wait out a storm, so there should be somewhere to camp.

Bull Harbour was named in the 1800s by officers of the Hudson's Bay Company, after the number of large bull sea lions they encountered in the area. Its entrance looks intriguing: convoluted rock formations along the bluffs and a stone pillar, topped by bonsai-like trees, that rises vertically out of the water. Beyond the pillar is a government dock, where a sign from the Tlatlasikwala Nation warns that no one should tie up without permission. We paddle over to two commercial fishing boats that are rafted together and anchored close by.

"You're a long way from home," says the man who comes on deck to talk to us. "I got a nice little spare engine if you want it. We could drop it into that middle hatch. Get you back to Nanaimo in no time."

His mood changes when we inquire about buildings at the head of bay. The whole of Hope Island is a reserve, and we're wondering whom we should ask for permission to camp.

NEXT PAGE : *The treacherous shores of Cape Scott.* Russ Heinl photo

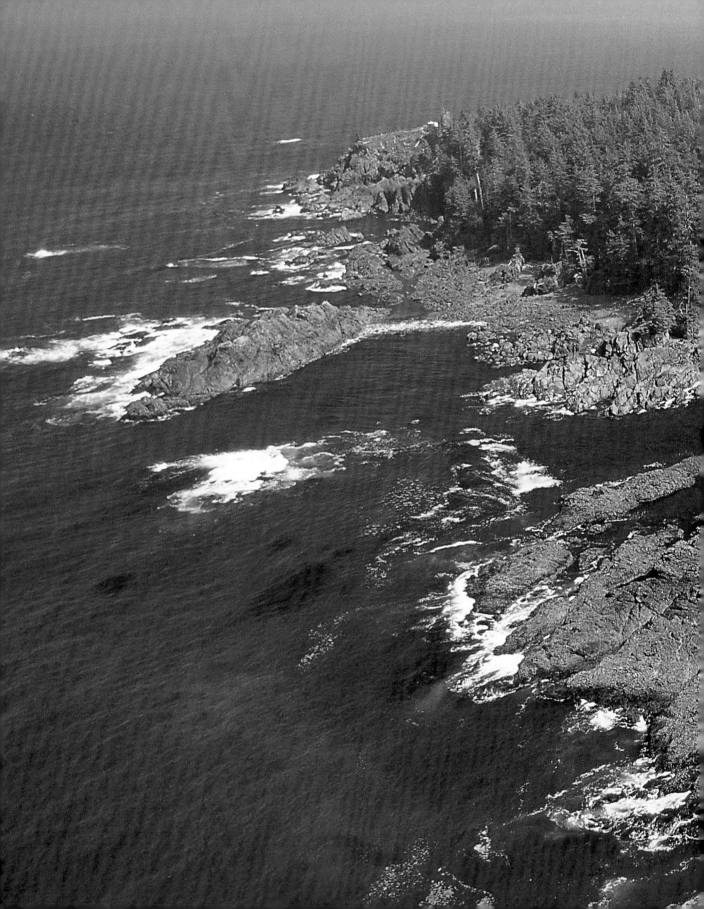

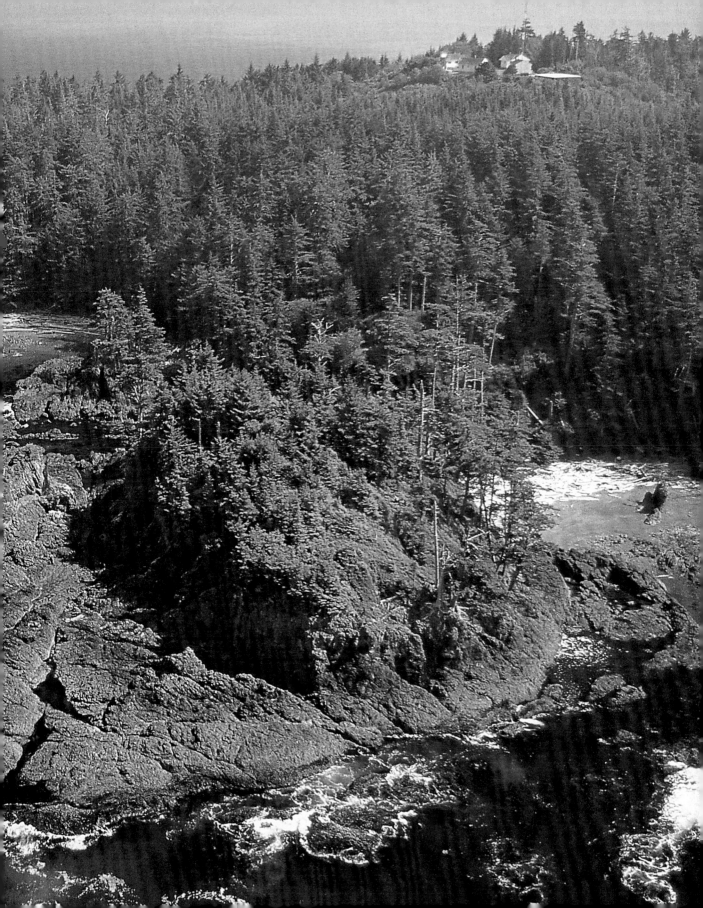

"Camp? They'll shoot you. Did you see the sign? They won't talk to us. They're mad about everything and they say it's all our fault."

Nervously, we paddle toward the buildings. This was once the site of Humtaspi, a village established by several bands of the Nahwitti peoples in the 1850s. They came here after their primary village site on Cape Sutil was destroyed by the Royal Navy, in retaliation for the suspected murder of three deserters from the Hudson's Bay Company. By 1954 the population had so dwindled that the remaining inhabitants moved to Fort Rupert. Until recently, the site was leased by the Coast Guard.

We can hear hammering from inside one of the houses, and as we go ashore two men appear on a porch. They tell us they're contractors from Port Hardy.

"We're fixing the place up," says one. "Some seine boat fishermen came in and got drunk, and they caused a lot of damage."

A young Native man wanders up, carrying some tools. His front teeth are missing and he wears a baseball hat on back to front.

"Here's Dave," says the contractor. "You'll have to ask him about camping."

Dave Wallas is caretaking the village. He's kind and accommodating, telling us we can put our tent anywhere.

"Watch your stuff," he advises. "People have been coming to steal things. A small tractor was stolen recently and cans of gas are always disappearing."

Before leaving the village, we wander across the strip of beach at the head of the bay, to the island's open ocean side. Facing directly northwest, it lies in the path of big seas coming in from the North Pacific. The steep embankment is covered with round stones, some as big as basketballs, obviously shaped by the ceaseless wave action. Although the ocean is relatively calm, the waves are steep, rearing up before they throw themselves with fury at this obstacle in their way. We can hardly hear each other speak above the noise of crashing water and tens of thousands of stones rolling about. I can't imagine what it's like here on stormy days.

"This is called Roller Bay," shouts Dag.

"That's because of the waves, right?"

"No, it's to warn kayakers that if they try to land here they'll be rolled up and down this beach until there isn't much left of them."

Dense vegetation grows almost to the high tide mark around the edge of Bull Harbour, and there's hardly anywhere suitable for a tent. Eventually we find a place by a creek, just past a float where several longliner fishing boats are tied up. The ground is covered with sharp rocks and slimy seaweed, and there are clouds of mosquitoes. But I'm happy to stop at last, to warm up by the fire and to drink that longed-for masala tea.

Wednesday July 28

DAY *27* BULL HARBOUR TO CAPE SUTIL

According to a Kwakiutl legend, when the first Nahwitti people lived in this area, frequent storms prevented them going out fishing and they faced starvation. They called on their supernatural chief to defeat Malalanukw, from whose anus the great winds were said to blow. The chief set Malalanukw on fire, and in return for his life made him promise that from time to time there would be four days of clement weather at a stretch, to enable his people to fish. As we hastily break camp in order to catch the slack tide over Nahwitti Bar, I find myself hoping that Malalnukw will be kind to us, and grant us one of those good stretches now.

The sky is watery grey. We're supposed to be coming under the influence of a low pressure system, which means rain and southerly wind. Right now, this is preferable to a high pressure, which would bring northwesterlies hammering onto this coast. Here we're protected from the full brunt of southerly gales, and the swell from the north should be low enough to allow us to land on an exposed beach that I know of on Cape Sutil. As we cross Nahwitti Bar, I register that the tide has just turned, but the water is benign, with only a few swirls here and there. This peaceful scene belies the potential chaos that an interaction of wind, waves and current can cause here. Where we're paddling now, the floor of Goletas Channel rises abruptly to a ledge only thirty feet below the surface. The huge volume of water ebbing out of Queen Charlotte Strait accelerates as it is squeezed over this ledge. Out in the middle of the northern Pacific, storms generate big waves that travel thousands of miles through deep oceanic water. As they encounter the sloping continental shelf, and finally the shallows of Nahwitti Bar, they transform their energy by increasing their wave height and steepness. This effect is intensified when these rollers collide with the ebbing current from Queen Charlotte Strait: their liquid mass is squeezed up vertically until it becomes unstable, and the wave crests tumble down in great crashing releases of energy. Add to this a strong northwest wind generating its own waves on top of all that, and you have the perfect recipe for horrendous conditions.

Two and a half hours of paddling take us to Cape Sutil, which on the chart resembles a fish hook. The inside of the hook is a protected crescent beach, perfectly sloped to land a heavily laden kayak or, by the same token, a cedar canoe. It's not surprising that this was once such an important village site. Though it's an ideal place to go ashore, I steer the boat farther around the point to the shank of the fish hook. The swell is breaking on an expansive reef system, and beyond it lies a high sandy beach exposed

to the relentless pounding of the ocean. Easing our boat through small surge channels, I look for places where we might safely land. Suddenly we find ourselves in a protected enclosure choked with giant kelp, where it feels like we are paddling across a big bowl of soup. The far side of this bowl is formed by the steep beach on which the surge gently rises and falls without breaking. I can't help but crack an idiotic smile. Here's why I started this trip: to arrive in such a place, small and hidden from the world, yet exposed to the raw power of elements that have shaped our planet since the beginning of time.

As soon the kayak touches the pebbles of the shore, Dag dashes excitedly up the beach, checking it out. He shrinks in comparison to his surroundings: the high banks of sand, the huge snags and logs and the dark forest beyond. For a better look around, he scrambles up a boulder the size of a small house and gesticulates to me wildly, shouting something that's drowned out by the din of the sea. I have to laugh. I love to see him like this—totally in his element, as joyful as a puppy.

We set up the tent facing west, and Dag builds a fire. After some tea, he goes off to follow wolf tracks he's noticed on the beach, while I have a nap. Though we've only paddled for two hours, I'm feeling strangely exhausted. The wind is picking up, and soon it's whistling round the tent, buffeting the walls. I've snoozed for barely ten minutes when the flaps of mud room are blown free from their moorings. I tie them down with big stones, but minutes later they are loose again. The wind is getting steadily stronger, slamming into the side of the tent. One back peg comes out, the poles are starting to bend, and Dag is nowhere in sight. Miserably, I wrestle with

ABOVE LEFT : *Dag's fire-building technique, Guise Bay, Cape Scott*
ABOVE RIGHT : *The remains of pioneers' fences on Sand Neck, Cape Scott*

the guy lines, securing them as much as I can. There's no point staying inside the tent: I sit disconsolately by the fire, which is roaring in the wind, until Dag returns.

"We'll have to move it," he says. "Let's go and choose a spot around the corner that's more protected from the south wind."

We empty the tent, let down the lines, carry it over to its new site, re-erect it, then drag all the gear over. Once the move is complete, I crawl into bed and sleep.

When I awake, a few hours later, it's raining hard. Dag is sitting in the mud room; a few feet in front of him, a fire crackles, its smoke curling back into the tent from time to time. Clouds scud across the sky, drawing more along behind them. For a brief moment, the sun breaks through, turning the ocean to silver against the dark grey horizon, and spinning rainbows off the tops of waves as they crash onto the beach. I fold my Therm-a-Rest mat into its chair position and crawl out to join Dag.

"Feeling any better?" he asks hopefully.

I tell him I am, willing it to be true.

After dinner, Dag goes off to haul our bags of food into a tree. There are bear scat and prints everywhere. Earlier today he found a place among some rocks where a bear had recently been digging among gravel and eelgrass, looking for sand hoppers—crustaceans that jump about like fleas and feed on dead seaweed.

"Poor bastards, having to resort to that," he said. "I think they'll be very interested in our food."

At 8:45 p.m. we listen to the forecast: strong westerlies are predicted for later. Dag secures the tent with extra guy lines and stakes, and soon we're in our sleeping bag, along with a huge amount of fine, grey sand.

Thursday July 29
DAY *28* CAPE SUTIL TO CAPE SCOTT

When I step out of the tent, I find a white eagle tail feather lying on the beach. Taking this as a good omen, I attach it carefully to the deck bag of my kayak. By the time we're leaving the beach, the sky has begun to brighten in the west, with blue patches appearing. It takes me a while to get used to being on the open ocean again, to remember the movement and rhythms and noise. We paddle close to the shore, so that the swells roll under us, then curl their backs, breaking with a roar and rumble close by. Playfully, Dag guides the boat through surge channels between rocks, where glacial green water rises up over barnacles and seaweed, then streams down again in shining silver ribbons. This is superb paddling, but we have to be constantly alert, watching out for submerged rocks on which boomer waves can unexpectedly break.

A narrow band of clear sky on the western horizon widens, probably because of the strong westerly wind that's forecast. After the passage of a frontal system, the west wind can often abruptly kick in, up to thirty-five knots. This unpredictable wind will be our main concern from here all the way down the west coast. I sense it as a hammer, poised in the sky above us, ready to unleash a blow when we let our guard down. As we skirt the shore I keep an eye out for bolt holes we can duck into if the wind picks up. But it seems we're in luck—it remains calm, with a mackerel sky and the sun casting a soft light on the glassy swells.

Just as we reach Shuttleworth Bight, Maria notices a tall, narrow cloud of mist against the dark shoreline. At first I think it's spray from a distant boomer, but then it reappears, followed by a faint yet distinctive hiss. A gray whale! It must be feeding here, scooping up great mouthfuls of sand in the shallows, then sifting out worms and crustaceans. We put down our paddles and wait. Two more whales appear, their wide flukes rising into the air before sliding below the surface. Meanwhile, we have become the centre of attention for a group of California sea lions. Significantly smaller than Steller sea lions, they are easily recognizable by their distinctive brow and forehead. They maintain a safe distance, but occasionally one breaks away from the group, barks loudly as if to build up courage and then dives and swims under our boat. When we start paddling, the braver ones follow closely behind us, only to snort and dive when I turn to look at them, like the Cowardly Lion in *The Wizard of Oz*.

By late morning, the settled conditions still prevail, so we decide to get farther along the coast. If the wind suddenly comes up, I figure we can turn around and be blown back into the shelter of the Stranby River, which empties into the bight.

Once we're around the next point, and crossing a bay, we see another spout, dead ahead. Again we stop paddling and wait. The whale seems to be milling about, feeding. Steadily, its spout comes closer, until it's a few hundred feet from us. Then, without warning, all thirty-six tons and forty feet of gray whale surface right behind the kayak. In seconds it's gone again, but two minutes later it reappears to our stern, less than a boat length away. I sit in lockjawed silence, aware that with one flick of its tail this giant creature could destroy our fragile craft—and us. *PHOOSH!* It comes up on our port side, closer than ever, showing off its long nose and mottled, slate-blue back. With its curiosity—or its appetite—sated at last, the whale moves out of the bay, leaving us humbled and awestruck by the encounter.

There's less of a hurry now, as I'm confident we'll make it today as far as a little bay at the base of the Nahwitti Cone, a few miles away. We paddle at a leisurely pace, taking in these stunning surroundings. By late afternoon there's still no wind and the sea is gently rising and falling. Behind the next headland, a large pyramid emerges from the haze. I check the chart. It must be Cox Island, part of a chain of uninhabited islands that lies off the northwest tip of Vancouver Island. Cape Scott, one of the most dreaded obstacles of our circumnavigation, is just over six miles away.

A year ago, I rounded the cape with my friend Steve, in conditions just like these. It would be unbelievably lucky to get around this obstacle twice in calm weather, but it looks like we might have the chance. By tomorrow the situation could be very different. Maybe we should go for it now...

Another part of my brain cautions me: unlike last year, we have a spring tide, and by the time we reach the cape the current will be peaking, setting at close to three knots against the southwest swell from yesterday's gale. That's not an encouraging thought—it could cause big seas. I flip on the weather radio. The wind warning has been downgraded, and the last report from the Cape Scott lighthouse monitors the sea conditions as being calm. I discuss the situation with Maria. It's not a straightforward decision. Conditions out here can change quickly and there is no easy way out. Along this next stretch we'll have no more protected nooks to escape to in an emergency, and we want to avoid having to land this heavily laden beast on beaches with surf.

When Dag suggests we go for Cape Scott, I think, why not? Conditions seem optimum, and I feel much better today. I can't believe how blessed we are, to be kayaking off the northernmost tip of Vancouver Island, one of the wildest places on Earth, on such a gorgeous afternoon, in the company of whales, sea lions and birds. How much better can things get?

"I'm in," I tell him.

Now that the decision is made, we move offshore to take advantage of the current. Along the beach in Nels Bight, a few tents put up by hikers who have completed the Cape Scott Trail become bright dots in the distance. For a while we're joined by a flock of terns, flying low over the water in a dipping motion. It's a comfort to have them along, but as soon as we draw close to the cape, they desert us.

Cape Scott's promontory is rapidly growing larger. My shoulders tense as I notice white specks on the horizon ahead. Minutes later some of the specks have joined to form white lines. This is not a good sign, and I know enough from past experience to take heed of it.

"Here goes," I think to myself, "this is where the west wind gets us."

As we paddle on, the breeze remains the same but the white lines become more distinctive, stretching from the base of Cape Scott off into the open ocean. Before long I can distinguish the shapes of individual breaking waves.

"What the hell's up there?" asks Maria.

Reluctantly, I tell her that it's lines of standing waves, extending a couple of miles offshore. The tidal stream has us firmly in its grip, and we're going through this whether we like it or not, so it's just a matter of choosing the best spot. My mind races through several options and I decide to go as close to the base of the cliffs as possible, as it seems to be the calmest there. It's a gamble, though, because we'll have to contend with submerged rocks and boomers.

As the current speeds us along, it feels like we are paddling on the spot with the waves and cliffs rapidly descending on us. For a fleeting moment my eyes open to the beauty of it all: warm evening light turning the rock a bright auburn colour, the black concave bellies of the waves with backlit crests of molten gold and veils of silver spray. An instant later, we are in the midst of it.

Just before the first wall of water lifts our bow, the dark shape of a big, sleek animal rises from the maelstrom and surfaces right beside Maria. It exhales and turns its head to look at her, open-mouthed. Maria's paddle remains poised in mid-air, and she stares back.

"Forget the sea lions," Dag yells, over the noise of breaking waves. "Focus ahead."

I've barely plunged my paddle into the water when we hit the first standing wave. The boat is yanked brutally upward, and my upper body jackknifes onto the deck. As the wave breaks over me, a solid blast of freezing water slams me back into an upright position. Gasping from the shock, I gape at the next teetering wave. It seems to be hesitating, reconsidering, then our boat rises to meet it and the crest tumbles down, whiplashing my head and soundly pummelling us both. Mercifully, the third wave passes under our boat without breaking. But off to our right, its even bigger cousins are curling and hissing as they throw themselves forward.

Dead ahead, an enormous boulder roars up from the melee, water pouring off its back. Dag swings our bow away from it, and we crash through some smaller waves. The worst is over. Our kayak slices through a patch of foam almost a foot high, which immediately silences the din we have left in our wake.

"Congratulations, honey," calls Dag. "We made it around Cape Scott."

I'm not ready for congratulations. We've still got another mile and a half to go

OPPOSITE : *Close to our campsite on Cape Sutil*

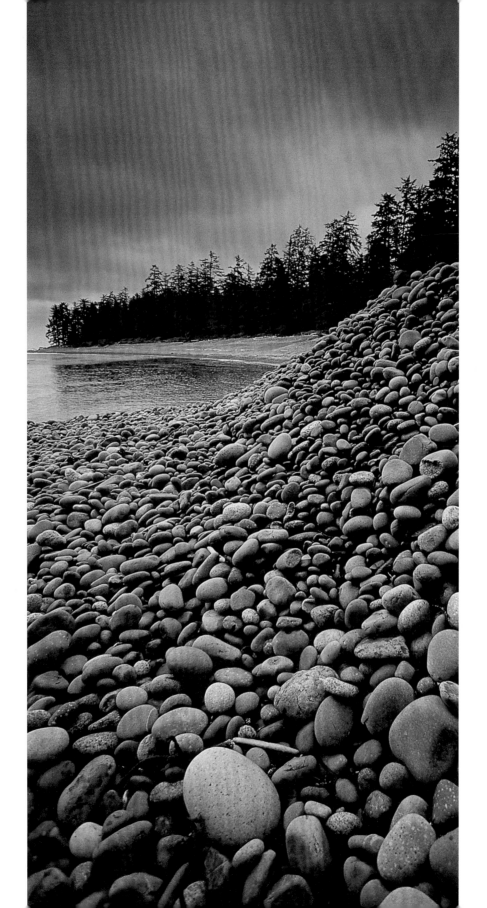

before we reach the safety of Guise Bay.

"Do you mind explaining what all that was about?" I demand.

"It must have been the strong ebbing current against the swell," he says. "I didn't expect it to be that bad."

"Was it like that when you went around it with Steve last year?"

"No."

"Any standing waves then?"

A pause.

"No. It was totally flat. I was disappointed. This was a hell of a lot more fun."

Friday July 30

DAY *29* **GUISE BAY**

Drinking tea by the fire, I gaze down the length of the beach. Behind it are the dunes of Sand Neck, the isthmus joining the rocky headland of Cape Scott to the mainland of Vancouver Island. I've read somewhere that in bad seas the Nahwitti people would drag their canoes over Sand Neck, rather than risk paddling around the cape. When I tell Dag this story, and laughingly suggest that maybe we should have done the same yesterday, he doesn't seem amused. He's uncharacteristically quiet this morning, locked in his own thoughts.

I woke up feeling strangely hollow. It's as if yesterday's adrenalin rushes have ebbed away, leaving me deflated. I keep thinking back to the unexpected sea conditions off Cape Scott, and questioning the judgement calls I made. I've always maintained that with enough time and proper assessment of the risks, we could paddle all the dangerous parts of this trip in relative safety. Maybe I was too eager to get around the cape yesterday. Maybe we should have waited a few hours for the current to ease. But by then daylight would have been waning, and it's not a place you want to be in the dark. I guess it's just not always possible to wait until all the risk factors are in your favour.

My mind drifts to the cruxes that lie ahead: the Brooks Peninsula, Bajo Reef off Nootka Island, Estevan Point, the long open coast of Juan de Fuca Strait. But it's not just those places that worry me. This whole coast is open to 4,000 miles of ocean, and, as Paul said, if we let our guard down we can get nailed just about anywhere along it. When we arrived here yesterday I was elated; I felt that with Cape Scott under our belts, the rest would be plain sailing. It seemed like we had turned a corner and were on our way home. But now I realize that the hard part is only just beginning. It's a game, I tell myself. Think in small steps. Be ready for the right moment, then make your move.

In the afternoon, we wander over Sand Neck. Everywhere in this windswept place are traces of violent storms and the desperate attempts by mankind to settle here. According to some Kwakiutl legends, it was on Sand Neck where Kanakelak the transformer lived. During his ancient pilgrimages this supernatural being created man and beast from a prehuman race, and restored order to the mythological world. Shell middens and skeleton remains found on Sand Neck are believed to the be traces of the original inhabitants, the Yutlinuk, Nakumgilisala and Tlatlasikwala, collectively known as the Nahwitti peoples, and there is an important village site close by. Raids by marauding tribes reduced the population, and by the mid-1800s the remaining Nakumgilisala had joined the Tlatlasikwala at their "capital" village on Cape Sutil, which was destroyed by the Royal Navy soon after.

In the late 1890s, Danish farmers arrived from Minnesota to homestead in the Cape Scott area. Perhaps the most courageous and idealistic of these pioneers was a man named Jensen, who tried to reclaim the Sand Neck by planting clover and erecting a huge split cedar fence. Most of the settlers soon became discouraged by the isolation and the storms and drifted away to kinder environments. But Jensen opted to stay, and he lies buried somewhere beneath these shifting dunes.

Our feet pass over patches of clover Jensen planted and snag on the creepers of his strawberry plants, which have long since gone wild. Sticking out of the sand are remnants of Jensen's fence, looking like weathered bones or the markers of simple graves.

ABOVE : *Our campsite on the north side of the Brooks Peninsula*
OPPOSITE : *Waiting for the right wave to surf ashore.* Mark Kaarremaa photo

Saturday July 31

DAY *30* GUISE BAY TO WINTER HARBOUR

Appropriately, our trip down the west coast of Vancouver Island begins with a launch through surf. At the water's edge we cinch down our deck bags in readiness. Dag holds the kayak steady while I get into the front cockpit and snap my spray skirt over the combing. He waits for a series of big waves to pass, then pushes the boat forward. I start paddling furiously, and he jumps in behind me. The next wave breaks on the bow, and boils across my spray skirt. The one behind it deals me a stinging slap in the face and forces cold water down my neck. A few more strokes take us beyond the surf zone, where we stop paddling. I shake the water out of my ears and eyes, thinking that this is a better kick-start to the day than the strongest cup of coffee.

As we paddle away from Guise Bay, the sun pours soft light over the swell rolling in from the northwest. Off Cape Russell we keep a careful watch for boomers ahead, noting their position in our minds—something we're going to have to do for the rest of our journey down this exposed coast. The most dangerous boomers are those that only

occur at intervals of half an hour or more, when a particularly big wave rolls in. You rarely see them in advance, so paddling on these rock-strewn coastlines can be akin to playing Russian roulette.

Behind Cape Russell we tuck into Sea Otter Cove for a break. It's aptly named, for among the islets and reefs guarding the entrance there are otters everywhere. They lie on their backs with their hind feet up in the air, stick their head and shoulders out to the water to get a better look at us, or somersault through the water, their thick pelts smooth and shiny. To rest, otters often anchor themselves in a kelp bed. We borrow this trick, pulling a few kelp stalks over the deck of the kayak, so that we can stay in one place while we have a snack. In the green depths of the forest beneath us, the stipes of the kelp sway gently in the surge. Mottled kelp greenlings dart between them and big coral pink snails crawl over the fronds, feeding busily.

All the millions of clefts and crevices in this reef, and the unusually dense kelp beds, offer protected nurseries for urchins, abalone and crustaceans that feed on kelp, and that in turn are preyed upon by sea otters. Before sea otters were hunted to extinction, they kept the population of urchins and crustaceans at bay, and the kelp forests flourished. Some theories suggest that these forests were once so extensive they formed a protective corridor that allowed Native people to navigate the west coast more easily in canoes and maintain villages in exposed places. This may be conjecture, but it is a fact that kelp beds are the basis of an ecological system that supports a large diversity of species, and that they provide a sanctuary for commercially important fish.

It was after Captain James Cook published an account of his expedition to this coast in 1778 that the trade in sea otter pelts began in earnest, and these animals were wiped out in BC. Without a natural predator, the populations of sea urchins and crustaceans exploded, decimating the vast tracts of kelp forests that once protected most of the coastline.

In the 1960s, sea otters were reintroduced to Kyuquot Sound, about fifty miles south of here. Since then, their population has increased to over 5,000 and they have spread farther north beyond Vancouver Island. Even though the reintroduction has been a success, there are many people who say that sea otters are destroying the already depleted abalone populations and ruining the lucrative urchin fishery. It may also be that one day the kelp forests will again form a "reef" down this west coast. If nothing else, it would be a boon for kayakers.

We're now halfway to our destination of Raft Cove. The chart shows a sandbar, with a river mouth behind it, where we should be able to land without a problem. My

bouts of nausea have returned yet again, and I'm longing for a break. I keep myself going by imagining our arrival at Raft Cove, where I'll strip off my wetsuit, lie in the warm sun and snooze.

After seven miles of steady paddling, Dag suddenly says, "I've been thinking about Raft Cove. These swells are pretty big, and depending on the tide it might not be so easy to get in there after all. We could be facing some big surf."

We decide to poke in and take a look. He's right: from half a mile away we can see—and hear—the surf. My little sunbathing fantasy crumbles into harsh reality, and we carry on.

At Top Knot Point, a gray whale surfaces close by, moving fast to the north. California sea lions cruise alongside the kayak, turning their big heads to look at us. Bobbing on the smooth swells are brown marbled murrelets, birds that lay their eggs on mossy branches high up in old-growth trees. Tiny black Cassin's auklets dive ahead of our bow, as do the common murres, white-breasted creatures with earnest expressions.

Way in the distance, hazy blue on the far horizon, lies the Brooks Peninsula, our next big obstacle. We're totally alone out here—it's just us, the waves, the sea creatures, the forested coast slipping by. I'm constantly aware of the sound of the breaking surf, way off to the left, reminding me that we can't go ashore, that we've got to keep paddling.

All day the northwest breeze has been helping us along, but around 3:30 p.m. it dies down. We've now been underway for six hours without a shore break.

"We just have to get around Lippy Point," says Dag. "Beyond it there's a beach in Grant Bay that should be fairly protected from these swells."

An hour later, sitting off Lippy Point, we squirm in our seats to take the aching pressure off our buttocks. The sky is changing, a veil of high cloud has moved in. According to the latest weather forecast a low pressure system is arriving tomorrow, and at Solander Island the wind has already switched to southwest. Feeling the way I do, the last thing I want is to be stuck in bad weather in a tent on the open coast.

"Let's not go ashore here," I suggest. "Let's carry on to Winter Harbour. There's a cute little bed and breakfast place there."

Dag groans. "It's another eight miles, Maria. Why is that when you suggest something it has to be so extreme? I'm about to pee in my pants."

"You're usually the camel of the family," I tease him. "If I can hold on, so can you."

Once past Grant Bay, we're committed. All the beaches between here and Quatsino Sound are exposed and rock-studded, and trying to land on them could

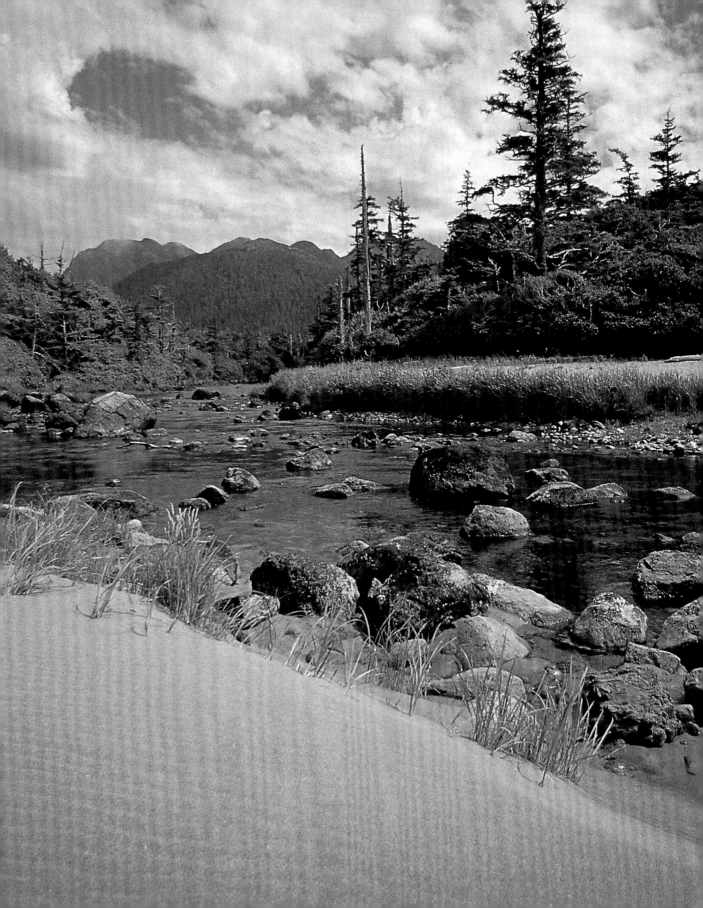

result in a real mess. My back is stiff, my legs are cramped and I'm feeling spacy and light-headed, but carrying on is not a problem: we've been paddling for so long today, it's become automatic, like breathing.

When I start seeing specks dancing over the water in the far distance, I begin to wonder if I'm hallucinating. Eventually I realize the specks are small sport fishing boats, off the cape protecting Quatsino Sound. Close up, they look even stranger than they did from afar, especially the one with a fisherman dressed in slippers and shorts, sitting atop his cabin on a blue plastic lawn chair.

Dag seems to have recovered from the threat of incontinence. Just before we turn into the passage between the cape and Kains Island he says, "Winter Harbour is still five miles from here. Kwakiutl Point is only seven miles away, and there's a great little place to camp just before that. Maybe we should take advantage of these conditions and go for it."

Earlier today, I was stoic about relinquishing my dream of a long rest in Raft Cove. But now, as I stare at the long, dark point in the distance, something in me snaps.

We've been in this kayak for seven and a half hours," I snarl at Dag. "I'm exhausted. I'm nauseous. I want to be away from the exposed coast, and from bad weather, and from even the slightest possibility of an epic. Do you understand?"

"Okay, okay," he reassures me, recognizing the strain in my voice. "It was just an idea."

We slip by the island and into still waters. Now that I know we can soon go ashore, the need to empty my poor bladder becomes overwhelmingly urgent, and we land on the first beach we see. There's no boulder big enough for me to hide behind,

ABOVE : *Bull kelp*
OPPOSITE : *River mouth in Brooks Bay*

but I don't care, and peel off my wetsuit without regard for the sport fishing boats cruising by on their way to Winter Harbour.

Easing our stiff bodies back into the kayak is a punishment. Three miles up the inlet, we pass a couple of islets, where we spot only one small beach suitable for camping. It's fully occupied.

"Oh, I've just remembered," Dag pipes up brightly. "This is a holiday weekend. It's going to be tough finding a room in Winter Harbour. And that was it as far as campsites go."

I feel like lying my head on the deck and weeping.

The tiny settlement of Winter Harbour, reputedly named by the captains of two English ships that holed up here for a winter in the late 1700s, is tucked into a protected corner of Quatsino Sound. The water is mirror-flat, until the sport fishermen cleaning their day's catch at the dock throw handfuls of guts into the water, and screaming seagulls swoop down to fight over the offal. Neither gulls nor fishermen pay us much heed as we climb awkwardly out of the kayak at the government dock. Still wearing our wetsuits, we pad along the narrow boardwalk that runs around one side of the bay, and past the village's handful of houses. Along the boardwalk are bushes of sweet-smelling honeysuckle, hedges of thimbleberries and stands of high foxgloves. Behind, in tangled gardens, hummingbirds flit about, busily feeding on flowers.

Reaching Dick's Last Resort Bed and Breakfast, we climb the steps and I bang loudly on the front door. It's opened by a small man dressed in baggy shorts and a T-shirt, with a dish towel draped over one shoulder.

"Do you have any room?" I ask.

He runs one hand over his bald pate. "Actually I'm full, but–"

"We've just kayaked thirty-two miles from Cape Scott," I interrupt him, my words tumbling out. "We're on our knees, there's nowhere to camp, we can't go any farther, and I'm not feeling very well, so if there's any way—"

Dick laughs and holds up his hands to silence me.

"I was going to say that I guess I can squeeze you in somehow."

I feel like kissing his feet—and there's more good news to come.

"You can tie up your kayak to my dock," he says, pointing to a series of makeshift fingers and boomsticks in the bay behind us. "Bring your gear in through the basement. There's a shower down there and a hot tub. How about some dinner? It should be ready by the time you've cleaned up."

Speechless with relief, we nod and back away.

"We won't be long," I croak.

"Don't you want to know what I charge?" he asks, perplexed.

"We don't care!" I call over my shoulder. "Right now you could charge us a fortune and we'd pay it!"

Sunday August 01

DAY *31* WINTER HARBOUR

Now that I'm able to relax, my body gives way to the bug that has been assailing me since Port Hardy, and I spend all morning in bed. Eventually I drag myself downstairs, where Dick tempts me to eat with little treats of cold chicken, salmon and cheese on crackers. While I nibble, he tells me about Winter Harbour. About fifty people live here now, and only half of them are full-time residents. It's hard to imagine the place in the 1840s, when it was home to over a thousand Quatsino people. White settlers arrived at the end of the nineteenth century and established a salmon and clam cannery and a booming ground. In the 1930s, new people were drawn by the rich fishing grounds nearby, and soon there was a general store, a post office, a blacksmith shop, a school and a small hotel. The Moore family towed in a floating log camp in 1936; their son Bill later expanded the operation, becoming responsible for most of the clear-cut mountainsides we saw as we paddled in.

"There's not much work in logging or commercial fishing anymore," says Dick from the kitchen, where he's making me some tea. "The sport fishermen are still an income spinner in the summer, though. It's them I'll be depending on for most of my business."

Though this is a long-established bed and breakfast, Dick only recently took it over.

"What did you do before that?" I ask.

"Oh, this and that. I travelled a lot. I worked in the logging industry for a while, and I dabbled in real estate. In the early eighties I was part-owner of a strip club in Nanaimo."

I sit up, astonished. "A strip club? Not the Globe Hotel?"

"That's the one," he says. "We turned that place around. We brought the famous strippers in, and we installed the shower on the stage. We made it a big success."

Before I can ask more, Dag returns. He's been out fishing all day with two Americans who are staying here, and between them they've caught a few medium-sized halibut and two large lingcod. Both his new friends have slow Midwestern drawls, and one chews tobacco, periodically spitting into an empty pop can he carries with him everywhere for the purpose. They stand on the boardwalk in the sun, cleaning the fish and making plans to go out again this evening to try for salmon.

It's been good to do a bit of fishing, and these guys impress me; they stick closely to the fishing regulations and don't throw even the tiniest scrap of garbage into the sea. But they are truly obsessed fishermen and talk about nothing else. They've even taken sport fishing courses at a college. I'm getting bored; I'd rather be camping on the wild Brooks Peninsula. The bad weather that was forecast never materialized. In fact, the conditions today and yesterday would have been perfect to paddle to the base of the Brooks. I can't help thinking that we're squandering this window, and might have to pay for it later. But I keep reminding myself that Maria needs time to really shake this bug and I've just got to be patient.

Tuesday August 03

DAY *33* **WINTER HARBOUR TO BROOKS BAY**

Away at last! There's barely any wind, and the sun warms us as we paddle out of Quatsino Sound and down the coast. I'm relieved that Maria is feeling strong again. She needs to be: we've got a twenty-four-mile day ahead, and we're on our way to the Brooks Peninsula, which is one place you don't want to end up incapacitated.

The Brooks, as everyone calls it, is a serious place for kayakers. Sticking out eight miles into the open ocean like a big thumb, it acts as a natural weather divide, with winds and fog banks piling up on its northern side. Its entire coastline is exposed and wave-battered, and there are few places along it where a boat can retreat in bad conditions.

We stop for a break on an islet adjacent to Kwakiutl Point, then follow a protected passage behind reefs down to Lawn Point. Occasionally we spot rhinoceros auklets, easily recognizable by the horn of feathers at the base of their beaks. A couple of small plump birds go whirring past us at high speed, and we catch a glimpse of their bright orange beaks.

"Puffins!" cries Maria excitedly.

This is the first time we've seen tufted puffins on the trip. They are birds of the open coast, nesting on inaccessible outcroppings and islets such as Solander Island, which sits in the haze off the end of the Brooks Peninsula.

After assessing the sky and consulting the weather radio, we decide conditions are stable enough to leave the protection of the shore and head straight across Brooks Bay. As we approach the base of the Brooks Peninsula, the rumbling of waves on Clerke Reefs to our right seem to warn us that we are approaching Vancouver Island's wildest corner. Standing beyond the reach of glaciers during the last ice age, the peninsula's mountains are jagged and defiant and its ecology unique, with plant species that are

OPPOSITE : *Fog closing in on the Bunsby Islands*

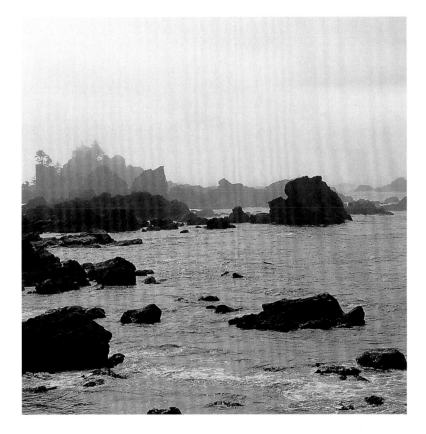

found only here and in the Queen Charlotte Islands. Though it was once the divide between the territories of the Kwakwa̱ka'wakw and the Nuu-chah-nulth, and the site of at least one major village, no one lives here now, and there is no road access. So far, the mountain slopes remain unscarred by roads and chain saws, although the trees above the beach on this northern side look ragged and battered, testimony to the storms and hurricane-force winds that frequently sweep through here.

Behind a group of islets we see a familiar beach: the place we camped three years ago after we paddled around the peninsula from the south. I'm a bit surprised to see that, this time, we won't be alone—a tent is pitched on the sand and a small figure sits beside it.

We're the new neighbours of Willie, who has invited us to camp right next to him. A kindly, fit-looking man in his fifties, he's on a solo trip from Winter Harbour to Tofino, and seems glad of our company. We invite him to have dinner with us, and Dag grills the fresh halibut that his fishermen friends gave us this morning as a farewell gift. Sunset brings a spectacular light show. "God rays" fan across the sky, casting golden hues onto the beach, brightly illuminating pale snag trees and transforming the mist streaming over the mountain tops into an unearthly, glowing yellow. I don't know where to look first, so I stand on the spot and slowly turn in full circles, trying to take it all in, while Dag dashes about frantically with his camera. With darkness comes the sparkling phosphorescence. We see explosions of light where swells break on an offshore reef, long stripes of silver as the waves meet the beach and a myriad of brilliant twinklings around our feet when we dance on the sand at the water's edge.

Wednesday August 04

DAY *34* **BROOKS BAY**

The trail behind the beach is littered with banana slugs—khaki and mottled brown in colour and as long as my hand. We follow it through dense thickets of salal and stands of spruce and hemlock, until the sound of the surf is barely a whisper in the distance. Eventually, it leads us to a high bogland, surrounded by forests and sharply peaked indigo mountains. The scene is straight from *Grimm's Fairy Tales*: dwarf trees grow in tortured shapes, there are big mounds of red byrum moss, and the thick ground is like a sponge underfoot. It's eerily quiet, and Willie and I whisper to each other as he identifies a multitude of native plants. He points to sweet gale, swamp gentian, dwarf blueberries and butterwort, and to the white tufted flowers

nodding atop narrow-leaved cotton-grass. His prize is the solitary camas blossom— a true late bloomer, for all the other camas plants have seed pods by now. Water lilies rise imperiously from the surfaces of small ponds, and along the banks of trickling streams, insect-eating sundews incline their faces to the light. I bend to examine these strange plants. They remind me of alien creatures, their little tentacles radiating from heart-shaped rosettes and coated with a sticky glistening secretion. Any insect unfortunate enough to land on them quickly gets stuck to the glue; slowly, the tentacles bend over, entrapping the prey, which is dissolved with enzymes and absorbed into the tissues of the sundew.

It's 6:30 p.m. and I'm lounging on the beach dressed in shorts and a T-shirt, soaking in the evening sun. The weather channel is crackling away. The recent spate of calm winds has been due to a stalemate between the low pressure area to the northeast and a stationary high pressure system off the coast. Tomorrow things are due to change; the high will move over the coast, bringing northwest winds that are supposed to rise to twenty-five knots. If the pressure system builds over the next few days, I'm worried these winds might increase to gale force.

We've decided to leave early tomorrow. If the conditions aren't just right as we approach Cape Cook, we'll turn back. Willie wants to accompany us around the Brooks. While planning this trip I always insisted that we should do the dangerous portions alone, so that we're responsible for no one but ourselves. Maria is reluctant to stray from that principle, but I feel that Willie can come with us. He's obviously a seasoned and competent kayaker, and we'll provide each other with additional security on what is a very serious stretch of coastline.

Cape Cook and Solander Island are landmarks that send shivers down the spine of any experienced mariner. As winds are pushed past the peninsula, they accelerate, making it the windiest spot on the whole coast. In fact, the winds recorded on Solander Island are often significantly higher than farther offshore. The energy of the ocean also concentrates on Cape Cook, and its swells are bigger and more chaotic than elsewhere. To make matters even worse, from here to the south side of the peninsula there are only a couple of places, eight to ten miles apart, where we can go ashore. If the conditions turn nasty there's no escape—we just have to deal with whatever comes our way.

Dinner is a subdued affair, as our thoughts turn to tomorrow's journey. It doesn't help that dark clouds are moving over the tip of the peninsula, blacking it out with such speed it's like watching a time-lapse sequence. I chat with Willie late into the

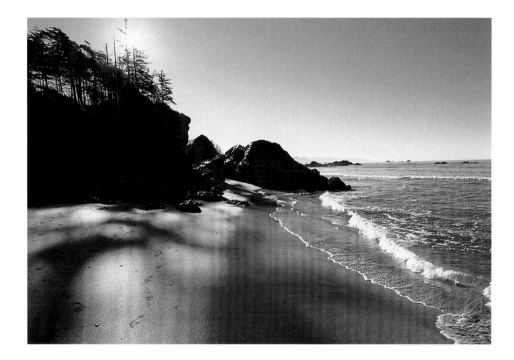

night. When I finally go to bed, the hiss and roar of the surf wash around my skull, providing the soundtrack for unsettling dreams.

Thursday August 05

DAY *35* BROOKS BAY TO JACKOBSON POINT

We're on the water by 6:30 a.m. Rain clouds cling to the mountain peaks of the peninsula and mist streams down between trees. There's a southerly breeze and swells from the northwest. The sea is the colour of flint and the horizon is lumpy— a sign of big rollers heading toward Cape Cook. As we start the five-mile paddle to the cape, I think about Rob and Laurie Wood's story of sailing by the tip of the Brooks in "waves as big as houses." This will be my second time around it, and right now I'm thinking that perhaps once was enough. I keep wishing I wasn't here, clad in a damp wetsuit and paddling a kayak toward one of the most notorious headlands of the whole BC coast. I fantasize about being magically whisked away from this situation to a downtown Vancouver hotel, where I'm elegantly dressed in linen and silver, and breakfasting on warm croissants, freshly squeezed orange juice and

ABOVE : *Morning on Jackobson Point*
OPPOSITE TOP : *Cinching down the deck bags, Jackobson Point*
OPPOSITE BOTTOM : *Tufted puffin.* Ian McAllister photo

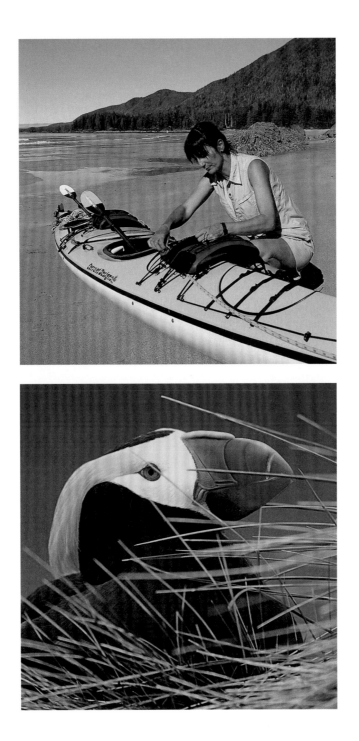

fragrant coffee. A civilized day in the city lies ahead, a visit to the Vancouver Art Gallery and some book shops, lunch at Granville Island, and then perhaps...

"What's up, Maria?" Dag's voice cuts sharply into my reverie. "You might as well be paddling backward."

Paddling a double kayak is a bit like dancing or singing in harmony: you adapt to your partner's pace and rhythm, and when things are going well there's a surge of energy that carries you forward. But if there is any hesitation or reluctance, the spell is broken; in kayaking terms that means you might as well be towing a driftwood log behind you.

We're now only a mile from Cape Cook. I keep an eye on Willie, who regularly disappears in the troughs of big swells. I'm uneasy about the fact that he's not wearing his life jacket.

"I don't think I'll need it," he said as we were launching, and stowed it under bungee cords on his deck. When I asked if he had ever tried to put on a life jacket while treading water, he just grinned.

Willie pauses to drink some Gatorade from a tube that leads to a flask on his deck. We stop paddling as well and pull out some chocolate.

"How are you doing, Willie?" I shout, and he waves nonchalantly before the next wave crest obscures him from view.

Mentally, I run through all the factors that could affect us as we round the cape. The northwest swell is steepening and losing its regular shape, which is probably due to waves rebounding off the rocky shore. The seas still feel friendly, though, and I see only the occasional big breaking wave farther out to sea. Short gusts of wind from different directions are banging around, roughening and darkening the backs of the swells. This is a bit disconcerting, as in my experience a strong wind is often preceded by such gusts. But half an hour of paddling should get us around the cape and into the shelter of the kelp forests.

We decide to go for it and begin to power forward, past slopes covered in a matted scrub forest. Soon the waves turn into formidable pyramids, bucking and peaking unexpectedly. Ahead, Solander Island rises sheer and black from the swells, with scraps of glowing white mist trailing around its mighty shoulders. Tiny winged specks wheel above the summit, which is set against an enormous sky of torn violet and grey clouds.

"Hey, Dag," says Maria. "Look at Willie."

He has stopped paddling and is slouched forward. When I call him, he doesn't reply. We manoeuvre our boat toward his, getting as close as we dare in these conditions.

"Willie? Are you alright?"

"No." His voice is weak. "I'm going to have to stop for a break when we get around the corner."

"What's wrong?"

"I'm dizzy. Sick."

My heart jumps. What if he can't keep his balance in the single? And he isn't wearing that bloody life jacket, either. In better conditions we could raft up and try to switch boats to get him into the relative safety of our double, but in these seas it's out of the question.

I coax him to carry on. "We'll stick close to you. We don't have too far to go before things will start to settle down. Just take it easy and keep going."

And with that he leans over the side of his boat and starts vomiting.

"What an idiot!" I hiss. "Why didn't he turn back while he had the chance?"

Instantly, I feel ashamed of my anger, which I know is born out of my own fears and uncertainties. I can't think of a worse place in the world than Cape Cook to be looking after an incapacitated paddler. If he capsizes, all our lives will be in serious danger.

Keeping pace with Willie, we move forward at an excruciatingly slow pace. I'm unnerved by these perilous waves and the promise of more wind. I just want to get the hell out of here, and I can barely refrain from paddling harder. Between Solander Island and the peninsula, a particularly big set of waves moves in. Each one hits the shoreline with a deep rumble, then bounces off and lumbers back toward our tiny boats. For the next few minutes, as swell meets rebounding waves, the world slopes at dizzying angles, and I fear for Willie, who's sitting limply in his kayak, tossed about like a helpless bath toy.

When finally we reach the kelp beds south of Cape Cook, everything changes. The swells lessen, and the bull kelp heads twirl and nod in the gently rising water. It's as if God has smoothed a hand over the ocean here, stilling its restlessness. At last we are able to raft up to Willie. He looks dreadful, with pallid skin and blue lips. But he insists on continuing in his own boat, and follows us to a safe nook that we know, a few miles farther on.

A reef of granite boulders protects the beach, making it easy for us to land. Dag brings his hatchet from the kayak to chop wood, and soon has a cheerful, warming fire going. Willie drinks a litre of water to rehydrate and nibbles at some gorp. We sit quietly, taking in the peace of this place. The bough of a huge Sitka spruce dips down close by, and sunlight shafts through its needles, dappling the stones around

NEXT PAGE : *Solander Island, from the end of the Brooks Peninsula*

my feet. Close to where I sit is the stump of a tree, home to soft green mosses and a garden of false lilies of the valley. Dune grasses rustle in the breeze. Heaps of eel-grass and kelp, as big as hay bales, are dotted about, and between them flowering Queen Anne's lace and clumps of sandwort appear to grow straight from the sand. Behind the beach is old-growth forest, tall spruce and hemlock trees with canopies at least a hundred feet high. At ground level is a dense undergrowth of salal, pene-trable only by the low "bear tunnels" that run through it.

Three years ago we camped for several days on this lonely beach. We didn't see another human being the whole time, but bears kept us company—the sand was rid-dled with their paw prints, and I would wake each morning to hear them foraging in the salal bushes. I smile as I remember Dag lying naked on a log one afternoon, read-ing *We, the Navigators*. Suddenly he looked up and announced that he had just decided we should do a kayak circumnavigation of Vancouver Island.

"You'll be on your own," I told him, and I really meant it. But the idea lodged in my brain, and before I knew it I was taking him up on the suggestion.

"What do you think, Willie?" says Dag, after an hour.

"Let's go," Willie replies.

From here we've got another three miles along this outward-facing side of the Brooks. The wind helps to push us south, and occasionally our kayaks are accelerated as a swell approaches from behind and steepens over a shallow spot. In other cir-cumstances, this free ride might be exhilarating, but now I cringe, hoping the wave won't break. We give Clerke Point a wide berth to avoid its extensive reef, and I'm relieved when we finally begin a long sweep to the left, into the protection of Checleset Bay.

At last the sun appears, but soon we find ourselves heading straight into a fresh breeze. It's hard work; I feel like I'm pulling my paddle through honey. By our side, Willie is paddling valiantly, but his head is hanging down. This must be hell for him. Four miles farther on, he insists he wants to land on a long beach where surf is break-ing. I'm worried about capsizing, and Dag is concerned about the possibility of the swell building up, trapping us there for days. We persuade Willie to carry on to the base of Jackobson Point, where we find a small, protected cove.

After we've made camp, we wander among the black basalt boulders that shield the southern side of our new home. Waves surge up through channels to fill a series of tidal pools sculpted into the smooth rock. Each pool is like a perfectly con-structed Zen water garden. Pushing aside the surf grass and the lime-green mem-branes of sea lettuce, we peer into a magical world lined with pink coraline algae,

clusters of red-tipped anemones and maroon sea urchins. Tiny sculpins dart back and forth, then settle onto the sand, merging into the background. Equally well-camouflaged is the chiton Dag points out: several inches long, it is barely discernible from the black rock that it clings to resolutely. I run my finger over this strange creature. It reminds me of a tiny armadillo, but apart from the series of bony protrusions along its back, it feels slick and rubbery.

After lunch, we lie naked on the fine yellow sand, relishing the feel of warm sun on our skins. We've just paddled seventeen miles around the Brooks Peninsula, and this is a fine reward.

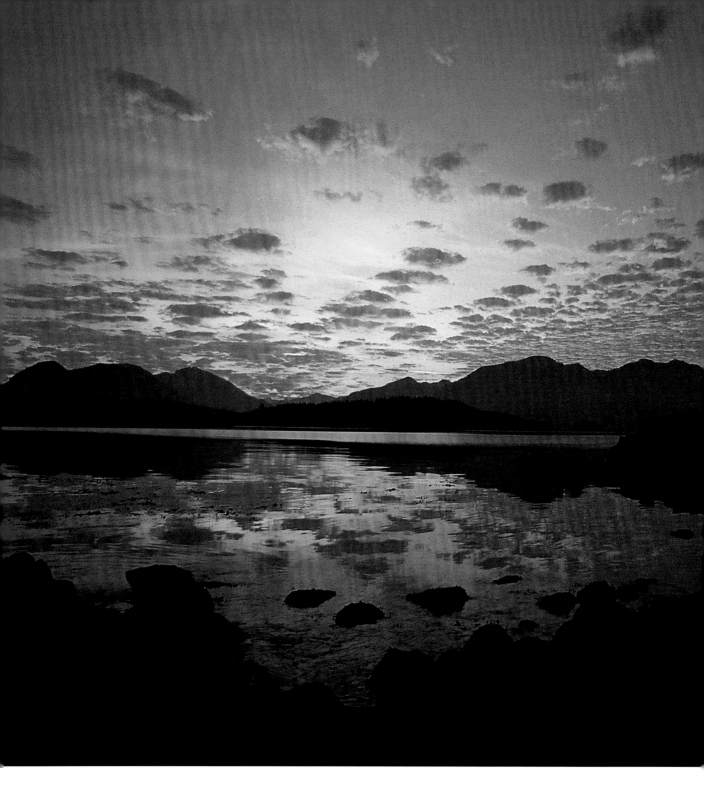

ABOVE : *The Bunsby Islands*
OPPOSITE : *Islet on the outer edge of Kyuquot Sound*

Friday August 06

DAY *36* JACKOBSON POINT

A high-pitched, tinkling bird cry comes from the driftwood, just several feet from where I lie in the tent. I rub my eyes and peer through the screen at a winter wren skipping and fluttering from one log to another. Long blue shadows on the sand gradually retreat as the sun rises behind the spruce trees at the edge of the beach. There's not a breath of wind, and the promise of a hot day hangs in the air. I yawn and stretch, luxuriating in the knowledge that we've overcome another major obstacle of the journey, and that we're going nowhere else today. For now, I'm free of the stress of having to make calculations and decisions that, if ill-informed, could lead to the abrupt end of our lives. When I step out of the tent, the world around me is vibrant and crystal clear: the rush of the waves carries the scent of wet, salty sand, and the sky, sea and forest are saturated with colour. I feel giddy with delight, and for a moment I register that this is it—happiness—and that I can never hope for anything more.

We spend all afternoon at a nearby beach, practising surfing skills with Willie, who is an excellent coach. Later, Dag goes off in the kayak by himself, to fish. From the beach I watch him in silhouette, black against a golden sky, throwing out his line. He returns with a lingcod and two rockfish, one of them with anchovies still in its mouth. We grill the fish over a fire and eat them with rice. Then we lie back and watch the stars appear and start their nightly revolution. It's a tropical sky—huge and bright, with the Milky Way running across it like a river. Stars twinkle in shades of red, yellow and green, and from time to time one burns out, streaking across the heavens with a long flaming tail. Waves pound unceasingly on the beach. The noise echoes off the rocks around us, and the vibrations of the biggest waves run up the sand and into our bodies, as if telling us not to stay away too long.

Saturday August 07

DAY *37* JACKOBSON POINT TO SPRING ISLAND

"Bear tracks," says Dag, when he steps out of the tent.

"Where?"

"About two feet from where we were sleeping. He came out of the forest and trooped right past us."

Despite the bear, Willie wants to linger here a while. We're tempted to stay, too, but we're barely a third of the way down the west coast, and the knowledge of what we still have to do pulls us on. Willie admits he'll be sad when we leave.

"These solo trips are very lonely. And it's not often I meet people I relate to. Other kayakers are usually standoffish. I'll have a hard couple of days after you've gone."

He stands on the beach as we paddle away, waving one arm above his head in farewell.

We set off across Checleset Bay, an ecological reserve established in 1981 to protect sea otters and their habitat. It stretches from Clerke Point on the Brooks Peninsula almost as far as Kyuquot, and encompasses the Bunsby Islands, where we hope to spend the night. A southeasterly breeze comes up as we draw adjacent to the Acous Peninsula. A ring of reef and islets shelters its beaches and the site of an important village of the Kyuquot Nation. Three years ago when we stopped there, we came across mossy mounds that were the foundations of a long gone Big House, and the remains of totem poles lying on the forest floor. One lone totem was still standing, but barely.

"I bet it's fallen now," says Dag. "The salal will be starting to cover it up. I'm glad we saw it when we did."

Even in this overcast weather, the Bunsby Islands have an almost tropical feel. Arms of granite protect snug, white shell beaches, and above these are groves of trees and tiny meadows of wildflowers. It's a popular spot with kayakers, and the few suitable camping sites have all been claimed. We decide to take a break anyway, and paddle up to one of the beaches. From behind the rocks a young black Labrador appears. She splashs through the shallow water, puts her paws on my spray skirt and licks my face, apparently overjoyed to see me. As we ease the boat onto the beach, she bounces around us, barking joyfully. But when I open the front cockpit and pull out a food bag, her charm fades. Aggressively she snaps at my hands, trying to snatch away the bread and cheese. Making a sandwich is impossible with her around; we stow the food bag and settle for some gorp, throwing her a few nuts and seeds that she gobbles voraciously. When we get back into our kayak, the dog's ears go down. She whines pitifully, then jumps into the water and swims after us. Thankfully, another kayak appears, heading toward a different island.

"Over there!" calls Dag, pointing to the kayak, and the dog dutifully changes tack and swims after it.

We decide to head for Spring Island in the Mission Group, eight miles across an open stretch of water. Our route takes us past Mount Paxton, which achieved world fame for its devastating clear-cuts, described in *National Geographic* as the worst in the world. The lonely, naked slopes stand stripped of their ancient forest, all the way from the bluffs lining the coast up to where they disappear into the clouds. Just as John and Maggie in Port Harvey told us, it's greener now than when we first saw it three years ago. From a distance it's hard to tell if this is from weeds and scrub alder, or if the slopes have been replanted. One thing is certain: virgin rain forest will never grow here again.

As we leave the shelter of the Brooks Peninsula, we feel swells from the northwest adding their rhythm to the low swell from the southwest. Behind us, low cloud and fog has descended over the Brooks, so poor Willie must be getting wet. He told me he usually foregoes the comfort of a fire, because he feels that beaches should be disturbed as little as possible. I imagine him in his tiny tent, the rain drumming down on it.

Our progress is slow against the rising wind, and it's almost 7:00 p.m. by the time we reach Spring Island. Several kayaks resting on logs above the high tide line mark the summer camp of West Coast Expeditions, an educational nature tour company. In a mossy clearing amid a stand of cedars, we find a large shelter built of driftwood and plastic sheeting, which houses a well-organized kitchen, tables, benches and a big wood stove. Several people are sitting around the firepit outside, and when we appear

one of them steps forward to greet us. Rupert Wong and I know each other from various kayak guides meets we've both attended, and he expected to see us on our way around the island.

"Why don't you stay overnight?" he offers. "We're in between groups, so there's plenty of space for camping. You should have dinner with us: tonight it's sushi and barbecued salmon."

Eagerly, we accept his hospitality. As we set off to unpack the kayak we hear him call out, "And there's a hot freshwater shower down on the beach. Help yourselves."

Did Rupert really say that, or was I dreaming? Hastily, we set up camp and then hurry back to the beach with towels and shampoo. The shower is an ingenious system of water tanks and a propane heater set in the convoluted root system of an enormous fallen tree, the base of which reaches far above our heads. We light the heater as instructed and seconds later hot water is pouring over us, washing away the strain of today's fourteen-mile paddle. Steam rises from our bodies as we dry off, and I shake my head, relishing the feel of soft, clean hair.

The rest of the evening passes pleasantly with good food and conversation, until a barred owl somewhere in the forest behind us signals our bedtime by calling repeatedly: "Who cooks for you...who cooks for you...all?"

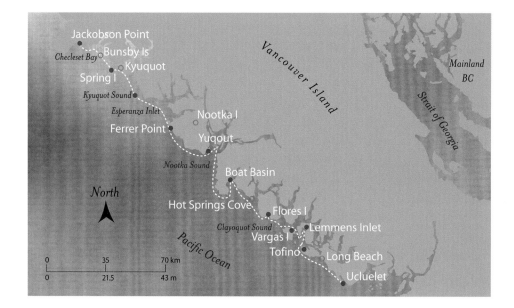

OPPOSITE : *Totem pole on the Acous Peninsula*

Sunday August 08

DAY *38* SPRING ISLAND TO KYUQUOT SOUND

An hour after leaving Spring Island, we glide into a narrow channel between the settlements of Walters Cove and Houpsitas, which together are known as Kyuquot. Neither settlement is accessible by land: this channel, and those separating the other islands that dot the entrance to Kyuquot Sound, are used like roadways, plied by small boats and the occasional float plane.

Houpsitas is the principal settlement of the Checleset and Kyuquot First Nations, part of the Nuu-chah-nulth peoples whose territory stretches from the south side of the Brooks Peninsula, almost to the southern tip of Vancouver Island. On the small island across from it, Walters Cove was established by Scandinavian pioneers who first arrived in 1907 to set up a whaling station close by. Thirty people live here now, and are served by a store, a school, a gas station and Miss Charlie's—a restaurant named after a local tame seal. The wooden houses along its boardwalk are painted in forest hues of green and brown, and their gardens are filled with blowsy poppies, bright nasturtiums, long stalks of montbretia and tall hollyhocks. Baskets of geraniums hang around the doorway to Miss Charlie's, and a vase of fresh flowers stands on every table. A sign on the walls asks, "IF IT'S TOURIST SEASON, WHY CAN'T WE SHOOT THEM?" George, the manager of the restaurant, is grumpy because he's got no help today.

"There's a big birthday party going on at Rugged Point," he tells us, "so I gave my girls the day off. I wasn't interested in it. I don't like crowds."

Because of the staff shortage, there are only hamburgers and homemade fruit pies on the menu. I order the biggest hamburger, along with cheese, bacon, mushrooms and fries. Then I have a huge slice of apple pie, with liberal heapings of whipped cream and ice cream. A couple of American sport fishermen are at the next table, and they watch in open awe as I wolf down all the food.

"I've never seen someone so thin eat so much," comments the man nearest to me.

We've both lost weight. Dag's wetsuit, which fitted him snugly at the start of the trip, now hangs in loose folds around his belly. But our muscles are hardening by the day, and the blisters on our hands have long since turned to thick, protective calluses.

The fishermen are intensely curious about our trip.

"Aren't you worried about bears?" asks one. "Do you have a Defender along?"

"A Defender?" I ask.

"Yeah, a pump-action shotgun. We wouldn't camp without one. If a bear comes anywhere near our camp, I shoot him."

"I once got a bear with a spud gun," says his friend. "Hit him right between the eyes. Did he ever look surprised!"

After lunch we stock up on food supplies at the store, and make calls home from the public phone booth on the gas dock, where someone has kindly placed a log stump so people can sit down while they talk. Three Native boys are fishing close by.

"Have you caught anything?" I ask.

"No," says one. "They're all still sleeping."

Lounging on the dock in the sun, we discuss what to do. We had considered heading to Rugged Point, but the thought of the huge party going on there has dampened our enthusiasm for this plan. Instead, we decide to try to find a place to camp on one of the sound's off-lying islets. The afternoon is warm and calm, and we're anticipating a protected paddle, so for once I decide it's not worth wearing my wetsuit.

As far as the eye can see, a maze of reefs and rocks stretches from the Mission Group down into Kyuquot Sound, with no obvious passage through them. Paddling out from behind Walters Island, I marvel at how, in the early days, people were able to navigate their way into Kyuquot in big vessels.

To get a better look at some of the outer islets, we skirt the rim of the sound as we head south. Between two reefs, we cut through a patch of seafoam drifting over from where the seas are regularly breaking. Suddenly I hear a sharp hissing sound followed by a loud crash, as a wave unexpectedly rears up and breaks close by, sending spray high into the air.

"Now I know why they're called boomers," I quip to Maria. She doesn't seem amused.

Eventually I spot what looks like a landable beach, on the eastern side of an islet surrounded by a riddle of reefs. I decide that the best way through them is to cut around to the western side of the islet—the side exposed to the open ocean. But once we get there, the sea is rougher than I expected. Waves are barrelling in from different directions and deflecting off the reef. We cross a distinct line in the water, beyond which the surface of these confused seas is further agitated by current. Our kayak slops and bounces around so much that sometimes our paddles scoop only air, throwing us off balance. We're whisked forward by the current, straight into an area where the waves are bucking like panicked, untamed beasts, corralled too tightly within the surrounding rocks. All around us the ocean is exploding, and my rib cage resonates with the detonations of water hitting rocks. For a few seconds I'm freaked, then abruptly my mind

shifts into another mode. I focus in on our immediate surroundings, and the cacophony around me becomes like a distant murmur as my eyes search for a way through this mess.

"Where are we going?" I yell. The water ahead is total chaos, I can't see where Dag is steering us, and I'm uncomfortably aware of not wearing my wetsuit. What if we tip in this stuff?

"Don't worry," he calls. "There's a way through. Just keep your hips loose."

"Well, great!" I say crossly. "Thanks for asking me if—"

My words are cut short as, on the peak of the next wave, our kayak swivels sharply to the left and faces a gap between two rocks. Water is sucked out from under us, and a deep gully appears. From out of the corner of my eye I glimpse the dark shape of the next wave rising behind us, and then our bow begins to drop into the gully. We surge forward and shoot through the gap with whitewater flying and smashing all around us.

"Holy shit!" crows Dag as we find ourselves on the other side of the reefs, and in the safety of placid water. The noise of breaking seas recedes behind us, and ahead wavelets wash gently onto a beautiful little beach.

A dense bed of kelp lies between us and the shore, and we push through it, digging our paddles into the thick growth. Halfway across there's a splashing sound several feet from our bow. Three sea otters, one clutching a baby on her stomach, stare at me from their bed of kelp. They are so close that I can make out every detail of their big button noses, their heavy whiskers and their little ears. For two or three seconds we lock eyes, before they dive and are gone.

We lie our gear on boulders imprinted with ancient fossils of shells and leaves. Red fireweed blossoms atop a small bluff at the head of the beach, and yellow gumweed flourishes between cracks in the rock. Red-legged oystercatchers fuss about nearby, piping warnings to us to keep away from their young. As darkness closes in, we are lulled to sleep by the fluting sounds of storm petrels, nesting in burrows that honeycomb this sandy island.

Monday August 09

DAY *39* KYUQUOT SOUND TO FERRER POINT

Dag fills last night's firepit with sand, throws dried seaweed on top and pitches the pieces of charred wood into the ocean. By the time we leave the beach, the only signs of our passing are footprints. Low tide has exposed a labyrinth of rocks around the island. As we thread between them, a puffin whirrs past us, holding a fish in its beak.

OPPOSITE : *Bear tracks by our tent on Jackobson Point*

Four and a half hours of paddling, with a light breeze on our backs, brings us to the mouth of Esperanza Inlet. The high slopes of Nootka Island lie ahead, and stretching out to sea is a translucent sliver of land that marks Ferrer Point. We stop for a break on Twin Island, where a family with a Zodiac is camped. The couple's two teenaged children sit in sullen silence by a smoking fire, but the parents are friendly enough, and invite us to join them. There is a section of the west side of Nootka Island that is not covered by my marine charts, so I ask if they know of any good beaches to land along that stretch. They give me vague directions to a beach where they recently went bodysurfing, while Maria shoots me a glance that says, "Forget it, buddy!"

The family tell us they are leaving today, so camping here is an option, but we decide to push on. Tomorrow Liz and Mark are arriving in Friendly Cove: we'd like to meet them there, but it's more than twenty miles away and we need to make allowances for the weather. As we paddle across the long open stretch to Ferrer Point, I keep myself occupied with various mind games. At first I imagine worst-case scenarios that might arise on the trip, and what we would need to do to survive them. Then I try to determine exactly where we are by dead reckoning: taking into consideration our compass course, speed, time and drift due to the current and wind. Another more accurate way of finding my position is to use ranges: distinctive features in the landscape that from our vantage point are lined up, like an islet and a mountain peak. Helped by these ranges, I can establish where I am on the chart with a precision that can rival that of a GPS receiver. This method also keeps me more attuned to my surroundings and subtle changes in them—and it's much more interesting than staring down at a little LCD screen strapped onto your deck.

On reaching Ferrer Point we have two choices: to duck into Nuchatlitz Inlet where we'll definitely find a protected campsite, or risk carrying on along this stretch of Nootka Island for which we don't have a chart, and hope to find a landable beach. Studying the contours in the landscape beyond Ferrer Point, I can see there is a ridge and then a dip before the mountains farther down the coast, and there's a good chance this will translate to a headland protecting a beach. It's a bit of a gamble, especially with the forecast of stronger winds building, but Maria agrees to go for it. We weave our way through thirty or so sport fishing boats mulling around off Ferrer Point, and then we're committed.

It's strange to be creeping along an inhospitable stretch of this coastline, late in the afternoon, without a chart or a clear idea of what lies ahead. I'm relieved when at last

we spy a generous span of yellow sand, washed by a gentle surf, with a forested slope rising steeply above it.

"This looks like a place straight out of French Polynesia!" Dag enthuses, as we go ashore.

Between the beach and the forest are small sand dunes covered with swaths of ox-eye daisies and fringes of tansy and silver burweed. They also harbour the remains of abandoned camps: a tattered tarpaulin pulled over a frame of bent branches, a tumble-down hut, charred logs left in firepits, a ripped up sleeping bag—sorry eye-sores in a place of such natural beauty.

At the far end of the bay, a stream carves through the sand, pooling to form a lagoon of slightly brackish water that's deep enough to bathe in. Beyond it we enter the cool shade of the old-growth forest. Illuminated by late afternoon sunlight filtering through the canopy high above, the medley of green mosses, ferns and leaves stands out vividly against the velvet grey ribbons of bark on the giant cedar trees. White lichen colonizing the Sitka spruce gleams from the shadows. Giant evergreen salal forms a solid undergrowth, interrupted only by the hulking, moss-covered remains of ancient fallen trees upon which new trees, already centuries old themselves, are growing. We follow a rough, narrow path—part of the hiking trail that runs along the outside of Nootka Island. It takes us under low branches, over enormous root systems, across canyons on slippery logs and up and down steep, muddy bluffs. Dag stops often to graze on bushes of huckleberries, eating them straight from the branch with his mouth in true bear-style.

"This is what the West Coast Trail used to be like," he says happily, "before they civilized it."

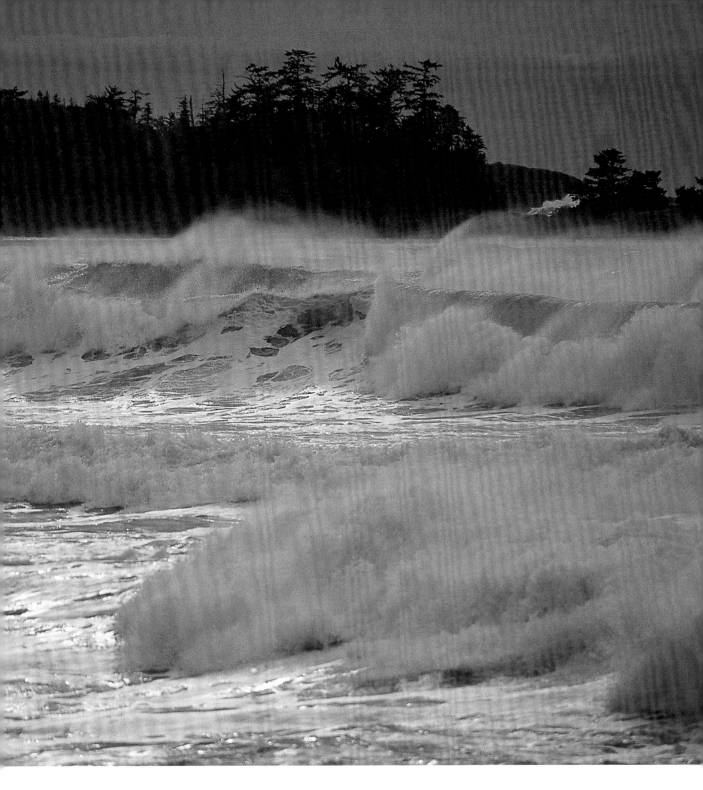

ABOVE : *Daunting waves for a fully laden double kayak*
OPPOSITE : *Dag checks the weather*

Tuesday August 10

DAY *40* FERRER POINT TO NOOTKA SOUND

Our headlamps throw two small pools of light on the beach as we dismantle the tent. I'm glad that we never had to break camp before dawn earlier on in the trip when we were less organized. There are certain things that we simply can't afford to leave behind—the axe that Dag uses to make kindling for our fires, matches, the radio, the medical kit—but by now we have a second sense about where everything is, at all times, and our routines are automatic and efficient.

The next hurdle is Bajo Reef, a range of rocky shallows extending three miles off-shore. Over large areas of it the ocean is less than twenty feet deep, creating hazardous conditions if there is a swell running. Our plan is straightforward: we will aim for a safe, deep passage, almost a mile wide, between the inner and outer reef. The charts show another deep channel between the inner reefs and the shoals along the shoreline, but this is narrow and winding and would be nearly impossible to navigate in rough conditions, with breaking swells and wind waves.

By the time we leave camp, the pink tinge above the mountains of Nootka Island is dissolving to light blue. The sky of the open coast is so big and dramatic, it can often be intimidating. This morning, the northwest is dominated by an enormous cloud, infused with ugly yellow striations. It reminds me of the kind of sky that in the Strait of Georgia heralds a notorious westerly gale called a qualicum. I don't trust the weather forecast that says the northwest wind will only rise later in the day, and I keep looking nervously over my shoulder, expecting the wind to whip up the waters at any moment.

This corner of the coastline isn't depicted on my charts, so I'm relying on dead reckoning. When we reach a beach that I take to be Skuna Bay, we head offshore on a southerly course. The relaxed swells quickly become more agitated, hitting us broadside. Within half an hour, some of the waves are over eight feet high. As each one passes we are lifted up to where we can feel the breeze, then slide down into the calm windless troughs. I don't really like this: it feels unnatural to be leaving land behind and paddling steadily into the open ocean and worsening conditions.

The backs of the waves become increasingly roughened by small, sharply pointed ripples. It could be current—after all, this is a spring tide—and if so, it will only exacerbate what is already a dicey situation. Suddenly, I notice that some of the swells ahead and to my right are beginning to break. Alarm bells go off: has a current pushed us onto the northern edge of the reef?

"Everything okay, Dag?" I ask over my shoulder.

"Yeah." He doesn't sound convinced. After a slight pause, he adds, "Except for the waves breaking over there."

I look to see what he's talking about, and my throat tightens: ranks of huge dark waves are rolling purposefully toward land, the odd crest curling and spilling forward.

"What are we going to do?"

"I don't know. It's probably not a good idea to change plans now. I know this sounds unlikely, but I figure it'll be calmer a mile farther out."

Silently, I gaze at the menacing waves.

"We'll be okay," he says. "Just be ready to brace."

The swells get bigger than ever. A wall of water towers above us to the right, lifts us like an elevator and then drops us with stomach-lurching speed into the trough behind it. The sky is darkened by the next approaching monster, and as it scoops us in its maw I register a translucent green crest curling into whitewater and rushing madly in our direction. I freeze for a moment, gripped by the conviction that we're about to capsize. Then adrenalin jolts my brain into action. I tuck in my head and

brace, stabbing my paddle blade into the teeth of the beast and leaning hard to the right while water thunders down onto my shoulders and back. For a few seconds, my entire world and consciousness narrow to the effort of staying upright amidst this seething, roaring, intensely frenetic element. When I pop out safely, I'm gasping with an exhilaration that has washed away my fear.

We paddle on in perfect synchronization—no longer cringing, but open and receptive, adapting instantaneously to every change in our surroundings, so that our movement through these waves becomes half dance and half rough-and-tumble sport. When the waves turn into innocuous rounded mounds that hurry silently past us, I'm filled with relief, yet at the same time feel twinges of disappointment. I'm reluctant to let go of that addictive moment when fear, joy and an intensity of focus fuse into a powerful emotion that we rarely experience in ordinary life.

Farther out to sea we can see white explosions of water against the sky, and hear the mournful call of a whistle buoy. When my compass bearing on Maquinna Point reads 95°, we change course and head for the south end of Nootka Island. We've done it! We've reached the safe passage between the two reefs that I plotted on the chart yesterday evening. I feel a glow of satisfaction that our perseverance has paid off, and that Maria's trust in my navigation wasn't displaced.

Beyond the reefs, the sea is peaceful. In the distance, the long low profile of the Hesquiat Peninsula stretches far southwestward to Estevan Point.

"There's our next big crux," I tell Maria, and she laughs.

"This coast never lets you relax, does it?" she says.

After all that excitement, the approach to Maquinna Point seems pedestrian by comparison. Along the shore of Nootka Island, we spot whale spouts silhouetted against trees, and a fog caused by water breaking endlessly on rock. I keep thinking that this is how Captain Cook must have seen the island, when he first spied it through a telescope in March 1778. Finally we round the point, and enter the channel named after Cook. A few more miles and we're approaching a small white church overlooking a long grey beach, and a lighthouse atop a headland. Behind the headland lie Friendly Cove and the village of Yuquot.

This area brims with history and ancient Native mythology. Close by, the tears of a lonely, weeping woman gave birth to Snot Boy, and her union with him produced the first ancestors of the Mowachaht people. A little farther up the channel is Bligh Island, where in 1778 Captain Cook became the first European to go ashore

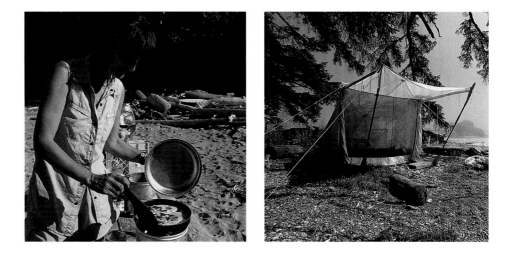

on the BC coast. As a result of the journals Cook published about his travels here, the widespread trade in sea otter pelts began. In the 1790s, Yuquot was the site of an international incident between England and Spain, who both wanted control of the northwest coast. And in 1803, John Jewitt and John Thompson escaped the massacre aboard the American ship *Boston*, only to be taken as slaves by Chief Maquinna. Jewitt's book about the three years he spent here—*Narrative of the Adventures and Sufferings of John R. Jewitt*—is a rich historical document, filled with valuable details of the local culture and way of life.

Given the richness of its past, I'm surprised to find Yuquot such an unprepossessing place. A few fishing boats are tied up to the dock, and some simple cabins stand at the far end of the beach. Even the tiny Church of Pope Pius V, built in 1956, looks forlorn. With only one family now living in the village, it's no longer used for services. All the pews have been removed, where the altar once stood there are now replicas of two sets of house posts from the original village site, and in the porch are stained glass windows depicting Captain George Vancouver of England and Juan Francisco de la Bodega y Quadra of Spain meeting in 1792 to resolve their countries' differences.

"No interpretive centre—how refreshing!" exclaims Dag.

We've been paddling for six and a half hours, so after a quick look around, we stretch out on the sand, resting our heads against a log. I tip my hat over my eyes to shade out the sun, and slip into daydreams about Captain Cook's arrival. I'm envious of the thrill and anticipation he must have felt as he sailed into these uncharted

ABOVE LEFT : *Our camp kitchen...* Mark Kaarremaa photo
ABOVE RIGHT : *...and our light, airy shelter*

waters, seeing local canoes being paddled out to meet him, not knowing what would happen next. People in the canoes pointed to the rocks off the bluff, and called out words that apparently sounded like "Nootka." They were giving him directions into the safe harbour that was later named as Friendly Cove, but Cook failed to realize this and carried on to Bligh Island, where he anchored off Resolution Cove. That night, several canoes clustered near Cook's two ships, and the occupants sang songs to the sailors on board. Cook wrote in his journals: "This mark of their attention we were unwilling to pass over unnoticed, and therefore gave them in return a few tunes on two French horns after their song was ended, and to these they were very attentive."

No one has ever recorded what the Mowachaht thought of this music, but it is known that they called the strange newcomers "mamalthi," meaning "people who live in a boat." Mamalthi had visited this area once before. On August 8, 1774, Juan Perez of Spain sailed close to the Hesquiat Peninsula in his ship *Santiago*. Some Hesquiat people came out in canoes to greet the strange craft, but a wind blew up and the vessel had to move offshore for its own safety.

Just after one o'clock, I open my eyes to see a familiar mint-green double kayak heading into the cove. It's three weeks since Liz and Mark waved goodbye to us at Telegraph Cove. Since then we've steered our kayak 160 nautical miles, right around the northern tip of Vancouver Island and over a third of the way down its west coast. "How does it feel?" asks Liz.

I shrug. It feels normal: this way of life has become so familiar, I can't remember what it's like to not have to get up and paddle every day.

This morning, Liz and Mark put in at Cougar Creek and came down the sound past the Spanish Pilot Islands.

"I'd like to go back and check them out," Liz suggests.

"Sure, we've got an inflow wind," I say. "Let's take advantage of it."

As we head up the inlet, I raise our kite, which pulls us along nicely. Liz knots the sleeves of her jacket and holds it aloft on her paddle, but she and Mark don't stand a chance, and we easily pull ahead of them. The islands offer only shallow, pebbly beaches, and the few available campsites have been taken by sport fishermen. Eventually we find a spot on Vernaci Island. It's a damp, buggy place, but the forest behind it is lovely. Liz finds some culturally modified trees—tall first-growth cedars stripped of long pieces of bark by Mowachaht people, who used the inner bark for weaving. Higher up the slope, she points to a western hemlock with a starburst forma-

tion of branches caused by western dwarf mistletoe, a parasite that lives on tree branches and makes them grow in unusual ways.

By six o'clock Mark is pouring us large shots of whiskey that go straight to our heads. Then comes red wine and a meal of pasta, pesto, salami and Parmesan cheese. We chat by the fire until tiredness and clouds of mosquitoes descend at the same time, and send us all to bed.

Wednesday August 11

DAY *41* NOOKTA SOUND

At 6:30 a.m. we find Mark on the beach in thick fog, brewing coffee.

"There was sunshine half an hour ago," he reports cheerfully.

Dag and I are anxious to leave. Our "inlet phobia" has surfaced—kayaking and camping in places like this, away from the open coast, always dampens our spirits.

"There's a big beach on the far side of Friendly Cove," says Dag. "When the fog lifts, let's check it out."

By the time we leave, an inflow wind has kicked in and it's drizzling. We slog around the lighthouse point, through short, choppy waves. The beach is a long sweep of gravel, with dumping surf. Dag and I hug the shore, just beyond the surf zone, checking for places where we can safely land and easily camp. Right at the end of the beach, where a wide river flows out, we spy the perfect spot, on top of a gravel bank, protected from westerly winds.

While we're drinking tea, a hiker comes along the beach carrying a backpack and shopping bags, and we invite him to join us. His name is David Pettigrew, and he's spent a lot of time in this area, researching for an interactive CD-ROM he's planning to make. Until the 1950s, he tells us, Yuquot was a thriving village, with the cannery in nearby Boca del Infierno Bay providing lots of employment. After the cannery closed, the village was relocated to the mouth of the Gold River. A pulp and paper mill was built next to the reserve and over a number of years a high rate of cancer and birth defects developed among the inhabitants.

"So the village was moved again, farther away from the mill," says David. "There was no media fuss. No lawsuits. No one has ever publicly linked the mill to the incidence of cancer."

In late afternoon, I sit in the mud room of our tent, writing notes, drinking wine, gazing out at the sea and the drizzle and feeling very content. Around six, Liz and Mark call me for dinner. Under the kitchen tarp, they're serving a chicken coconut curry, rice and dhal. David joins us, bringing a vegetarian dish of beets,

spinach and sugar peas. By the time we're on dessert, the rain is hammering on the tarp, and we are collecting water in pans, the coffee pot and the wok.

"We need a rest," jokes Dag, when we retreat to our tent. "We paddled all of five miles today!"

Thursday August 12

DAY *42* NOOKTA SOUND TO BOAT BASIN

Lying in bed, looking through our net doorway at a steady drizzle, we listen to the forecast: 10–15-knot southwest winds, rising to 15–20 knots by the afternoon. Outlook: a deepening low.

As usual, Mark is up first. He's brewed a pot of coffee, the eggs are boiled and he's frying up a panful of bacon. He tells us that he and Liz have decided to leave this morning, a day earlier than they had planned. They have lots of pressing work commitments back in Nanaimo, and would rather get back to them than hang about here in lousy weather.

We decide to leave too, and by 2:00 p.m. we're on our way across Nootka Sound. It's an easy five-mile paddle to Escalante Point. From here, we head down the peninsula as far as Split Cape. Behind it, in Barcester Bay, is a beach where there is bound to be surf.

"It's open to northwest swells, so it might be a bit of a crash landing," I warn Maria, knowing this is one thing she wants to avoid at all costs.

Predictably, she suggests going for Estevan Point, and getting round it this evening. It's not a bad idea. There's still no wind, and barely a ripple on the water. If anything blows up, I've heard there's a bolt hole in Homan's Cove, which is tucked in behind a series of reefs, two miles before Estevan Point.

I almost agreed to the crash landing, simply because I'm desperate to relieve my bladder. But in these conditions, in a stable, heavily laden kayak, it's possible to pee over the side of the boat. The main hindrance is all the awkward clothing I'm wearing. While I'm wriggling around in the cockpit, trying to strip off my wetsuit, Dag notices a couple of whale spouts, silhouetted against the trees in Barcester Bay. Just as I'm easing myself up onto the side of the kayak, a mother whale and her baby decide to surface right next to us. I'm so surprised I let go of the combing, and almost fall backward into the water.

"Darn!" cries Dag, who is leaning hard over on the other side to stabilize the kayak. "Hurry up, Maria, I want to get a picture of these guys."

By the time I've dressed myself again, more spouts have appeared. "There's one!"

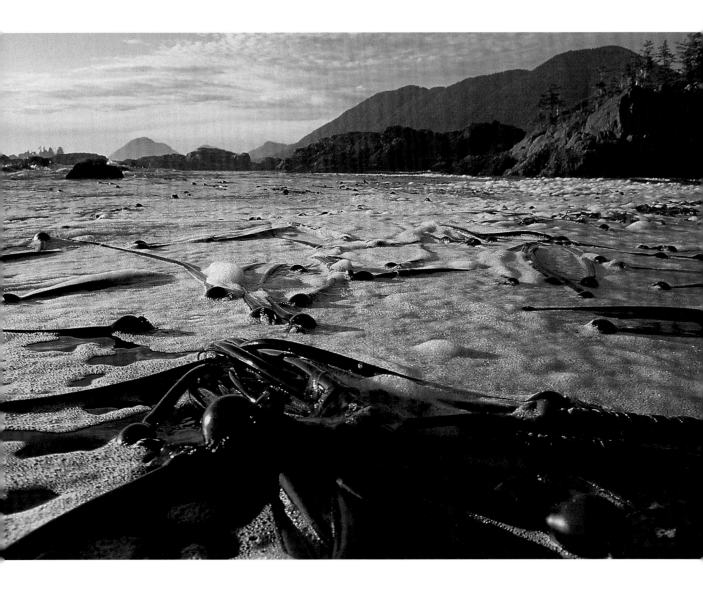

ABOVE : *Seafoam and bull kelp, Brooks Bay*
OPPOSITE : *Kelp, aptly named 'feather boa'*

"Another to your left."

"One right ahead!"

Enormous black backs arch out of the glassy water. All around us, shoals of little fish keep leaping from the surface, as if being chased.

"These must be humpback whales," muses Dag. "They often feed on fish. They swim around underneath a shoal, exhaling to form a net of bubbles. Then they swoop upward with their mouths open."

Instantly, I imagine a whale swimming nose-first for the surface, directly beneath us.

"Okay, let's get going," I say briskly, as another shoal of tiny fish sprays from the surface close by.

The sky is low and flat, threatening rain, and the sea is eerily calm. When we reach the reefs close to Estevan Point, however, big, friendly swells form. I feel like we're on the back of a giant animal, rising up as it takes a breath, and coming down when it exhales. On the upward motions we see the rocket-shaped lighthouse tower at the end of the headland, and the spouts of the whales all around us.

"There's another one—that's nine!"

"Over there, ten!"

Down in the troughs of the swells, the spouts are hidden, but we can hear the whales, disconcertingly close, and the sound is like someone breathing in an iron lung.

By now we've spotted fourteen humpbacks and one orca. We paddle slowly, with frequent stops, taking in the bizarre experience of being off one of Vancouver Island's most notorious headlands in a kayak, surrounded by whales. The sky is turning shades of pink, but to the west, a dark, hostile band of cloud is forming.

"It's raining again in Friendly Cove," says Dag. "We'd better get going; we don't want to be stuck out here if some weather moves in. After three miles we'll be round Matlahaw Point and in the protection of Hesquiat Harbour. Then it's six miles into Boat Basin."

Nine more miles! We've already done seventeen and I'm feeling very weary, but I'm looking forward to getting to Boat Basin, where our friend Pete Buckland and his partner Margaret Horsfield are expecting us. I imagine an evening of warmth and good conversation, and these happy thoughts put new strength into my paddle strokes, so that the exposed shoreline and the blinking light slip quickly by.

Once around Matlahaw Point, the open coast is behind us, but it's a long, tiring stint to Boat Basin. By the time we approach the head of Hesquiat Harbour, darkness is falling fast. Apart from the tiny Hesquiat village, which we passed four miles back, Pete's place is the only settlement here, so we're hoping to spot the lights of

his house easily. Ten years ago, Dag came here by powerboat, and as we slip along the shore, he tries to remember shapes, textures and landmarks. Dusk deceives our eyes. There's a cabin—no, it's only one fallen tree resting against another. That looks like smoke—no, it's mist hanging in the trees.

"We could paddle all night and not find the place," I say. "Let's go ashore and camp before it's completely dark."

"That's too much work," says Dag. "And anyway, camping's not encouraged by the local First Nations people. We must be nearly there."

A few paddle strokes later, he says, "See that thing on the beach, Maria? Is it a bear or a boulder?"

In such shallow water, we're an easy target for a hungry bear. Fear shoots up my spine, and my mind begins shape-shifting.

"It is a bear! He's coming!" I hiss, paddling furiously.

"Hold on," says Dag. "It's a boulder after all."

The bear-boulder stays where it is while we slide away. At last some structures appear, a cabin on the beach and a house half hidden behind the trees, wrapped in near-darkness.

"Looks like no one's around," says Dag. "I'll bet the beach hut is open. Pete won't mind if we move in."

The one-room hut is built directly on a huge log on the beach, with pebbles as its flooring. Every winter, storms shift the log, so all the walls are on a slant. But it's cosy and well appointed: a pile of wood and kindling sits next to a firepit with a stove hood and chimney pipe; there are driftwood shelves, a line and hangers for clothing, and two sleeping platforms with foam mattresses on top. In candlelight, I cook pasta on our camp stove. We eat our meal in front of the fire, warming our toes over the flames. After eight hours in the kayak we're bone-weary, but immensely happy to have a sweet little shelter on this protected beach.

Friday August 13

DAY *43* BOAT BASIN

Considering today's date, and the weather report of a southwest wind off Estevan Point, I'm relieved not to be out on the water. This protected bay seems a very feminine place, nurturing and giving, unlike the open coast, which is filled with wild, restless energy. As we step onto the boardwalk leading into the forest, I tell Dag I feel very safe here.

"Oh yeah?" he says teasingly, pointing to a very large, fresh, purple bear scat.

"Now we know who's eaten all the salal berries."

By mid-morning, heavy rain sets in, and we spend the rest of the day in the cabin, by the fire. We hang our clothes and sleeping bag to dry and air. We catch up on notes, we relax and talk. I'm glad of this chance to let the events of the past days settle in. So much of the trip has been about movement—making camp, breaking camp, paddling, planning our next move—there's been little time left for reflection. Even in the kayak, we have to be constantly alert on the open coast, and can rarely afford to let ourselves slip into reveries.

From time to time, I glance out of the window, hoping to see Pete's boat coming into the harbour.

"In these conditions, I doubt they'll come around the outside from Tofino," says Dag eventually. "They'll take the water taxi to Stewardson Inlet and then drive along the logging road."

By six, we've given up on anyone arriving today. But as we start preparing dinner, we hear voices. I run up to the house and push open the door. Pete, Margaret and little Emma, Margaret's daughter, are in the kitchen, unpacking a cooler. They freeze, wide-eyed with surprise, then grins break across their faces.

"Maria! You're here already!"

The welcome I'd hoped for yesterday comes now, with delighted laughter, hugs, and a beer pushed into my hand. Pete calls Dag over, the pot-bellied stove is stoked up with wood, oil lamps are lit, a bottle of good wine is uncorked and we settle around the table to catch up on news.

Saturday August 14

DAY *44* BOAT BASIN

Over a late and leisurely breakfast of porridge, fruit, yogourt and coffee, Pete talks about the woman whose memory now dominates his life. In 1969, he was checking out some mining claims in this area when he met and befriended Cougar Annie, who by then had homesteaded here for fifty-four years. During that time she survived four husbands, at least one of whom it was rumoured she murdered, raised eleven children, become a famed cougar trapper, established a nursery garden, built up a dahlia mail-order business and ran a post office, of which she was the principle customer. Her great passion was her garden; she had beaten back five acres of bush and in its place created an astonishing palette of colourful flowers. Filled with azaleas, rhododendrons, dahlias, heather, irises, lilies, begonias, peonies, shasta daisies, hostas and countless decorative shrubs and trees, this was a garden that, despite the

wild and inclement weather, bloomed year round.

"I was captivated by Boat Basin from the start," says Pete, "and by Cougar Annie."

They became firm friends, and he returned often to visit, helping Annie in the garden and packing groceries and supplies for her. When she was ninety-three and almost blind, she proposed that Pete should buy her property, on the understanding that she could remain here for the rest of her life, in his care. An agreement was reached. Pete signed for the land, employed a couple to move in and look after Cougar Annie, and returned every month to see her. Over the next two years her health failed, and in 1983 she left Boat Basin for good. She died a few weeks before her ninety-seventh birthday.

"Her family wanted her ashes scattered from an airplane flying low over Boat Basin," says Pete. "So I was sitting in the garden one time drinking some coffee, when a plane flew over. A few specks of ash floated into my mug, and I thought, 'Hey, Annie just dropped in!' "

Margaret rolls her eyes at this story, and makes skeptical noises.

"It's true!" Pete insists, but his grin is wicked.

In 1987, Pete moved full-time to Boat Basin. He arrived with a mission: to rescue Annie's garden from the choking bush that had covered it during the last years of her life, and to restore it to its former beauty. He also planned to protect Annie's legacy by turning the property into a foundation for botanical research. To help this process along, he decided to self-publish a book about Cougar Annie, and asked

ABOVE : *Cougar Annie's garden.* Peter Buckland photo

Margaret, a journalist, author and broadcaster, to write it. The undertaking turned into a huge research project, during the course of which Pete and Margaret's friendship blossomed into a love affair.

The book is due for publication in the fall, and Margaret is busily working on the galley proofs.* Leaving her to it, Pete takes us on a tour of the garden, which lies beyond the sliver of old-growth forest behind his house.

"The first thing I had to do was let the garden breathe again," he tells us on the way. "Things grow so big here. When I started, the broom had trunks like fence posts and the salmonberry bushes were huge. I just waded in with my chain saw and whacked it all back. Once it got some light and air, it started to bloom."

At the entrance to the garden he's built a walkway from planks that become increasingly narrower, creating an optical illusion of great length. Other features also bear the stamp of his whimsical sense of humour. A memorial garden, on the site of Cougar Annie's vegetable patch, features a gnarled tree branch vaguely resembling a whale, which spouts on cue when Pete turns the tap of a concealed hose. A doorway inscribed with the Japanese word for "whale" opens onto a table made of a slab of clear yellow cedar, twenty-five feet long and and fifty-one inches wide, that Pete milled himself, then painstakingly planed and oiled.

"The Japanese like pale wood in their restaurants," he says. "So I reckon that if the local First Nations manage to get their whaling rights back, we'll need a sushi bar this size."

Nature has added another joke: on top of the table are the muddy prints of a bear who jumped up here and, unaccustomed to such smooth surfaces, skidded along its length.

What I like best is the garden itself, and its sense of resurrection. Because of Pete's tireless work, plants that lay dormant for decades have stirred and come back to life. He leads us along old boardwalks laid by Annie, past stands of lilies, through rhododendron bushes and by large clumps of hosta that once flourished under her hands, and without Pete's intervention would have disappeared forever.

"Whenever I cleared a new area, things just appeared," he says, gazing around. "I didn't know the names of half of what was growing, and I didn't care. I just enjoyed them. It's still happening. Every year something comes up that we never knew was there."

On our way out of the garden, we pass by where Annie lived. Trees grow through the roof of her goat shed, and the house from where she ran the post office is now collapsing to one side. Pete tells us that many of her belongings are still

*The book, Cougar Annie's Garden, was published in 1999 and won the Roderick Haig-Brown prize for best book about British Columbia.

inside—cougar pelts, jars of meat, old books and clothes. But the building is beyond repair and he intends to leave it undisturbed, until it crumbles into the ground.

Monday August 16

DAY *46* BOAT BASIN

Yesterday, we were grounded by another frontal system that brought strong southerly winds. This morning, the wind is calm and we're sure that we'll make it to Hot Springs Cove, where we're due to meet our friends Alison Watt and Kim Waterman. Ten minutes after we've waved goodbye to Pete, Margaret and Emma, we have the wind on our nose, blowing at about fifteen knots, and a mist of rain has moved in, obscuring the mouth of the harbour. Presently a sailboat emerges, heading in.

"That doesn't look good," I say. "We'll poke our nose around Rondeault Point to see what it's like out there."

Against the strengthening wind, it takes us forty minutes to cover one and a half miles. Just past Rondeault we stop, and listen to the weather forecast.

"Sécurité, Sécurité, Sécurité," calls the familiar voice.

An unscheduled weather warning has been issued for gales, due to peak around noon. It's pointless carrying on, so we turn and paddle over to the sailboat, which is now anchored. On the deck, a silver-haired man with brown windburnt skin is busy coiling ropes. He tells us that he had also hoped to reach Hot Springs Cove today.

"I came around Estevan this morning at nine o'clock, and by Perez Rocks it was really rough. The swell was up and the waves were piling in over the rocks."

He says he was surprised to see us heading out. "But I wasn't surprised to see you coming back," he laughs.

We're not comfortable about presuming on Pete and Margaret's hospitality once more, but camping in the harbour is a sensitive issue. Retracing this morning's journey, we land on the beach and sheepishly tramp up to the house.

"We're back," we say apologetically.

"That's good, because the soup will be ready soon," says Margaret, with a smile.

"And I've just made fresh coffee," adds Pete. "Sit down!"

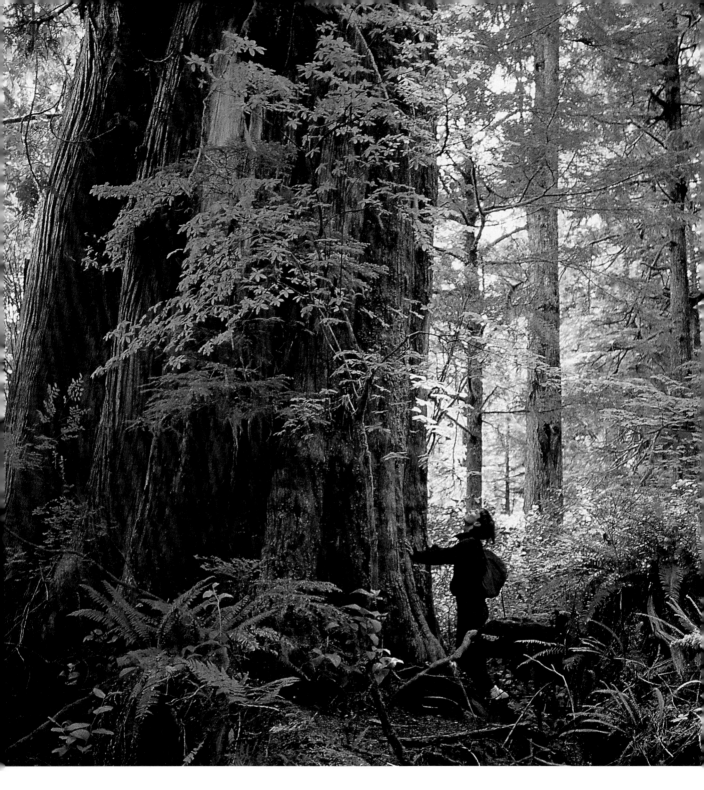

ABOVE : *Giant cedar, Meares Island*
OPPOSITE : *Floating home in Lemmens Inlet*

Tuesday August 17

DAY *47* BOAT BASIN TO FLORES ISLAND

The haunting cries of loons drift across the water to us as we leave Boat Basin, and a bear lumbering along the shore raises his head, sniffs the air, then continues on his way. We make good progress toward the mouth of Hesquiat Harbour, covering four miles in less than an hour. Fog clings to the open coast. The sailboat we saw yesterday is still anchored in the same place, and as we paddle by we call out a greeting. The man pokes his head out of the companionway.

"I'm waiting for this fog to lift," he says. "I've got GPS, but I don't like not being able to see the shore. You got a GPS?"

"No way," I laugh. "It's against my principles."

Fortunately, the six-mile stretch south from Hesquiat Point is almost free of off-lying rocks and boomers, which means we can hug the coastline. We paddle by cliffs with intricate arches and caves, all wrapped in mist. Waves smack against the rocks and race up surge channels that end in steep pebbly beaches. This isn't a place I would want to find myself trying to go ashore. The fog thickens, and I make note of the compass

reading in case we lose sight of land. Even though I'm keeping track of our precise position, the lack of visibility is disorienting.

A rumbling announces Barney Rocks, which guard the entrance to Hot Springs Cove. The gentle grey swells beat languidly down over the outcrops, which appear one by one from the fog. Carefully, we pick our way around these obstacles, while in the distance the shrill whistle of a fog signal on Sharp Point pierces the gloom. A ghostly outline materializes, a sudden splash of colour in this monochromatic world, and another double kayak appears from the mist.

"Could that be the Goerings?" cries a familiar voice.

It's Kim and Alison, out for a morning paddle, and keeping watch for us. For them this is the start of a week-long holiday; they look relaxed and at ease, and I realize how different the last few hours have been for us, feeling our way along an exposed coastline in thick fog.

As they lead us toward the entrance to Hot Springs Cove, the fog rolls back and we paddle into bright sunshine. On one side of the cove, the houses of a reserve cling to the contours of a steep hillside; on the other is dense forest with lots of "grey ghosts," the dead tops of high cedars, still touched by fog. Mist rising up from some rocks marks the site of the hot springs—that and a naked man wobbling about on one leg, trying to balance while he pulls on his pants. Behind him we can see more heads; already the day trippers have arrived from Tofino by water taxi and float plane, and people will be vying for space in the thermal pools.

Lying at anchor in the middle of the cove is an old fishing boat, converted into a floating B & B. We ask the charming German girl aboard it if she serves lunch.

"Not today," she tells us, "But try Mr. B's over on the reserve. He makes the best salmon burgers and fruit smoothies in BC."

Above a government dock crowded with fishing boats, dirt trails wind up between buildings of simple construction. From one house comes the sound of traditional Native drumming, and deep, guttural singing.

"Where's the restaurant?" I call to a group of children, who are peering down at us from a high deck.

"No restaurant," they reply.

A man with a brown, deeply wrinkled face walks past us on the trail.

"You looking for Mr. B's? It's up there, the second house along. There's no sign. He's home, so just bang on the door."

From inside the house we hear the whine of a vacuum cleaner. After we've

knocked loudly a couple of times, the door is opened by a young man with red, hennaed hair, wearing an apron over his jeans. I can see past him to a tidy room, with a poster of Berlin on one wall and a mantelpiece covered with framed photos of an elderly lady.

"Are you Mr. B?" I ask.

"I'm Bernard," he says. "Do you want lunch? It's nice and sunny now, so you can eat up on the deck."

The deck is painted blue, and has white plastic garden furniture and hanging baskets of geraniums that rock in the freshening wind. From here we can look down into the cove and across to the mountain peaks of Flores Island.

Following the German girl's advice, we order salmon burgers and smoothies. "My smoothies are *so* healthy," says Bernard, "your mothers would approve. Shall I bring them first?"

He has a cosmopolitan air, and when he returns with the drinks we learn that he's a trained chef, and that his boyfriend, whom he visited this past winter, is a photographer in Berlin. This restaurant is a new business. He had been planning to open up earlier in the season, but his mother took sick and he was caring for her instead.

"She died just two weeks ago," he says sadly, and I think of the photos on his mantelpiece.

The smoothies are made of yogourt, honey and fresh peaches; the burgers that follow are big slabs of wild salmon, perfectly seasoned, served on lightly toasted buns along with freshly made fries. When Dag asks for ketchup, Bernard arches his eyebrows.

"Monkey blood?" he says, through pursed lips. "On my burgers? Okay, if you insist."

By 5:00 p.m. we're halfway into the nine-mile crossing to Flores Island. Alison and Kim are keen birders, and stop often to identify species through their binoculars. They point to some red-necked phalaropes that are spinning on the spot. Alison explains that the air trapped in their belly feathers makes them too buoyant to dive, so they stir up the water to make the plankton they feed on rise to the surface.

"They're also polyandrous," she adds with a smile. "They have several mates in one season, and they leave the males to incubate the eggs and raise the chicks."

A mile off Flores Island we contemplate the expansive beach stretching across Cow Bay; since lunchtime the swell has increased, and we can see surf breaking along its length. While we're discussing where we should land, a Zodiac whale-watching boat speeds up to us. The group of people aboard are dressed in identical bright red survival

ABOVE : *Pacific chorus (tree) frog*
OPPOSITE : *Morning in Lemmens Inlet*

suits, and the young skipper is wearing a Peruvian woollen hat with earflaps and a pointed crown.

"Have you seen any whales?" he asks hopefully. "We've been out all afternoon and haven't found any, so we thought we'd come and look at you instead."

He advises us not to land on the south end of the beach because the surf there is too high today, and instead suggests a nook that I've been eyeing, away at the northern side of the bay. Soon we're stepping ashore, onto a crescent of soft sand marked with several sets of fresh wolf prints.

Wednesday August 18

DAY *48* **FLORES ISLAND**

We're sitting on logs around the fire. Dag is cooking bannock for breakfast, and the rest of us are drinking coffee, gazing out at the grey sea and sky and listening to the wheezy cry of a bird that Alison identifies as a Townsend's warbler. From the corner of my eye, I see a movement at the far end of the beach.

"Here's someone's dog," I say, then instantly register that no dog I've ever seen has such a long, easy lope.

Dag's hand and the spatula he's holding are frozen above the frying pan.

"Holy smokes," he says quietly. "It's a wolf."

The wolf is lean and loose-limbed, with a reddish coat. He trots along the beach, parallel to the shore. As he passes us, about fifteen yards away, he stops, and turns his head. We sit perfectly still, holding our breaths. The wolf gazes at us, takes a few steps in our direction, then stops again, as if reconsidering. Several seconds later, he's reached the far end of the beach, where with easy grace he leaps atop a jumble of logs and disappears into the forest.

At first, no one speaks or moves. Then Kim breaks the silence.

"He's obviously tired of bannock. If Dag had been cooking bacon, I bet he'd have joined us."

Later in the day, when we're following a track through the forest toward Cow Bay's main beach, Alison notices a wolf scat. Poking through it with a stick, she finds lots of black and grey hairs, and a set of little claws.

"His last dinner was a raccoon," she says.

As we step onto the beach, the sun breaks through the clouds. The tide is out, and at the water's edge western sandpipers and semipalmated plovers are busily foraging, dashing up and down ahead of the wash. We stop to look at the delicate shells of razor clams, and the ghostly impressions of bull kelp that have recently been eaten

away by sandhoppers. The sand shines with a slick of water and has been sculpted into patterns by the retreating tide, and the stones, kelp and seaweed pulled along with it. There are sickles and curlicues, herringbones and swirls, spirals, striations and cross-hatches. It's a vast canvas, graced with a work of art that within hours will be wiped away, then quickly made anew.

Thursday August 19

DAY *49* FLORES ISLAND TO VARGAS ISLAND

All morning, the rain falls in bucketfuls, and the southeast wind blows steadily. Dag sets up a tarp facing into the forest and away from the wind. We sit under it, blinking against the smoke from the fire, and gazing at the dripping alder trees. Kim grumbles that he's on holiday, and had ordered sunshine and calm seas. Dag keeps busy chopping wood and tending the fire, and Alison and I read, gossip about mutual friends, and drink tea. According to the forecast, the wind is due to ease off by late morning, but by 1:30 p.m. there's still no sign of it abating. The idea of breaking camp in the rain is not appealing, nor is paddling against a twenty-knot southeast wind, so we resign ourselves to a camp-bound day. An hour later, however, the sky begins to lighten and the rain eases to a fine drizzle. We tune in to the updated weather forecast: the winds are due to further ease to light southeasterly this afternoon, followed by another front that will move in tonight.

"Here's our window," says Dag. "Let's get going."

I watch Kim and Alison searching endlessly through dry bags for clothes and equipment, and squabbling good-naturedly about what should go where in their kayak. They remind me of Dag and me at the start of this trip, and I realize how efficient our teamwork has become over the past seven weeks, as if its rough edges have been smoothed away by the demands of the journey, leaving us functioning like a well-oiled engine.

By five we're afloat in the gentle swells of outer Clayoquot Sound, surrounded by common murres. I'd been considering heading for an exposed beach on Vargas Island, but it's bounded by a nasty reef, and if the wind picks up tomorrow it could be treacherous getting out through it again. Instead we make for one of the island's protected beaches, paddling past Whaler Islet, a saddle of sand between two rocky outcrops, then across Brabant Channel.

The beach is busy, with a commercial kayak group camped at one end, and a private group at the other. But it's already 7:30 p.m., and Alison and Kim are eager to call

NEXT PAGE : *Brooks Bay*

it a day, so we find a space where we can squeeze in. As soon as we land, Alison takes out her paints and starts to sketch the quickly changing scene on the horizon—treed islets steeped in gold, a blue sky turning to pink and mauve and a fog bank set alight by the rays of the sinking sun.

Friday August 20

DAY *50* VARGAS ISLAND TO LEMMENS INLET

"How many miles did we do yesterday?" asks Alison over breakfast, rubbing her shoulder. "Eleven? My muscles aren't used to the paddling."

"But you're so fit," I say.

"Not my upper body. Did you have many aches and pains at the start of the trip?"

I can barely think back that far.

"A few," I say.

Dag hoots with laughter. "A few? Are you kidding? After those first twenty-mile stints, you used to lie in the tent saying your back felt like a board. Don't you remember how we used to pop Extra Strength Tylenol before setting off each morning? And then some more, if we felt the slightest twinge en route?"

Alison's looking relieved. "This makes me feel much better," she says.

The frontal system that was supposed to move in last night has stalled. A fog bank still lies on the horizon, but above it the sky is eggshell blue. We leave our campsite after lunch, and meander through nearby islets, each one a unique little universe of rock, meadows, shell beaches and gnarled trees. The high pristine slopes of Catface Mountain rise proudly above us. Gazing up at them, I think how exquisite Clayoquot Sound is, and how few places like it are left along the coast. Three quarters of Vancouver Island's old-growth forests have already been destroyed by logging; of its 170 major watershed systems, only eleven remain in their natural state, and six of these are in Clayoquot Sound, which encompasses one of the largest remaining tracts of temperate rain forest in North America. The area has now been designated a UNESCO World Biosphere Reserve, but this has not changed any regulations about logging. Interfor, a giant logging company, intends to start clear-cutting on Catface Mountain this fall. It plans to cut sixty-five thousand cubic metres of wood—the equivalent of two thousand full logging trucks, a huge number of trees from such a small area. People we know in The Friends of Clayoquot Sound organization are already setting up camps high on Catface, and if necessary, they will blockade the roads to stop the logging trucks getting through.* In 1993, there were huge protests against the proposed logging

Despite repeated protests, in 2001 Interfor was logging on Catface Mountain.

of Meares Island, and over nine hundred people were arrested. As we paddle into the channel between Vargas and Meares, I wonder if a repeat of that situation might soon occur.

Our peaceful paddling is shattered by a train of whale-watching boats that have just roared out of Tofino. These large, rigid hull inflatables are fitted with benches, on which the red-suited passengers sit in neat rows, facing the same way.

"It's like a Disneyland ride," cries Maria as they zip by and throw up a huge wake.

Soon we turn into Lemmens Inlet. We're on the way to visit a friend of Alison and Kim who lives in a floathouse, and we've timed our journey so that the flooding tide helps us on our way. The steep slopes of Meares Island seem to guard these waters and the atmosphere is serene. We pass large sandbanks, with plovers and sandpipers wading on them, and a great blue heron that stands perfectly motionless, its neck feathers stirring in the gentle breeze. Eventually we glide into a bay where the surface of the water is winking with thousands of small jellyfish. The floathouse, our home for the night, is anchored near the shore. Tall sunflowers grow from boxes on its flat roof, nasturtiums and honeysuckle climb up its front wall and around the doorway. A large black dog is lying on the deck; as we approach he jumps up, his barking echoing off the surrounding rocks and hillsides.

Saturday August 21

DAY *51* **LEMMENS INLET TO TOFINO**

Last night the long-delayed storm finally arrived, and even in this sheltered spot it blew hard. This morning, however, peace is restored. Mist curls between small islets, and the sun creeps above the mountains of Meares Island, turning the water of Lemmens Inlet to pure liquid gold. As we leave the floathouse, our paddles slice through a reflection of clouds and forest-clad slopes. On the shore, we see a mink run across grey rocks, and the air is filled with the sounds of ravens going through their morning repertoire of rattling, ringings, pops and clicks.

Alison and Kim plan to stay here another night, but for us it's time to move. Waiting for us in Tofino, sent by courier from our other life, is a manuscript I must proof and return within two days. It's a necessary but unwelcome diversion from our journey, and I'm anxious to complete it so we can carry on.

Tofino is the busiest place we've been in since we left Nanaimo. What used to be a sleepy fishing village has become a centre for tourists, who are drawn here by the whale-watching and the spectacular beaches nearby. The few small streets running down to the dock, and the cafes, galleries and gift stores along them, are

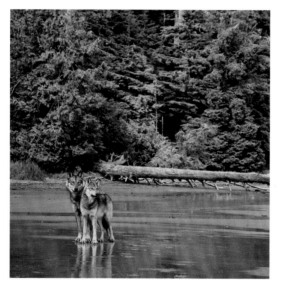

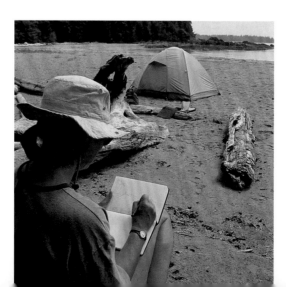

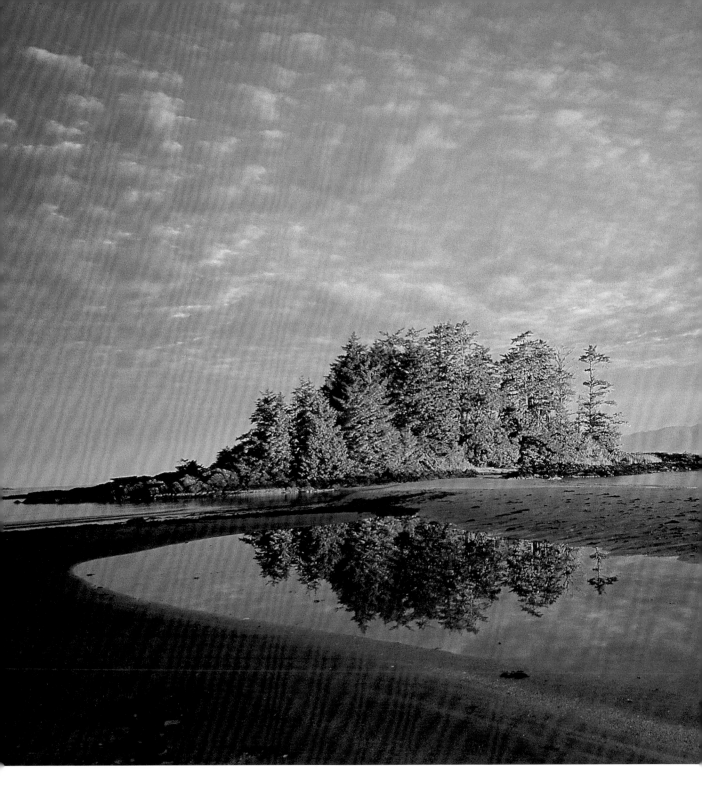

ABOVE : *Vargas Island*
OPPOSITE TOP : *Paddlers in the mist, Kyuquot Sound*
OPPOSITE MIDDLE : *Wolves on Vargas Island.* Jacqueline Windh photo
OPPOSITE BOTTOM : *Alison Watt sketching on Flores Island*

thronged with people. We retreat to the Paddlers' Inn, which also houses the Wildside Booksellers and Espresso Bar, businesses run by our friends Dorothy and Michael. The manuscript is waiting for me behind their counter; I order a coffee, settle at a table on their deck overlooking the ocean, and start to work.

Monday August 23

DAY *53* TOFINO

The weather report calls for a front moving in tomorrow, with an outlook for low pressure until Friday. We're anxious to put the long exposed stretch between here and Ucluelet behind us, so after an early breakfast we start packing right away. Down on the beach below the Paddlers' Inn, I'm stuffing the bag with my sleeping mat into the back hatch of the kayak when I hear Dag say, "Looks like we should have stayed in bed."

A thick bank of fog has rolled in, and is already obscuring Wickanninish Island, a mile away. We hang around all day, hoping the fog will leave as quickly as it arrived, but it's 4:30 p.m. before it finally rolls out again. In Wildside Booksellers, we talk the situation over with Dorothy, an experienced kayaker who knows this part of the coast well.

"I reckon we could leave right away," says Dag. "We'd end up paddling the last part of the journey to Ucluelet in the dark, but the moon is almost full, and if the sky stays this clear we'd have its light."

"What if you run into fog?" reasons Dorothy. "And what about boat traffic? I've kept your room free. Stay here tonight and leave very early in the morning."

Tuesday August 24

DAY *54* TOFINO

The forecast is in our favour, with light to moderate winds expected until this evening. Seizing the opportunity, by 6:45 a.m. we're paddling away from Tofino into a cloud of very fine, soaking rain. Once we round Grice Point, the familiar swell from the open ocean greets us. Soon we pass MacKenzie Beach and Chesterman Beach, where people are jogging or throwing sticks for dogs. These activities seem so familiar—and far more sane, perhaps, than what we are doing. As we pull past the rocks at the end of Wickanninish Beach, the people slip out of sight; I forget about "ordinary life" and click back into our present reality.

Four miles of miserable paddling brings us close to Cox Point. The current is against us, it's beginning to rain hard and the building southeast wind is kicking up short, choppy waves on top of the swell. We pause to consider our options. The prospect of

reaching Ucluelet in these conditions is quickly fading. Apparently there is a small pro- tected cove up ahead, adjacent to Radar Hill, but camping isn't allowed there, and any- way it seems pointless setting up a tent in the rain only five miles from where we could be warm and dry, sipping a steaming cappuccino. We swing the boat around and head back the way we came, relieved to have the wind and current at our back.

At 9:30 a.m., when we walk into the bookstore with water dripping from our sou'westers, Dorothy looks relieved.

"I heard it was getting nasty out there, and I was worried about you. Your room is still free, but the girls are already cleaning it. Go and have breakfast, and by the time you've finished you can check in again."

At the Alleyway Cafe we order eggs, sausages, bacon, toast and home fries. By the time we return to the Paddlers' Inn, wind is snapping the flags on the poles out- side, and rivers of water are flowing down the steep road to the dock, making a mockery of the forecast.

Wednesday August 25

DAY 55 TOFINO TO UCLUELET

Sunlight floods through the window of our room in the Paddlers' Inn. The wind has switched to the west in the wake of yesterday's front, the radio informs us, and is sup- posed to die around midday.

"Let's get out of here," says Dag. "Otherwise we might as well rent a house and get ourselves jobs in a gift shop."

At 11:00 a.m., when we're just about ready to push off, I run up to the Common Loaf Bakery to buy some cheese buns for the journey. When I return, Dag is talking intently to Tasha, a local kayak guide, and they're both gazing at the clouds. There's just been an extra, updated weather report, warning that the wind is blowing twenty-two knots at Lennard Island with six-foot seas, and thirty knots far- ther offshore.

"Look at the high clouds screaming by," says Dag.

"I think the weather is telling you guys to hang around Tofino for a while," laughs Tasha.

There's nothing for it but to sit in the sun on the beach and wait. While Dag reads up on the currents in Juan de Fuca Strait, I watch groups of beginner kayakers preparing for their introductory paddle. Full of nervous anticipation, they fumble with their spray skirts and life jackets, and climb awkwardly into the rented boats.

With humility, I remember my own huge fears when I first got into a kayak—and consider that if someone had told me back then that eventually I'd set off to paddle around Vancouver Island, I'd have thought they were out of their mind.

The wind finally stops blowing in mid-afternoon. It's getting a little late to start on a twenty-four-mile trip, but I'm beginning to wonder if we can afford to hold off until perfect conditions last all day. Sometimes, the best time to paddle is in the evenings, when the land cools and the sea breeze diminishes. Besides, I feel like we are quickly becoming fixtures here in Tofino; I've already heard someone refer to us as "that couple who are trying to paddle around Vancouver Island."

We're on the water at 4:00 p.m., in calm conditions and with warm sun on our backs. Perfect. If we crank it, we can be around Amphitrite Point before it's completely dark. An easy six-foot swell greets us as we clear Lennard Island. Approaching Long Beach, we go a couple of miles offshore to avoid the current coming off the beach at either end. A line of blue haze marks where the waves are breaking on this famous stretch of sand. I imagine all the activity there on such a fine day, and wonder if anyone is gazing out and wondering about the regular glint of sunlight reflecting off our paddles as we draw past. Far in the distance, we get our first glimpse of the Olympic Range, which lines the American side of Juan de Fuca Strait. Paddling so far from shore, it feels as if we are stationary, while an enormous landscape is scrolling slowly toward us.

When we stop for a break, I notice a disc almost three feet in diameter floating in the water close by. It's a sunfish, brought in by warm oceanic currents.

"It looks half dead," Maria comments, as we manoeuvre closer to have a better look.

A big dark eye stares up at us, and a pointed pectoral fin flaps bizarrely in the air.

"It doesn't need to be very lively to catch jellyfish," Dag tells me. "That's all it eats." As an afterthought, he adds: "I wonder what it tastes like. Fish jello, maybe? But then again it might be nice and and firm like tuna."

I make noises to let him know that I'm eager to carry on. The last thing I want is for Dag to try and wrestle this thing onto the deck of our boat, so that we can have it for dinner. It's getting late, and I'm starting to worry about being caught out by the night.

Eight o'clock, and the sun has almost reached the horizon. The high red beacon off Amphitrite Point stands out clearly against the changing colours of the sky, and the beam from the lighthouse flashes at regular intervals. A cold realization creeps up my back: we haven't a chance of reaching Ucluelet in the light, and there's

nowhere on the way that we can go ashore. We're kayaking in the open ocean, along an exposed coast, and we're about to round a dangerous headland *in the dark*. It seems utterly absurd to me, and there's absolutely nothing I can do about it.

The sun slips away. Then the moon floats up over the logged slopes to the east; it's big, beautiful and full.

"Look, we'll have the moonlight, at least," says Dag cheerfully. "We'll be fine."

But a thick band of clouds has formed above the horizon, and presently the moon disappears behind it.

"Let's stop and have some chocolate," suggests Dag.

"Stop?" I cry. "Are you out of your mind?"

"We both need some energy, Maria."

I glance at my watch. It's now 8:40 p.m., and we've been paddling hard for almost five hours. Within forty-five minutes, a full fledged night will have descended upon us.

"Look at it this way," says Dag, passing me a large chunk of Toblerone. "Sea conditions are good, there's no wind to speak of, and no fog. The moonlight will help us, even from behind the clouds. We've got nothing to worry about."

I insist he mount our stick light and radar reflector.

"On this tiny boat, and in these big swells, they'll hardly be effective," he argues.

"Just do it," I say threateningly.

"Okay, okay."

Soon, the deep blue velvet of the sky is punctured by millions of glowing pinpricks. A strange inky blackness seems to rise from the water and gradually obscures everything around us. I can't recognize the swells anymore; there is only the sensation in my lower belly that tells me I am rising and falling gently. I feel like I'm floating in space; I can imagine how easy it would be to slip into some strange hallucinatory state out here. Tightening my grip on my paddle, I concentrate on the intermittent flashing from the lighthouse ahead, and strain my ears to listen for the warning sounds of breaking water.

A fish boat comes up from behind us and passes a few hundred yards to our starboard side. I wonder if they see our light or register us on their radar screen. The drumming of the engine and the navigation lights gradually fade in the distance. Then, directly ahead, there's a sudden, explosive roar. Frantically, we start backpaddling. It's hard to tell how close the boomer was, but I can just make out a lighter patch caused by foaming water in the darkness ahead. We give the area a wide berth.

A painful tension is crawling up my spine and into my shoulders. Grimly, I paddle on, half expecting the sea to erupt beneath me at any second.

"I know where we are now," says Dag. "That was the rock I was a bit worried about when I last checked the chart. We're exactly a mile from Amphitrite Point. It's pretty straightforward from here until we round the point. Then it gets a bit messy for a while."

I don't like the sound of that at all. It occurs to me that we might be heading into a major epic, one from which it might not be so easy to escape. I begin to feel angry toward Dag for getting us into such a predicament, but this isn't a situation in which I can give way to my feelings, so I find another way to vent them.

"Dag," I say, over my shoulder. "If we get through this unscathed, will you promise me something?"

"Anything."

"Will you put the mouldings around the living room windows? You've been saying you'll do it for nine years now."

He's silent for a minute.

"I'll never understand how your mind works," he says at last.

Twenty minutes later we're round the point and in Carolina Channel, which lies between the end of the Ucluth Peninsula and a muddle of off-lying rocks. The stark beam of lighthouse sweeps around, alternately blinding us and illuminating the mist rising from breaking water on the rocks below. A quarter of a mile away to the south, we can hear waves smashing onto the reef known as Jenny Reef. Uneasily, I recall that this was the site of two major shipwrecks. All hands perished when the *Pass of Melfort*, a steel barque, was pounded to bits on the reef in 1905; almost sixty years later a huge Greek freighter, the *Glafkos*, came to grief on almost the same spot.

The waves have steepened and become devious, jumping about in different directions. When the boat lurches and tilts unexpectedly, I have to curb my instinct to brace, in case I find myself leaning hard into air instead of water.

"God, I don't know if we're on the right side of that channel marker, or not," Dag frets, referring to the red light on a buoy ahead. "I can't see where to turn into the harbour, either."

He steers us closer to shore, toward what he hopes is a channel leading to Ucluelet Inlet, but a long hiss followed by the crashing of a breaking wave sends us into rapid backward motion once again.

Red and green navigation lights appear, and the dark shape of a fish boat glides by and disappears to our left.

"That must be the channel to Ucluelet he's going up," Dag says. "We'll follow him. If he's got it wrong and crashes we should have enough time to back off."

I can hardly believe it when finally we see the lights of Ucluelet, and the ocean beneath our hull quietens. A pier looms up, brightly lit, with a Petro-Can gas station on the end. Two men are sitting on plastic chairs on a deck over the water, and as we glide beneath them they gaze down at us in quizzical silence.

"Where've you come from?" says one eventually.

"Tofino," I tell them, and they exchange bemused glances.

"Can we tie up to your dock?" I ask.

"Sure can."

While Dag talks to them, I go to a phone booth to call the Morrisons, a family with whom we've arranged to spend the night. Just before we left Tofino, I called to say we'd be in Ucluelet by ten at the latest. As I stand in the phone booth and punch out their number, I check the time: 11:10 p.m. It's only seven hours since we left Tofino, yet in that short time I feel I've gained—albeit unwillingly—years of experience. At the first ring, Margaret Morrison picks up the phone. "Where are you?" she asks anxiously.

By the time her husband Myles arrives in his truck to pick us up, we're carrying our boat into a large storeroom behind the Petro-Can station. The kind manager of the station, Brian Galloway, has not only offered to let us store all our gear here overnight, he helps us carry the twenty-two-foot boat up the ramp and manoeuvre it around corners and through doorways.

"Don't worry," he assures us, when all our bags are heaped along the side of the kayak. "Everything will be locked up and safe."

More kindness awaits us at the Morrisons' house, where Margaret offers us soup, a hot bath and a comfortable bed. The tension and adrenalin that kept me going for twenty-four miles of open ocean paddling and around a dangerous headland in the dark suddenly dissolves away. What's left is a total exhaustion of mind and body, and I collapse like a child into a deep, luxurious sleep.

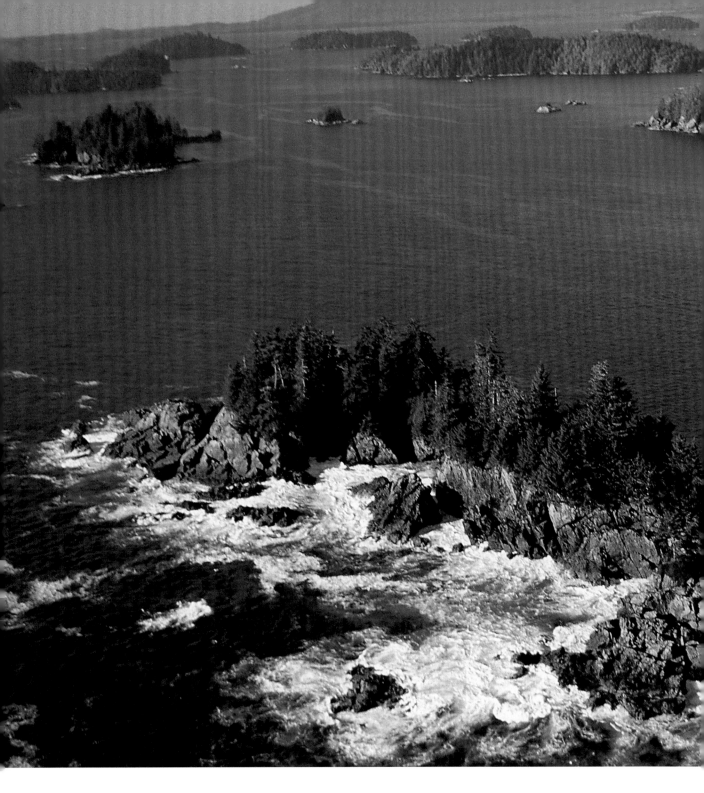

ABOVE : *The Broken Group, Barkley Sound*
OPPOSITE : *Sea urchin "shell"*

Thursday August 26

DAY *56* UCLUELET TO THE DEER GROUP

When first I open my eyes, I don't know where I am. From somewhere above me I hear children's voices and the scuffling of feet. Slowly, I piece it all together: yesterday's long journey, the night paddle around Amphitrite Point, arriving in Ucluelet and coming to the Morrisons' house. Dag stirs, and turns over.

"I had a bizarre dream about paddling in the dark," he mumbles, and it's hard to tell whether or not he's joking.

At 10:30, Myles drives us to the dock. Brian Galloway is there to open up the storeroom, and shortly after noon we're paddling away from Ucluelet, starting a five-mile crossing toward the Broken Group.

It's as if someone took pieces of all the loveliest spots along this coast—a hundred or so small islands with tiny sand beaches and wind-dwarfed trees, vistas of snow-capped mountains, sea lion rookeries, protected waters and a fringe of big ocean breakers—and arranged them neatly in Barkley Sound. We cruise along its outer edge,

past Wouwer Island, where a large colony of sea lions fill the air with their barking and honking. Back up the sound, we spy several groups of kayakers threading through some of the islands. This is a mecca for paddlers, most of whom come here aboard the *Lady Rose*, which does regular runs from Port Alberni. The Broken Group is part of the Pacific Rim National Park, so camping is limited and at this time of year it's hard to find space to pitch a tent. We decide to carry on to the Deer Group, a smaller and less visited archipelago, another five miles away.

An hour or so later, we're drifting into the lagoon-like waters between Diana and Edward King Islands. On Diana there's a small cabin, with nets and floats hanging over its roof and strewn across the surrounding rocks. This is the home of Doreen Clapus, a First Nations elder whom I met here two years ago, when I was kayaking with a friend, Phil Ashbee. Doreen was unfriendly at first, belligerently demanding camping fees, until she realized that Phil was part Native.

"After that," I tell Maria, "she couldn't do enough for us."

The cabin is empty, so we go ahead and set up our tent on Edward King Island. We're just finishing supper when a motorboat drives into the channel. The two people aboard transfer to a dinghy on Diana Island, then start rowing across to us. A man is sitting aft, facing forward as he rows. In the prow is a small, hunched woman. A handbag lies on the thwart next to her.

"That's Doreen," I say. "You have to watch yourself with her; she can be like a snapping turtle."

As the rowboat scrapes the shore, Doreen shouts, "So you want to stay the night, eh?"

We begin to explain why we set up camp before getting permission, but she waves away our apologies.

"That's alright. It'll cost you ten bucks, though."

"Do you remember me?" I ask her, handing over the money. "I was here before with a Native guy, a carver."

"Oh. Yeah." Frowning, she turns to the man behind her. "Lawrence, do you remember him?"

Lawrence shakes his head.

"Doreen has claimed this land," he says, in a quiet voice. "She's lived here all her life."

"I was born on the water, in a boat," Doreen adds. "My mother couldn't make it to the hospital in time. I been here ever since."

As they row away, she says, "If you want to stay another night, you can. It's on the house."

In the clear sky above them, a huge moon is rising, casting a silvery path across the

ocean. Maria stares up at it, exasperated.

"So where were you yesterday, when we needed you ?" she asks.

Friday August 27

DAY *57* THE DEER GROUP TO PACHENA BAY

An hour's paddle from the Deer Group brings us to Cape Beale. From here to Sheringham Point, this stretch of coastline is known as the Graveyard of the Pacific, because of all the ships that have been wrecked along it. We observe the cape peacefully from half a mile offshore. Big swells roll under the kayak, looking perfectly friendly until they reach the shore, where they foam over reefs and smash against the cliffs. Above them, the red and white structures of the lighthouse zigzag down the steep headland. I imagine I see a tiny figure emerge from one of the buildings; as we carry on I wave, in case someone is watching our passage.

After six miles of pleasant paddling we turn into the protection of Pachena Bay, whose waters have been turned the colour of oxtail soup by an algae bloom. Two miles away, at its head, is a huge sweep of white sand. Tomorrow afternoon we're due to rendezvous here with our friend Tara, who plans to accompany us for a few days. After the experience with Willie on the Brooks Peninsula, I have strong reservations about paddling with anyone else, particularly on this next section, where there are precious few bolt holes to escape the winds that can blow fiercely up the Juan de Fuca Strait. But Dag assures me that it will be fine. As well as being twenty years younger than us, Tara is fit, athletic and determined.

"Our main problem will be keeping up with her," he says.

Sunday August 29

DAY *59* PACHENA BAY

By 4:30 in the morning I'm rolling around restlessly in my sleeping bag, thinking about what lies ahead: the Long Flat Line, as a kayaking friend in Tofino called it. He was referring to the straight coastline of Juan de Fuca Strait, which stretches almost eighty miles down to Victoria. There is plenty to worry about on this leg of our trip. For the last few weeks the wind has been consistently howling down the strait, often reaching gale force. This is quite common in the summer months, due to northwest winds funnelling in off the open coast. Recently this situation has been exacerbated by the influence of a stationary low farther inland, sucking the wind toward the interior.

All the water from the Strait of Georgia and Puget Sound drain through the relatively narrow Juan de Fuca Strait, creating chaotic wave conditions when the tide is

against the wind. To top it all off, this rugged coastline offers few safe havens where we can land should conditions get too rough. There will be a window of calm, I keep repeating to myself. We just need to be poised and ready to go.

I switch on the weather radio. At Sheringham Point it's already blowing twenty knots northwest, and forecast to rise to thirty-five. This isn't the day, I think, so I might as well go back to sleep.

All day, big white-tipped waves can be clearly seen a few miles away, marching south across the entrance of Pachena Bay. I'm glad we've decided to stay put. While Tara and Dag practise their surf kayaking skills, I spend much of the day catching up on notes and reading. Perhaps unwisely, I become totally engrossed in a book entitled *Breakers Ahead: A History of the Shipwrecks on the Graveyard of the Pacific*. Just around the corner from here, at the start of the next part of our journey, is the site of the worst shipwreck ever along this part of the coast. In January 1906, the *Valencia*, a seventy-six metre iron steamship, was sailing from Victoria to Seattle. Due to thick fog, and because her captain had failed to account for the effects of current, the *Valencia* overshot the entrance to Juan de Fuca Strait. She went forty miles off course, and ran aground on some reefs near Pachena Point, punching a hole in its bow. The lifeboats were lowered but most capsized on the way to shore, which was fifty yards away across a maelstrom of turbulent waters. Only a handful of people survived their passage through the pounding surf. Scrambling up the cliffs, they came across part of a trail through the bush, established a few years before to maintain

ABOVE LEFT : *Jerry Etzkorn, keeper of the Carmanah Point light*
ABOVE RIGHT : *Chez Monique café on the West Coast Trail*

the telegraph line running from Victoria to Cape Beale. They followed this trail until they reached a cabin, which was equipped with a telephone. Fifteen miles down the line, in Clo-oose, linesman David Logan answered his phone, to hear almost incoherent babbling at the other end. He calmed the caller and ascertained where he was—and so the rescue operation for the *Valencia* was mounted.

After Logan had raised the alarm, he hiked for a night and a day to Pachena Point. Sea conditions were so bad that none of the newly arrived rescue boats had dared to get close enough to the beleaguered ship to pick people up from the decks. Scores of survivors were clinging to the rigging and the parts of the hull that were still above water; when David appeared on the bluff they gestured frantically to him, but there was nothing he could do. For two hours he watched helplessly as they were battered by the sea, until finally a huge wave turned the boat over and smashed it to pieces. Of the 164 passengers and crew, only 38 survived.

As a result of this tragedy, the Pachena lighthouse was built, and its wooden tower still stands on the point. In 1910 work was completed on the West Coast Lifesaving Trail. Running from the entrance to the Juan de Fuca Strait up as far as Cape Beale, it had cabins at six-mile intervals where shipwrecked mariners could find shelter and emergency supplies. By the 1950s it was no longer being maintained, but in 1973 it was reopened between Pachena Bay and Port Renfrew as a hiking trail, one that several of our fellow campers on this beach will be setting off on tomorrow.

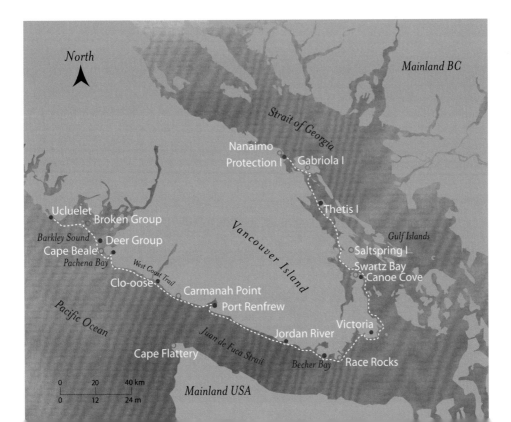

Monday August 30

DAY *60* PACHENA BAY TO CLO-OOSE

The forecast calls for ten- to twenty-knot northwesterlies this morning, rising to thirty knots by this afternoon. We rouse Tara, pack up quickly and by 7:00 a.m. we're on our way. As we start to round Pachena Point, sunlight glints off the smooth, three-foot swell, and there's barely any wind. Tara is paddling strongly beside us in a single kayak, but after half an hour she starts falling behind.

"I feel woozy," she tell us. "It's the swells, I'm not used to the motion."

Her wooziness soon turns to dizziness and nausea. She insists we shouldn't turn back, so in the shelter of Pachena Point we pull in close to shore. Watched by West Coast Trail hikers, who are just beginning to emerge from their tents, we manoeuvre to a rocky ledge protected by kelp beds, and play a quick game of musical kayaks: Dag takes the single, I go into the back of the double and Tara sits in my usual seat.

It's fifteen miles to the next place where we can safely go ashore. As it's too late for Tara to take motion sickness pills, Dag encourages her to eat something, to help settle her stomach and give her strength for the long stint ahead. She nibbles on a date square, drinks a little water, and starts paddling. We've covered the first mile before she puts down her paddle and turns around. Her face is grey.

"I'm sorry, Maria," she says quietly. "I'm going to be sick."

For the next two hours, Tara is in a bad state.

"Talk to me," she pleads between bouts of nausea. "Tell me stories. I need to think about something else."

I recount some of our adventures on this trip so far—the currents of Johnstone Strait, the standing waves off Cape Scott, the nasty conditions on Bajo Reef, the night paddle around Amphitrite Point. I regale her with memories of our times in Ireland, where Dag worked as a large-animal vet, describing the eccentric farmers we got to know, the operations I assisted Dag with, and the two orphaned lambs I raised. I recite my two published children's stories to her and then, because I've run out of things to talk about, I make up one more.

I have to admit I'm enjoying the feeling of paddling a single kayak once again. In comparison with our Libra XT double, the Solstice feels sleek and wonderfully manoeuvrable, even though it is loaded with gear. Maria, however, is having a hard time paddling the double on her own, with Tara now completely incapacitated in the front cockpit. Tara's sea sickness has thrown a new factor into the complex equation of the risks involved in this leg of the trip. But as long as the weather holds we'll be fine.

It turns out to be a stunning day. The rocks and forest on the shoreline file past in deep green and russet hues. I recognize some of the landmarks from the two times I hiked the West Coast Trail, over a decade ago. White ribbons of water cascading from a high ledge onto the sandy beach mark Tsusiat Falls, and even from a hundred yards off-shore, it's an unforgettable sight. Nitinat Narrows, a little farther along, is a slot in the otherwise impenetrable rocky shore, where a tidal lake connects to the Pacific. We keep a safe distance from it, as the current that comes out of here can cause confused seas. Eventually we arrive at Clo-oose. The beach beyond it is being pounded heavily by surf, but a small point hides a steep beach on the lee side that looks landable for us.

"I'll go in first," Dag calls to us. "If you get a big wave when you're coming in, don't try to surf it. Just backpaddle and let it break under you."

Once ashore, Tara collapses under the shade of an arched driftwood log, still dressed in all her kayaking gear, and doesn't move for the next hour and a half. Around four o'clock, she wakes up and joins us for a walk. As we head down the beach, I think about David Logan, the man who raised the alarm when the *Valencia* floundered on Pachena Point. He lived not far from here, at the mouth of the Cheewhat River, where he and his wife were the first white settlers. They ran a general store and post office, but David's main work was on the telegraph line that was strung from tree to tree along the coast between Victoria and Cape Beale. Logan's job was to maintain thirty miles of the line and to keep that part of the trail open. It was said he would be away on the trail for weeks on end, going bare-foot through the bush, often foraging for his food.

At the end of the beach are a couple of houses, possibly the legacy of a dis-reputable real estate agent who is said to have sold waterfront lots here at the turn of the century, claiming there would be road access to them before long. One house is built in a Panabode style, with lots of driftwood and shake siding. In the overgrown garden behind it stands a strange wooden tower, about thirty feet high, with three storeys. Poking our heads inside, we see that the top two storeys are only accessible by ladder and rope, which can then be pulled up through a trap-door. We're delighted by the folly: in design it's just like an Irish round tower, where monks took refuge from marauders in the upper storeys.

Beyond the garden, we come across a section of the West Coast Trail. Alongside it, snaking through huge skunk cabbages, is part of the old telegraph line that David Logan looked after so many years ago. I laugh to think what he would make of the well-maintained boardwalks up ahead, the new suspension

bridge spanning the river, and the sign advising hikers they have now completed thirty-five kilometres of the trail.

Tuesday August 31

DAY 61 CLO-OOSE TO PORT RENFREW

Once again I'm up early, with my ear to the radio. The stable high pressure area is forecast to start breaking down, and the wind is supposed to back to the southwest. I breathe a sigh of relief. It's unlikely that the northwest wind will surprise us today. A second day of relatively calm weather is more than we could hope for.

By 8:00 a.m. we've broken camp and are on the water. Tara has taken motion sickness tablets, and she's doing so much better than yesterday that I have to work hard to keep up with the double. Off in the distance, toward the American shoreline, a dark band of cloud is forming and moving rapidly toward us. Trailing behind it is an indigo curtain of rain, ruffled by strong gusts of winds. It looks daunting. The sky above us darkens, and as the squall moves in, Maria and Tara start disappearing behind big swells covered in whitecaps. Beyond this front I can see blue sky, which gives me confidence that it is only a short-lived squall.

The wall of rain and wind hits us with a vengeance.

"I don't think this will last too long," Dag reassures us. "Once it passes the wind will probably switch back to the northwest."

Thankfully, he's right; within minutes the sun is shining and the wind is pushing us toward the lighthouse on Carmanah Point. We've been told that there is an old Native canoe run behind the point; soon we see a little moorage buoy and start working our way carefully through a series of channels in to shore.

The last thing we expected to find on this beach was a café—but there it is, in a large shelter made from driftwood and tarps. Next to a solar panel hanging on a pole, a cardboard sign welcomes us to Chez Monique, and another sign announces, "Yes, you are welcome to camp here." Arranged on the sand are sun umbrellas, plastic tables and chairs with broken legs that have been mended with bits of wood. Inside the shelter is more seating, a little store selling candies, pop and fruit, and a "free box" where hikers can leave things they don't want and take whatever they fancy. Behind a wide counter, in the kitchen area, we find Monique. She's standing at a propane stove, preparing breakfast for several young hikers.

"I can take your order next," she tells us. "I got hamburgers, veggie burgers, eggs and hash browns, ham omelettes, veggie omelettes, you just say what you want."

OPPOSITE : *Sand dollar*

I lean on the counter, chatting to Monique as she cooks. The offspring of an Algonquian father and an Irish mother, she was brought up in Quebec, and sent to a residential school run by nuns of the Order of the Sisters of St. Anne. In her late teens she moved to Vancouver to study business and finance.

"One day in Vancouver I met a Native woman who had never eaten moose meat. I'd brought some dried meat with me, so I made a stew. It was a big stew, because this woman had five kids. I brought it round to her house in two pots. The woman's brother was there, and—well, I ended up marrying him and moving out to his land."

Her husband Peter is one of the hereditary chiefs of the Ditidaht people, an amalgamation of a number of formally autonomous tribes. They have a home in Vancouver, but for the last nine years they have been running this cafe from May to September. They used to pack in all their food and equipment on their backs, hiking for an hour and a half down the trail. Now they mostly use a barge or a water taxi out of Port Renfrew. They stay in a small, simple cabin just behind the beach. A Frenchman who came here to work with them built a more substantial house from split cedar, but Monique found she was allergic to the wood, so she sometimes lets wet hikers stay there to dry off.

"We're about halfway along the trail here," she says. "These kids come down the beach carrying their big heavy packs, and when they see this place they can't believe their eyes. They're so appreciative. I never get tired of that."

Along the beach from Chez Monique, a steep staircase leads up to the headland where the Carmanah lighthouse stands. Tall irises, lilies and sweet peas grow against the white-sided walls of its two family houses, and the well-kept yard includes vegetable beds, a greenhouse and a chicken house covered with honeysuckle. There's also a large lawn, with a labyrinth carefully mowed into it.

"This labyrinth has the same design as the one in Chartres Cathedral," says Jerry Etzkorn, the keeper of the light. "My wife Janet made it. It's a meditation device."

"Are you into the occult?" asks Dag jovially.

For a few moments Jerry strokes his long grey beard, seriously considering the question. Eventually he fixes Dag with his soft, brown eyes.

"I guess I am," he answers.

During the summer months, thousands of hikers pass by Carmanah lighthouse, and Jerry is frequently asked for help. Early this morning he had to call in a helicopter to evacuate a hiker who had a panic attack in the night. And a few hours ago he was involved in co-ordinating the rescue of the crew of a fishing boat that caught fire, a few miles away from here. So at this time of year, life is busy. But in

the winter... As we say our goodbyes, I try to imagine the reality of living here year round, as Jerry and his family have for over a decade, and find that my creative powers simply won't stretch that far.

A little farther down the coast we see a huge pall of smoke and flames. A burning boat on a vast ocean—it's a surreal sight. Two Parks Canada Zodiacs are rafted up and anchored at a safe distance. Aboard them are several young men and women in short-sleeved uniforms and fashionable sunglasses, lounging in the sunshine and looking thoroughly relaxed.

"Nice work if you can get it!" I call as we pass, and they laugh and wave us over.

"Where are you guys going?" asks one.

We explain, then inquire about the crew of the fish boat.

"Yeah, they're okay. Everyone got off in time."

The mountains of Washington's Olympic Range rise gradually above the southeastern horizon. Cape Flattery, marking the beginning of the Strait of Juan de Fuca, drifts slowly past us. For weeks we've been paddling with 5,000 miles of open ocean to our right, and it's odd to have land on both sides of us again. I feel as if two big arms are reaching out to embrace us and offer protection from a wild and unforgiving world. But I'm not sure if I am ready yet to be drawn back to the bosom of a safe and civilized life.

Just as we turn into Port San Juan toward Port Renfrew, Maria and Tara shout simultaneously and point straight at me. I sense the presence of something very large, very close by, and turn to see the enormous crusty back of a gray whale less than ten feet off to my port side. The closeness of the giant makes my scalp tingle. Through the crystal clear water I can see the great white shape of the beast sink to the bottom. Very soon it rises to the surface again, and exhales a cloud of mist that slowly descends on me.

Dag is dwarfed by a whale that resurfaces by his side. One moment he appears transfixed, and the next he is doubled over and clutching his face.

"Oh, God!" he screeches. "Urgggh! Horrible breath!"

The whale seems disconcerted by these utterings and immediately sounds. For a moment I think that Dag is about to capsize and follow him, but he recovers, muttering darkly about the poor dental hygiene of gray whales.

We land on a stony beach below the Port Renfrew Hotel. This establishment has been here since the 1930s, and by all appearances it has changed little since then. There appears to be no one around, except for a young man in the bar, bending over the pool table, and a sandy-haired woman leaning on her cue next to him.

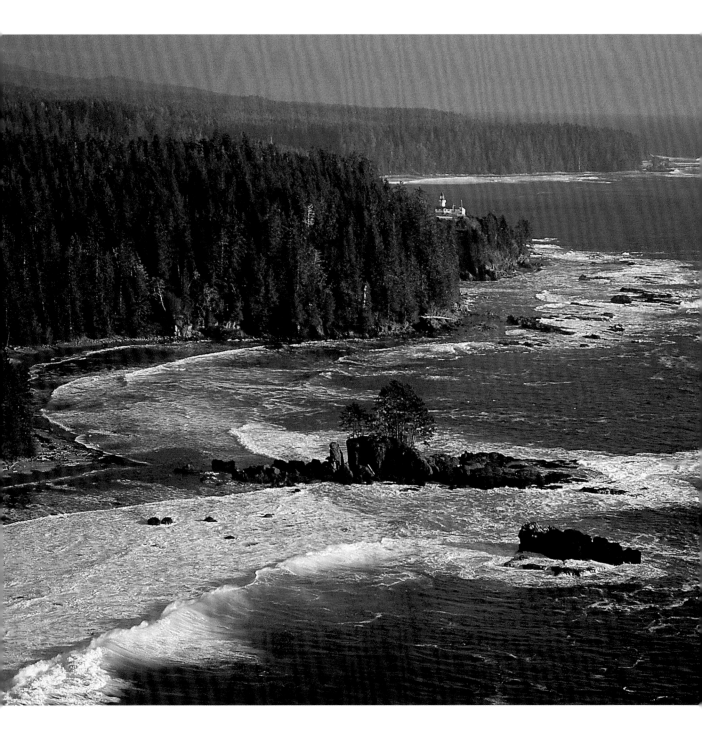

ABOVE : *Carmanah Point*
OPPOSITE : *Fishing floats washed ashore along the "Graveyard of the Pacific"*

"Can we help you?" she asks, giving me a hard, steady gaze.

"We've just kayaked here, and we wondered if there's any room in the hotel," I ask. "There are three of us, a couple and a single."

"Rooms are thirty-three dollars plus tax," says the man, still focused on the game. He jabs the cue at a ball, which speeds across the green baize and ricochets off the side of the table. Then he stands up and faces me. He's tall, rangy and handsome in a feckless sort of way.

"The attic room has three beds, if you don't mind sharing. Leave the kayaks behind the building. Bring your stuff through here—it will be quicker."

Amazed by the ease of these arrangements, I ask if he gets lots of kayakers staying in the hotel.

"Nope," he says, watching his friend intently as she lines up for a shot. "I only started working here recently and you're my first."

We spend much of the evening in the bar. Across from us, a man drinking beer and eating chips is accompanied by a large German shepherd that sits with its ears cocked, watching its master's every move. When the man goes to the bathroom the dog follows him, and stands outside the door whining pitifully. The place steadily fills up with locals, a line-up forms for the pool table, and loud music blares incessantly from the jukebox. The only other group of tourists to come in are some Germans. They're dressed in hiking gear, and I hear them telling the barman that they have just finished the Juan de Fuca Trail, which runs between Jordan River and Port Renfrew. They apologize to him about their muddy boots.

"We get more than mud in here," he says.

He's keeping his eye on two men who are heatedly discussing the fact that one tied up his boat to the other's dock without permission. Both are drunk and rather unsteady on their feet. They stand nose to nose, and the barman's glance switches between them as they argue, as if he's watching a tennis match.

"What's the problem, man, I was only there half an hour."

"So? What if I'd of needed to tie up? Eh?"

"If it makes you feel better, I'm sorry."

"I'll feel better when you pay me twenty bucks."

Back at our table, Tara is giggling into her pint of beer.

"What an incredible day," she says. "How can so much have happened in such a short time?"

"It started with the wall of wind," Dag recalls.

"Then the old canoe run," I chip in.

"Chez Monique."

"Burgers and fries on the beach!"

"The lighthouse. And all the flowers around it."

"Oh, and that labyrinth!"

"The whale with bad breath."

"It's certainly been a day," I conclude. "Let's celebrate. Everyone ready for another beer?"

"The burning boat, you guys," squeals Tara, as I stand up. "Don't forget the burning boat!"

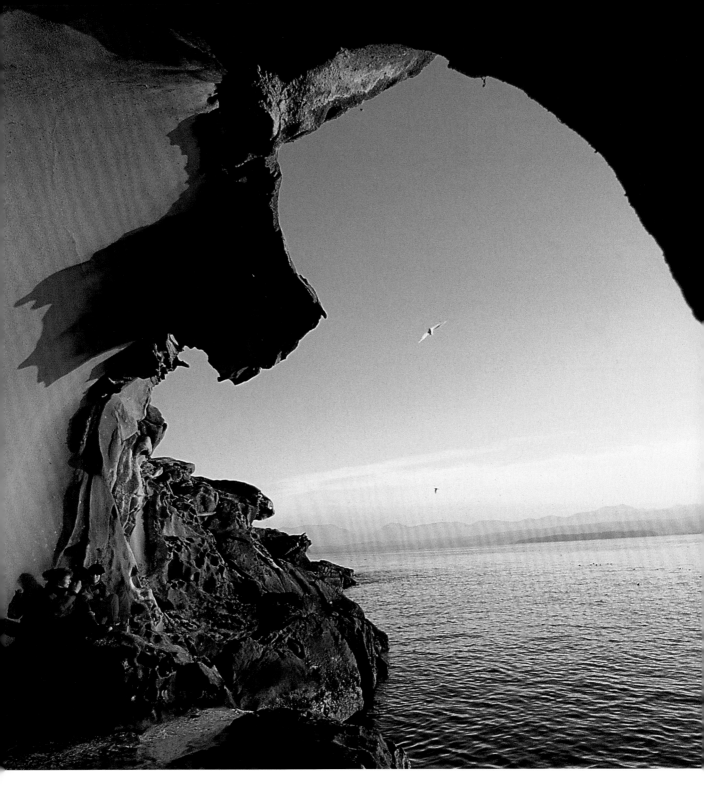

ABOVE : *Snake Island*
OPPOSITE : *Blood star in tide pool*

Wednesday September 01

DAY 62 PORT RENFREW TO JORDAN RIVER

The wooden floor of the hotel lobby is studded by years of loggers' cork boots, and hanging on the brown-panelled walls are sepia-toned photos of men with saws, proudly posing atop the trunks of felled old-growth giants. The only other person around is a man in jeans, a checkered shirt and a baseball cap who is sitting by the wood stove reading a newspaper.

"Do you know where we could get breakfast?" I ask him.

He points to a door leading off the lobby. "End of the Line Cafe. I'm waiting for it to open. It's the best place in town for breakfast. In fact, it's the only place in town for breakfast."

Tara is leaving us here, and she has arranged for her parents to drive out from Nanaimo to pick her up. In mid-morning she waves us off, dancing up and down on the dock and singing to us as we paddle away. Today's leisurely start not only gave us time to clear our heads from the effects of last night's pub session, but it also allowed the tide to turn

in our favour. When we round the corner and return to the open coast, however, we find that the current is unexpectedly on our nose. We've been warned that the currents in Juan de Fuca Strait don't always behave the way you would expect them to, and it hasn't taken us long to find this out for ourselves. I don't mind, though: I feel grateful that we are having a third day of good weather. The sun is beating down, and soon we take off our paddling jackets and work our way steadily along the shoreline in bare arms.

For the next few miles, cliffs rise from the water. We glimpse signs of the Juan de Fuca Trail on top of them: a hanging bridge across a ravine, a few hikers here and there. An earsplitting cacophony of barking heralds a rookery of California sea lions, and as we pass by some of the males dive into the water to follow us for a few hundred yards. Around noon, we ride the low remains of oceanic swells into the mouth of a small river that meanders through a gateway of beautifully contoured bluffs. Above us the smooth rock walls drip with water and sprout clusters of purple asters and yellow apargidium. We strip off our wetsuits, lie naked on the warm rocks and snooze.

One of the few possible campsites along this stretch—and the only one where we can legally pitch a tent—is Mystic Beach, which we reach in mid-afternoon. Despite the barely discernible swell, waves are dumping onto a rocky beach, and the place is packed with hikers' tents. Our only other option is Jordan River. From a distance it doesn't look at all promising: a bridge with logging trucks rumbling across it, a diner with a neon sign, a stony shoreline lined with RVs. But we can't afford to be choosy, so we manoeuvre through the breaking waves on the gravel bar where, in winter months, surfers congregate, and paddle up to the beach.

Right above where we land, a couple with a toddler and a baby are sitting on a blanket in front of their RV. As we emerge from the kayak, our spray skirts flapping around our knees, they stare at us in open wonder. But they're very helpful; the man tells us there are camping spots for tents in the trees behind, and that we're welcome to leave our kayak next to their RV.

"We won't drive away with it," he promises.

Set among big cedars, the campsites are pleasing, each one screened by trees and salal bushes. There are tables and benches, firepits, water taps and outhouses. The place is looked after by Bob, a small man nattily dressed in pressed jeans, a black leather waistcoat and cowboy boots. He lives on the site year round, in a little camper van. There's no doubt he loves his job; he takes great pride in keeping the surroundings clean, litter-free and pleasant for the people who stop by, and while we're setting up our tent he brings us an armload of wood, and carefully stacks it next to

our firepit. Bob is employed by the logging company that has been largely responsible for the clear-cuts on the surrounding mountainsides. Without a trace of irony, he proudly tells us that the company acquired this land and established a free campground, as its contribution to the environment.

Thursday September 02

DAY 63 JORDAN RIVER TO NORTH OF BECHER BAY

I can't believe our luck. Another sunny morning, still with no wind screaming down the strait. Not only did we get the calm period when we needed it, but it is forecast to hold for the rest of the day. Cape Flattery is now well behind us, and the steady ripple streaming off our bow disturbs the water's reflection of snow peaks in the Olympic Range. Such idyllic paddling is tainted only by the naval exercise taking place on the US side of the strait, from where we hear dull thuds of artillery rounds, and see the sombre outlines of destroyers and an aircraft carrier.

Along our side of the Juan de Fuca Strait, we're back to the trappings of "civilization"—a road, cars, telephone wires, houses. I feel as if we're being sucked away from the simplicity of this journey and toward our other life. For the last two months I've barely thought of home, but now unwelcomed concerns start to crowd in: bills to pay, work awaiting us, a garden to rescue from a summer of neglect. Dag, however, seems blissfully unencumbered by such things. For the past hour he's been busily trying to perfect his imitation of a murre's call, making loud cawing noises in the back of his throat. To his delight a murre has answered him, and he's convinced they are now having a conversation. Eventually, I beg him to stop.

"Well, at least I've learned murre this morning," he says triumphantly. "What have you accomplished?"

We take off our jackets, enjoying the feel of the sun on our backs. Nineteen miles slip easily by under our hull. Above us, turkey vultures and hawks circle over the cliffs and bluffs of East Sooke Park, riding the thermals to make the jump across to the Olympic Peninsula. We had planned to keep going to Becher Bay, where there is an official campsite, but before the headland that protects it Dag spots a tiny beach, bounded by high bluffs, with just enough room for one tent.

By nine o'clock we're in bed, with the alarm set for 3:30 a.m. The wind is forecast to come up again tomorrow afternoon, and I want to make sure we catch the early slack at Race Rocks. This is another notorious area, where currents and strong wind regularly

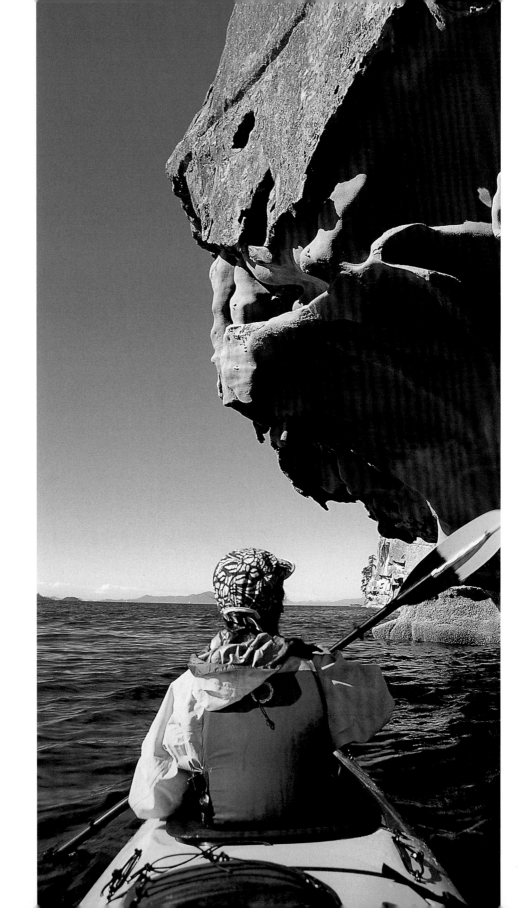

cause hair-raising conditions, and we've heard lots of horror stories about it. Plus, I keep remembering Paul's warning in Alert Bay: we are most likely to get clobbered when we think we've made it and have let our guard down. To be honest, I am plagued by a superstitious fear that we're about to get our come-uppance for all the good fortune we had on our way around Vancouver Island. I sleep poorly, starting awake every now and again, convinced we have missed the alarm and slept in.

Friday September 03

DAY 64 NORTH OF BECHER BAY TO VICTORIA

I'm relieved when the alarm finally goes off and I'm channelling my nervous energy into breaking camp. The beach has been exposed by the low tide, so we fashion a ramp from bits of driftwood on which we slide the boat to the water. It's a warm night and the half-moon has already dropped below the horizon. The world is still asleep; only a scattering of blinking light beacons and the stars keep vigil as we paddle away.

After five weeks on the exposed west coast, and the constant noise of surf, this paddling is unnervingly quiet. I'm acutely aware of the sounds of my paddle passing through water and of the drips falling from its shaft onto my deck. As dawn breaks, the bow of the kayak skims over a sea like golden silk. Ahead lie Race Rocks. The water roughens as we encounter a patch of current, and I begin to wonder if more of the same and worse is awaiting us. Soon we're passing between a low headland

ABOVE : *Nature's sandstone sculptures, Gabriola Island*
OPPOSITE : *Almost home—paddling past the sandstone bluffs of Gabriola Island*

and the infamous rocks. Conditions in Race Passage are totally calm; large logs drift by us, with gulls and cormorants nonchalantly perched on them. Within minutes, it's behind us.

I turn around and stare at Dag incredulously.

"Was that it?"

"Yep. Our last big challenge of the trip. Terrifying, wasn't it?"

I shake my head in wonder. "We've done it, haven't we? We're just about home free."

"And here comes our prize," he says.

From behind Mount Baker, a huge, golden orb rises shimmering into the sky, as if in celebration of our safe passage.

There's no need to hurry now, and we set a leisurely pace toward Victoria. In its harbour, float planes roar over our heads, little foot ferries tootle by, and tugboats motor past pushing up big bow waves. Along the seawall, young mothers point out our kayak to their small children, and blue-rinsed ladies sitting on benches wave merrily to us. The city skyline of pink and grey buildings is washed in morning sunshine, and dominated by the crenellated, ivy-clad Empress Hotel. At the head of the harbour, a sea of masts clinks gently in the wind. Tomorrow is the start of the Classic Boat Show, and proud owners are putting the final touches to their lovely old craft. After passing under the blue Johnston Street bridge, we pull up to the dock outside the Ocean River Sports kayak rental shop. The manager, Chris, is dubious when we tell him we've arranged to leave our boat and gear here.

"It's a holiday weekend, there's no room," he insists.

We persuade him to check with the owner, Brian Henry, who designed our Libra XT kayak. Minutes later, Chris emerges, full of apologies.

"Brian wants to take you out to lunch," he says.

The fancy Italian restaurant is filled with elegantly dressed people who to me seem polished to a shine. Across the table, Dag is deep in conversation with Brian about the performance of our kayak. He appears totally unselfconscious about his stubble, his stringy hair or the salt stains on his T-shirt. But I'm painfully aware of looking and smelling exactly like someone who has been kayaking and camping for two months. When the waiter shakes out a linen napkin and bends over to place it on my lap, I'm convinced he gets a whiff of my woodsmoky sweater and my rancid Teva sandals. By the end of my second glass of wine, however, I don't care. What we've just accomplished is beginning to dawn on me, and I can barely refrain from standing on my chair and announcing that, "Hey! We've just paddled down the west coast of Vancouver Island!"

DAY 65

Saturday September 04

VICTORIA

It's become automatic: as soon as I wake, and before I even properly open my eyes, I roll over and reach for the weather radio. This morning, however, my groping hand encounters thick carpet. I register that we're sleeping under the crisp cotton sheets of a large double bed in a friend's apartment, and that instead of the sound of surf, I hear cars passing by outside and a siren wailing in the distance.

When we step onto the street, the first thing I notice is how fast the clouds are scudding by overhead. Down at the harbour, the line of flags atop their high poles is straining and snapping in the wind. All day I keep wondering what's happening out at Race Rocks, and over dinner I find out. Barry Fairall, who runs a tugboat, confirms it's been howling out there again today. He tells us we got through Race Passage during one of the few windows of calm weather this summer. It's been blowing so hard, he says, he's been holed up and unable to tow any log booms for most of the last four weeks.

DAY 67

Monday September 06

VICTORIA TO CANOE COVE

Yesterday we were pinned down here by winds of up to thirty knots. Today they're forecast to pick up to northwest twenty-five, but I'm eager to get home and have decided to risk it. Though the water is rough when we leave the mouth of the harbour, we have the current and a twenty-knot wind with us, and the coastline flies by as we scoot along, making over seven knots.

At Trial Island we hit more serious currents and eddy lines seem to dash toward us, sucking us into their steep chop. Ahead lies Baynes Passage; Brian Henry warned us about the tricky currents here, but said we could sneak along the shore in the shelter of some rocks and miss the currents entirely. As we cut across Cadboro Bay toward these rocks, we feel the current trying to pull us out into the main channel. I keep steering toward the shore, and I'm frustrated when a sailboat crosses our path and forces us to stop. But we reach the rocks and cruise between them on still water, while less than a hundred feet away Baynes Passage is white and boiling with nasty tide rips. Then— at last! we've turned the corner—we're truly back on the east side of Vancouver Island and paddling home.

We've decide to boot it twenty-four miles today, as far as Canoe Cove, where Brian Henry said we can stay overnight in another of his kayak rental sheds. The afternoon turns into a long slog, past miles of subdivisions. There's no doubt that we're back in so-called "civilization": on Cordova Spit, where we stop for a break, the dunes are full of

garbage and there's an overpowering smell of raw sewage. But on the approach to Canoe Cove, among the tiny islets of Pager Pass, scores of arbutus trees grow from the rocky bluffs, their green limbs and peeling red bark standing in clear contrast against the blue sky. They seem to be welcoming us to the Gulf Islands, and heralding the fact that danger and uncertainty are at last behind us.

The kayak rental hut is an old wooden building standing on pilings over the water. Inside, scores of kayaks are laid on ceiling-high racks, PFDs and spray skirts hang on the walls, and paddles, pumps, throw lines and various other bits and pieces of safety gear are arranged in neat piles.

"I've got good news for you," says Ross, the charming young manager. "The marina has really hot showers, there's a pub up the road where you can get decent food and Race Rocks beer, and the coffee shop opens for breakfast at six in the morning."

Then he hands us the key, and bids us good night.

DAY 68
Tuesday September 07
CANOE COVE TO THETIS ISLAND

At the Swartz Bay terminal, a white ferry gleams in the early morning sunshine, contentedly puffing smoke from its funnels and sucking up a new load of vehicles. As cars clank over the ramps, I think how glad I am to be paddling home over the next couple of days, instead of driving the distance in two hours. By the time we're crossing toward Saltspring Island, the ferry is pulling out to begin its journey to Vancouver, and as it steams by, towering above us, we hear the familiar prerecorded announcement blaring out, "Welcome aboard BC Ferries..."

On the east side of Saltspring Island, forested slopes drop steeply to the shore. A doe with twin fawns steps delicately over the rocky beach. Families of raccoons forage at the water's edge, and as we paddle by the mothers lumber back to the safety of the trees, temporarily abandoning their babies.

Ahead, a blue line has formed on the water, the sign of northwest winds. I hope it's only blowing out of Cowichan Bay, but as we turn up into Samsun Narrows it gets stronger, up to fifteen knots, and it's on our nose. It's hard work getting through the narrows and there are several bands of tide rips to contend with. Our biggest problem is dealing with the powerboats going through at the same time as us. Some of the skippers are obviously nervous and keep changing direction as they approach the rips, making it hard for us to keep our course. Once in the rips, their boats swerve about

alarmingly, and kick up big wakes that combine with the eddies to make the paddling uncomfortable.

Beyond the narrows, we glide through the sleepy, sun-soaked Gulf Islands, passing sculpted sandstone bluffs, sloping meadows of dried grasses, and stands of twisted Garry oak, arbutus and juniper trees. The wind is still on our nose and the current has turned against us, but we don't care. Even Dag, who usually hankers after wild places, admits that these forgiving waters are a welcome change from raw exposed coastlines.

By late afternoon, we're hugging the west-facing shore of Thetis Island, and wondering where we can spend the night. We spy a camper van in the trees, a tent a little farther along, and beyond it another van. Above a smooth rock ledge, a perfect place for pulling up the kayak, we find a meadow with a picnic table, a firepit and kindling, and a stand pipe.

"Here's our campsite," says Dag. "The last one of the trip."

I walk through the trees to the nearest camper van, where a couple and their young son are preparing a meal. They explain that this is a private campground owned by an eighty-two-year-old Thetis Islander. He doesn't advertise it, and only rents out sites to people he knows and likes.

"He comes around once a day and you've missed him," says the man. "But I'm sure that in your circumstances he won't mind you staying a night."

I leave them with fifteen dollars, the daily camping fee, which they promise to pass on to the owner tomorrow.

When the sun goes down, the grasshoppers start singing. Eating dinner by a fire,

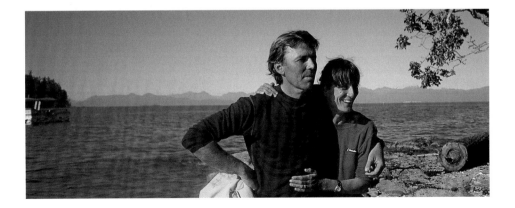

ABOVE : *Journey's end! We step onto the beach outside our house*

we watch the sky darken and the stars appear. Below us, waves gently lap against rock, fish slap their tails on the water and a seal snorts. Across the channel, lights twinkle on Vancouver Island. We're almost home.

Wednesday September 08
DAY 69 **THETIS ISLAND TO PROTECTION ISLAND**
The morning is clear, blue and calm. Over breakfast, I suggest that we linger here a day, and maybe explore Thetis Island. Dag laughs.

"You're always reluctant to get going on our expeditions," he reminds me, "and then you never want them to end."

We have to wait a few hours for the current in False Narrows to switch in our favour, so we decide to stop off and visit Julian Matson in Boat Harbour. The old house on the bluff protecting the harbour was originally the home of Arthur Lloyd Kendall, or Pirate Ken as he was better known. He first came here in 1944, and soon became renowned for his habit of building small cannons and firing them at passing sailboats. After Ken's death, Julian bought the property and developed a small marina. Fifteen years ago, a goose with a gangrenous foot swam up to his dock. Julian spent five weeks nursing the goose back to health, and they've been inseparable ever since.

As we walk up toward the house, Toulouse the goose comes waddling down the path, honking in warning and pecking at our sandals. While we're having coffee on a first-floor deck with Julian and his girlfriend, Toulouse stands below us, stamping his feet and noisily demanding attention.

"He wants a bath," explains Julian.

Down by the dock, he shows us the plastic paddling pool and shower he has set up for the goose.

"He won't go in unless the water's fresh," he says, filling the pool from the tap. Soon Toulouse is happily swimming in circles, dipping his beak into the water, then rubbing it over his chest. When Julian turns on the shower, the goose floats under it, his head pointing up into the flow, the water rolling in droplets from his feathers.

"There aren't many geese on the coast with their own bath and shower unit," says Julian proudly.

After squeezing through the tiny gap between Link and De Courcy Islands, we turn into False Narrows, between Gabriola and Mudge Islands, where the current carries us along. As we pass the entrance to Dodd Narrows, we cross an invisible line and are

suddenly hit by the northwest winds. On our left a pulp and paper mill belches out towers of smoke. Across the narrows, at the bottom of Gabriola Island's cliffs, a log-salvaging boat is moored to a rickety dock. On deck is a man with bright blue eyes set in a tanned, deeply lined face. As we pass by and say hello, he looks down at us rather disparagingly.

"How are you guys going to manage when you get out there?" he challenges, jerking his thumb toward the whitecaps in the open water ahead.

"The same way we managed paddling around Vancouver Island, I guess," I reply.

The man's jaw drops.

"You serious? You just paddled around the whole island in that little boat? Where did you start?"

"Right over there, on Protection Island."

"You guys are crazy!" says the man, but there's an admiring twinkle in his eyes.

The last leg of the journey is a forty-five-minute sprint across Northumberland Channel. In the distance we can make out the sandstone bluffs of Snake Island, and beyond them the blue outline of Lasqueti Island on the horizon.

"It's such a strange feeling to be coming in from the opposite direction, yet ending up at the same place we left from," muses Dag. "It seems like magic—that you can go in a full circle around this huge chunk of land we live on. I guess it's how Francis Drake felt when he sailed around the world."

Drawing close to home, I reflect on how Vancouver Island has become like an old friend to us during this journey. We've learned much about it: we've seen its failings, its frailties and its scars, but we've embraced it nonetheless.

Full circle. As we enter the channel between Protection and Newcastle, a cheer goes up from shore: the same neighbours who saw us off ten weeks ago are waiting to welcome us home. Rick Scott starts to play the tuba, Valley rings a bell, Pat blows a mouth harp, there's clapping and shouting and whistles. How often have I told myself that I can't let down my guard until we reach the familiar rocks outside our house? Finally that moment has come, and while Dag steadies the kayak I climb out of the cockpit and into the arms of friends. The journey is over—for me at least, but not, it seems, for Dag. A friend's son, three-year old William Grace, has jumped into my seat and is yelling excitedly to him, "Come on, let's paddle around the island!"

ACKNOWLEDGEMENTS

Throughout our journey around Vancouver Island, we received help, hospitality and encouragement from friends both new-found and long-standing. Many of them are mentioned in these pages; our heartfelt thanks to them all. A special note of appreciation is due to Liz Hammond and Mark Kaarremaa for their unstinting support, boundless generosity and cheerful company–and for the supply line of salami and wine!

We were lucky to have some of the best equipment on the market along with us on this voyage. Our kayak, a Current Designs Libra XT, proved to be an excellent boat for a long expedition—it is roomy, comfortable and fast, and performs well in rough seas and surf. Our ultra-light graphite Medusa and Sabella paddles, also from Current Designs, eased the strain of a million and a half paddle strokes and still look brand new. Cascade Designs improved our quality of life during the trip in many ways. Their range of waterproof SealLine Bags kept our gear dry and well-stowed: the Kodiac Taper bags fitted snugly into the prow and bow of the kayak, the Kodiac Sacs were easy to stuff into small spaces, our sleeping bag shrank to a manageable size in a Black Canyon Compression bag, and our food was easy to organize in the transparent See bags. While we were paddling we kept our snacks at hand and our maps dry in the SealLine Deck Bags and Map Cases. We used a Sweetwater Guardian Microfilter to purify our water, which we carried in Platypus water bottles. And after long days of paddling, we could sit comfortably in our campsites on Therm-a-Rest Chair Kits, and sleep soundly on Therm-a-Rest mats. Patagonia clothed us from head to foot in garments that felt great to wear and once again proved to withstand endless amounts of ravaging by salt, sun, sand and rain. Their Skanoraks remain the best kayak touring jackets we've ever used, and their Synchilla sweaters and R1 stretch fleece tights were a joy to slip into after a day on the water. The Lotus Designs PFDs were comfortable to wear and carefully designed so as not to impede paddling. Horizons Unlimited/Churchill River Canoe Outfitters provided our Camp Fire Tent. Its light, airy interior kept our spirits up on tent-bound days, the space it provided us was a great boon on such a long trip, the mud room enabled us to hang up and dry our clothes, and the possibility of having a fire close by while sheltering from the rain was enormously cheering. It is a tent we would recommend for any kayaking expedition. Snap Dragon provided us with a new pair of indestructible Sea Touring spray skirts (our old ones lasted over ten years!), which once again kept us warm and dry in the kayak. Fuji Canada generous-ly provided us with high quality and superbly stable photographic film. Our thanks to you all, for greatly assisting our well-being and safety along the way.

We also thank Oriane Lee Johnson, for her invitation to stay at Hollyhock Farm on Cortes Island. The extract on pg.33 is from Wendell Berry's book *The Unforeseen Wilderness* (Harcourt Brace, 1972). For the use of their photos, our thanks to Peter Buckland, Morris Donaldson, Russ Heinl, Mark Kaarremaa, Ian McAllister and Jaqueline Windh.

Maria gratefully acknowledges the Canada Council for the Arts for its support towards the writing of the manuscript. We thank Alison Watt for her advice on the references to natural history. A salute to Peter Robson for his hard work in coordinating the production of the book. And to Tara Williams, for sharing the vision, *un multitude de Gracias, amiga espiritual.*

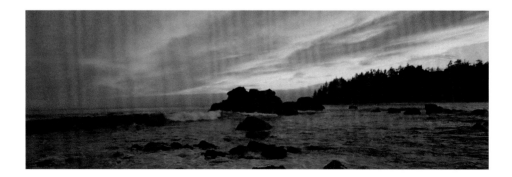